Bison

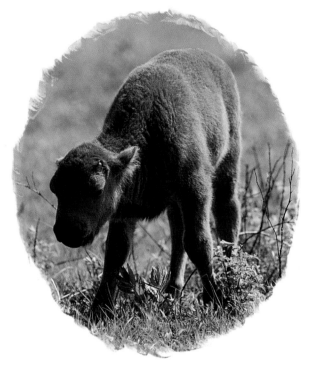

PHOTOS:

Front jacket and pages 8-9: A bison bull's horn is scarred from being rubbed on trees and perhaps from battles with other bulls. The thick, curly hair between his horns may grow twenty-two inches long, as insulation and protection for the heavy bone and hide beneath.

Back jacket: Young bison running through spring grass.

Page 1: A bison calf, likely born in May, takes its first shaky steps. In a few hours it will be able to keep up with its mother and the herd.

Page 3: A mature bison bull appears to doze in the sun, but he's chewing his cud—regurgitating small amounts of his most recent meal to chew it more carefully and swallow it again.

Page 4: A vigorous roll in dusty grass is a favorite bison grooming method. In a prairie dog down, a bull may pierce the ground with his horns and paw the soil loose to create a wallow.

Page 5: Bison bull dozing.

Pages 10-11, 12-13 (flopped): Early morning fog along the Yellowstone River veils bison from one of the nation's largest herds, who spend their summers in the lush Hayden Valley of Wyoming.

Page 120: A frosty bison dozes in 9 degree February weather near Firehole River, Yellowstone National Park, Wyoming.

Page 124: Over a few months, a young bison's hair color will change to dark brown.

Page 125: Bison calf and its mother.

Page 128: Bison bull at rest on the prairie.

Bison
MONARCH *of the* PLAINS

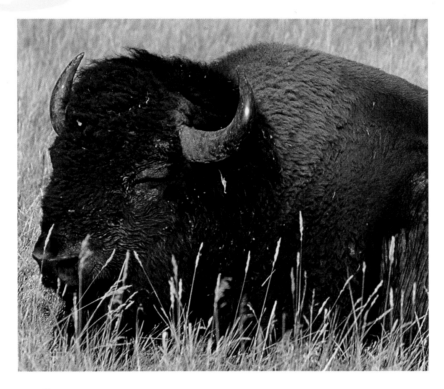

PHOTOGRAPHY BY DAVID FITZGERALD

TEXT BY LINDA HASSELSTROM
FOREWORD BY JAMES WELCH

GRAPHIC ARTS CENTER PUBLISHING®

Photographs © MCMXCVIII by David Fitzgerald
Text © by Linda Hasselstrom
Foreword © by James Welch
Book compilation and map © MCMXCVIII
by Graphic Arts Center Publishing Company
P.O. Box 10306 • Portland, Oregon 97296-0306 • 800/452-3032

President/Publisher: Charles M. Hopkins
Editorial Staff: Douglas A. Pfeiffer, Ellen Harkins Wheat,
 Diana S. Eilers, Jean Andrews, Alicia I. Paulson,
 Deborah J. Loop, Joanna M. Hooley
Production Staff: Richard L. Owsiany, Lauren Taylor
Editorial Services: Marlene Blessing, Watershed Books
Designer: Elizabeth Watson
Map: Michelle Taverniti
Book Manufacturing: Lincoln & Allen Company
Printed in the United States of America

Library of Congress Cataloging-in-Publication Data
Fitzgerald, David 1935-
 Bison : monarch of the plains / photography by David
Fitzgerald ; essays by Linda M. Hasselstrom ; foreword by
James Welch.
 p. cm.
 Includes bibliographical references and index.
 ISBN 1-55868-406-9
 1. American bison. 2. Indians of North America.
3. American bison hunting—History. 4. Wildlife conservation—
United States. I. Hasselstrom, Linda M.
II. Title.
QL737.U53F58 1998 98-25858
599.64'3—dc21 CIP

ART WORK AND PHOTO CREDITS

The owners or custodians of art works in this book who gave
David Fitzgerald permission to photograph their pieces are:

Collection of Ataloa Lodge Museum, Bacone College, Muskogee,
Oklahoma: page 17 (right), 30 (top), 33 (left bottom), 34, 44
(top and bottom), 45 (middle), 49 (top and bottom), 53 (right),
76, 77 (top), 109 (right bottom), 111 (right).

Collection of Jeff Briley: 65.

Collection of Buffalo Bill Museum, Cody, Wyoming: 31 (left),
48 (top), 52 (top), 57 (left), 59 (right).

Fort Sill Museum, Lawton, Oklahoma: 33 (right bottom),
35 (bottom) and 41 (right), 48 (left top and middle), 48 (bottom,
personal collection of Towana Spivey, Director), 51, 58 (top),
59 (left), 62 (right), 63 (top), 71 (bottom).

Collection of Vanessa Morgan-Jennings: 33 (left), 63 (bottom),
109 (top right).

Oklahoma Historical Society: 20, 44 (middle), 45 (bottom),
52 (bottom), 57 (right), 75 (right), 84 (bottom).

Red Earth, Inc.: 112.

Collection of Rainette Sutton: 62 (left bottom).

All photos in the book are by David Fitzgerald except: 50 (right),
John A. Anderson, courtesy of Nebraska State Historical Society;
69, courtesy of Saskatchewan Archives Board; 71 (top), courtesy of
Burton Historical Collection, Detroit Public Library; 110, courtesy
AP/WIDE WORLD PHOTOS.

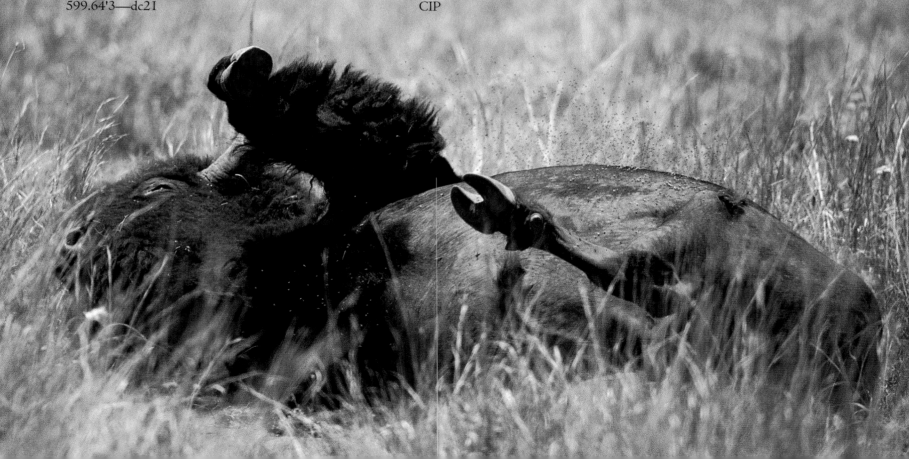

To my wife, Mari Spencer Fitzgerald

—D. F.

To all lovers of the 1840s era, especially my buckskinning friends,

whose fascination with living the life of the fur traders stimulated my interest in the era,

in buffalo, and in the wisdom of Plains Indians.

—L. H.

ACKNOWLEDGMENTS

Several people were invaluable to the rich content of this book: Carrie Geoeringer, whose expertise in Native American culture, and bison-related artifacts and museums where they could be found, was the early cornerstone of this project; my longtime friend Jeff Briley, Registrar of the Oklahoma Historical Society, whose broad knowledge not only encompasses bison-related pieces within the museum but also a broad range of information on the animal; Randy Ledford, Director of the Pawnee Bill Museum, Pawnee, Oklahoma; Arlyn Miller, helicopter pilot extraordinaire; Towana Spivey, Director of the Fort Sill Museum, Lawton, Oklahoma; Tom McKinney, Director of the Ataloa Lodge Museum, Bacone College, Muskogee, Oklahoma; Vanessa Morgan-Jennings, who generously allowed me to photograph her family's artifacts; The University of Oklahoma Archaeological Survey, Norman, Oklahoma; Scott Hagel and Elizabeth Holmes of the famous Buffalo Bill Museum in Cody, Wyoming; Dub Adams, owner of the Wilds Restaurant, El Reno, Oklahoma; Red Earth, Inc.; John Parker, keeper of the late "Ralphie III" (mascot to the University of Colorado football team, who I'm sorry to say passed away in January 1998).

Many thanks to Mary Stevens, who did a superb job of running my business while I was off photographing bison, and a special thanks to my assistant, Rae Sutton, whose sharp warning kept me from becoming a punching bag for a large bull in the Badlands of South Dakota.

—D. F.

Thanks to Jerry L. Ellerman, my in-house weapons expert; to authors I've never met, like Joseph Epes Brown, Dee Brown, William K. Powers, Melvin R. Gilmore, George E. Hyde, Bruce Nelson, Royal Hassrick, Paul Goble, Thomas Mails, Richard Manning, and dozens of others whose research has taught me so much about Plains Indians; to writers I have met—John Neihardt, James Welch, Elizabeth Cook-Lynn, James Heynen, Diane Glancy—whose written words are enhanced by their living testimony to authenticity.

—L. H.

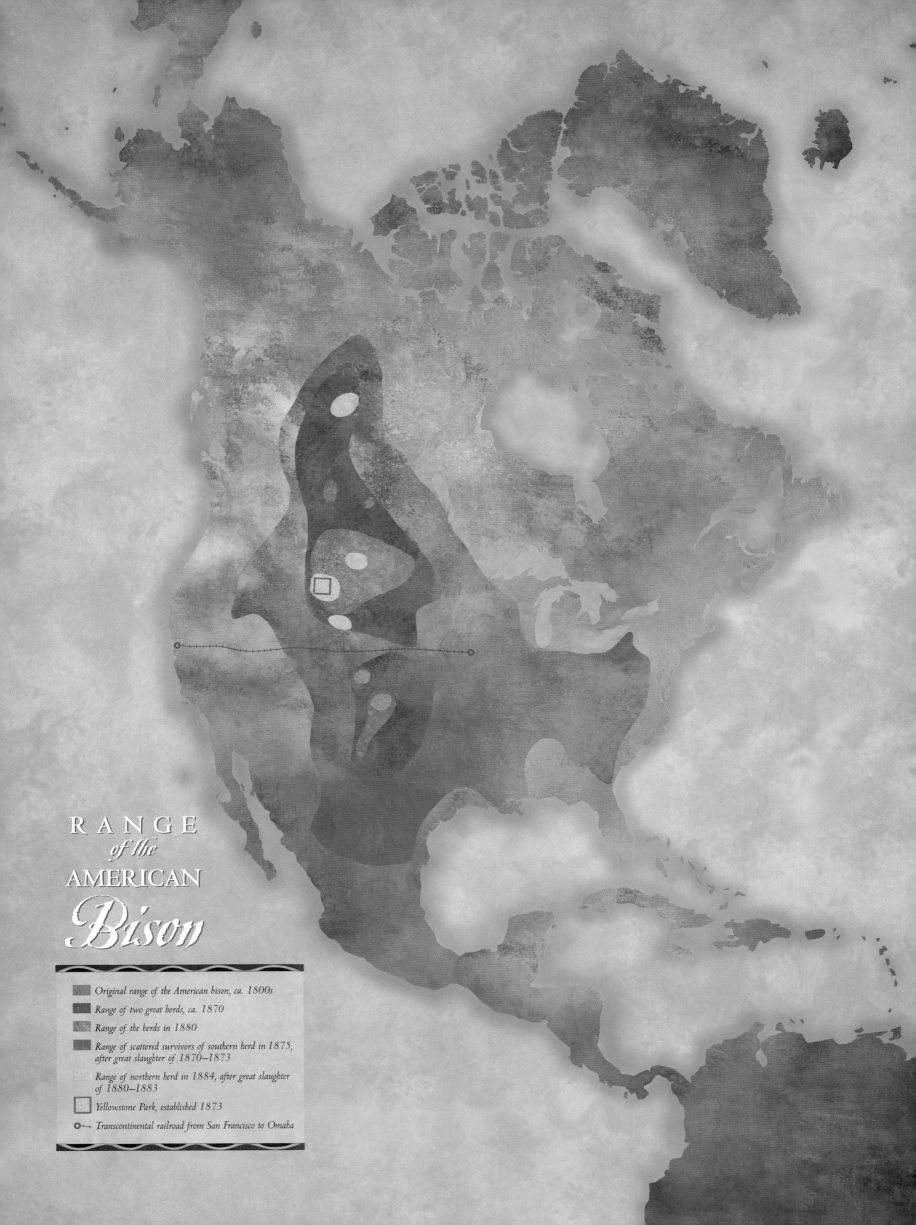

RANGE
of the
AMERICAN
Bison

- Original range of the American bison, ca. 1800s
- Range of two great herds, ca. 1870
- Range of the herds in 1880
- Range of scattered survivors of southern herd in 1875, after great slaughter of 1870–1873
- Range of northern herd in 1884, after great slaughter of 1880–1883
- Yellowstone Park, established 1873
- Transcontinental railroad from San Francisco to Omaha

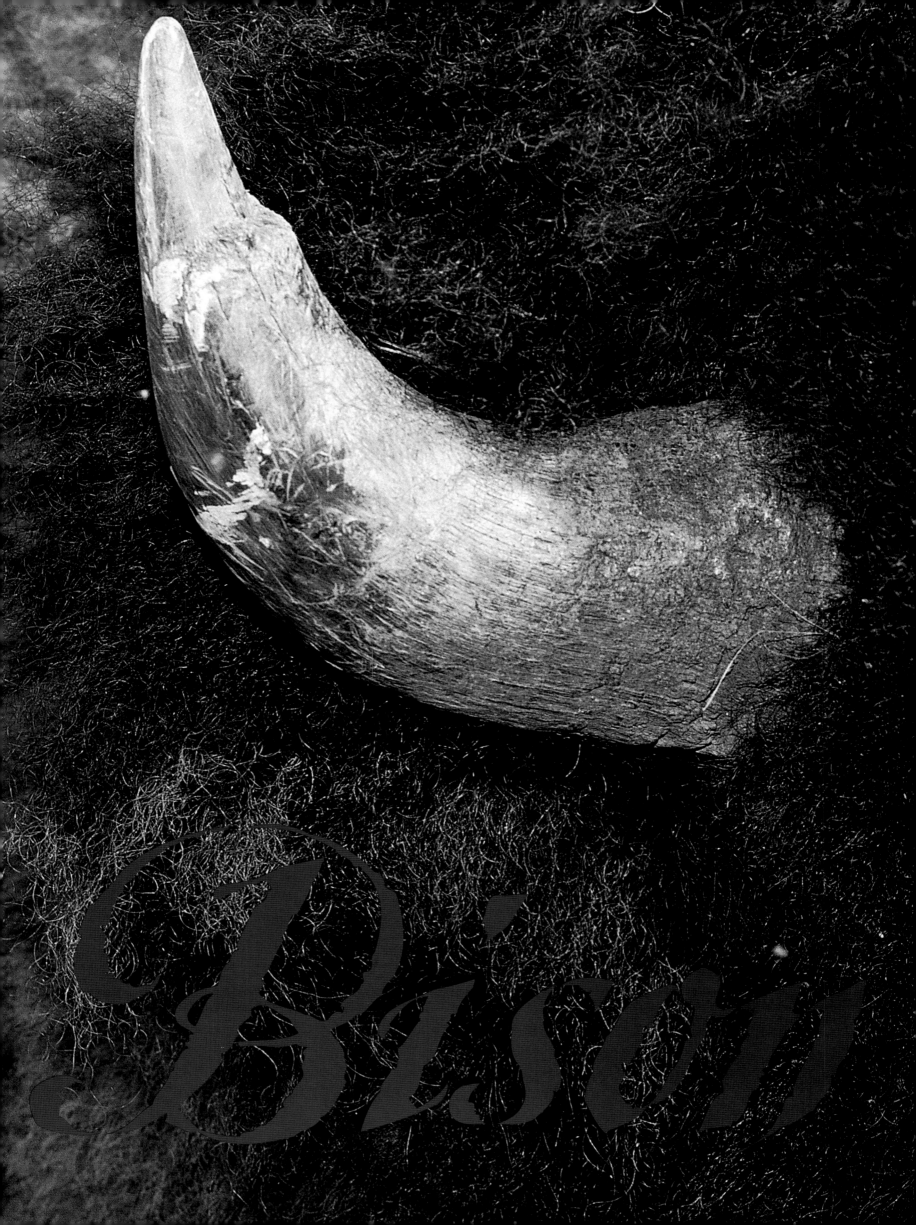

Bison

CONTENTS

Foreword

The first real buffalo I ever saw was dead. And now that I think about it, it wasn't a real buffalo. It was hide, bones, and meat. It was a big woolly head with black horns and glazed eyes. It had no legs below the knees, no hooves, no tail. It had no kidneys, no entrails, no heart, or lungs. It had a liver, but the liver was not inside it. The carcass was cut into four quarters, and the quarters, the head, the hide, and liver lay on the back of a flatbed truck. This buffalo, or what was left of it, along with many others similarly skinned and quartered, had ridden under a tarp on a flatbed truck all the way from Yellowstone Park to the Fort Belknap Indian Reservation in northern Montana.

That was back in 1961, and the buffalo had been slaughtered by park rangers the day before. I don't remember if they had wandered out of the park onto some rancher's land—brucellosis was an issue back then, just as it is today—or if rangers were simply thinning the herd. But it was park policy in those days to notify the surrounding tribes that they were going to kill a good number of buffalo and if the tribes wanted the meat, they could come and get it. Usually these phone calls came the day before slaughter, hence the urgency of assembling volunteers and equipment at a moment's notice to take off for the park. What I do remember is that it was a cold winter night when the flatbed truck pulled up to the agency office.

I was there because my father was one of the men who had driven down to the park the night before and had spent that whole day skinning and quartering the animals, then loading them on the truck and driving all the way back to the agency. It was close to midnight when the truck arrived. We unloaded the meat, the hides, and heads, putting everything into a garage that had a good padlock on it. The next day, other volunteers would butcher the quarters to distribute to families across the reservation. The Gros Ventres and Assiniboines would feast on government largesse. The hides would be tanned and the heads skinned and taken to a secret place for the maggots to clean up in the spring. Later, these skulls would be used in ceremonials.

In some ways, this almost surreal event reminded me of the old

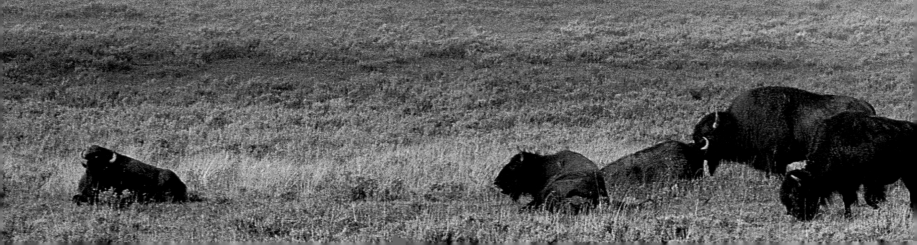

ration days around the turn of the century, when government agents would slaughter cattle to give a portion of meat to each family. The cattle were often thin; sometimes the meat rotted before the agents got around to apportioning it; sometimes the meat never got to the Indians, having been sold on the hoof to one of the local ranchers. Corruption was very nearly rampant in those days.

But that night, the meat was heavy and fresh and sweet. It was buffalo meat and it would allow many families, even communities of families, to feast on the flesh of the animal that had provided a living and a way of life to their ancestors. The various tribes on the Plains, in their various languages, called this flesh "real meat" to distinguish it from the meat of other animals, such as elk, deer, mountain sheep, birds—and later cattle.

Now the Gros Ventres and Assiniboines on the reservation have their own buffalo herd. It's a small herd, acquired during a surge of optimism that a major market would develop for the lean, dark meat. They, along with Ted Turner, are still waiting. But it is a wonderful thing to see those few buffalo grazing on the open grasslands of the reservation. One can almost imagine that they are their ancestors.

It would be ten years after that cold winter night that I would see my first live buffalo. Like thousands of Americans, including Indians and the many Montanans who boast of being anywhere from third- to seventh-generation Montanans, I would see this buffalo in Yellowstone National Park. My wife and I, not long after we were married, took a trip through the park, and it wasn't long before we saw that first buffalo, then two, then twenty and fifty, grazing out among the thermal hot springs and seeps, oblivious to the lunar landscape. This was not the Charlie Russell country of rolling plains and dramatic buttes, of meandering rivers and sagebrush, bunchgrass and prickly pear cactus. It was difficult to imagine that these dark animals were descended from those great herds that blackened the Plains for miles on end. No, these Yellowstone buffalo were in a "setting," almost an animal prison, picturesque as it might be. And the thought that any escapees would be shot on sight only furthered the notion of an unnatural setting.

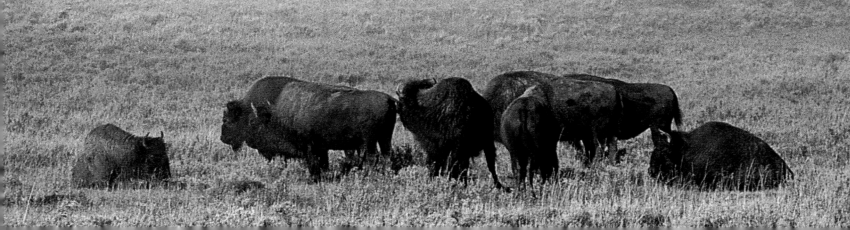

The last great northern Plains herd roamed the area that is now Montana and northern Wyoming. It was to this herd that Sitting Bull and Crazy Horse led their people in the two or three years before the Battle of the Little Bighorn. They wanted to live out away from the agencies that had been created on the Great Sioux Reservation. They wanted to follow the buffalo in the old way, to live in peace and accordance with their traditions, to perform the ceremonies necessary to ensure the further abundance of these great animals. But they were not naive. They knew that it was government policy, carried out by the military, to allow the hide hunters to slaughter as many buffalo as possible. As General Philip Sheridan said at the time, "Let them kill, skin and sell until the buffalo are exterminated. Then your prairies can be covered with speckled cattle and the festive cowboy."

Plains Indians without the buffalo became agency Indians in short order. So it was that the Fort Belknap Agency Indians unloaded the buffalo parts from the flatbed truck that winter night. It would be tempting to say that the buffalo had returned to the people, but that probably is a little disingenuous. More likely, that midnight delivery had presented an opportunity for many very poor people to fill their bellies, and the bellies of their children, at least temporarily. Maybe some prayers were said, some words of thanks to the buffalo spirit that had once provided them with abundance. Maybe some of the elders told stories that had been handed down to them by those who had lived the life of following the great herds. I would like to think so.

A few years ago I visited the Pine Ridge Reservation in South Dakota to give readings and talks in various schools around the reservation and at the tribal college in Pine Ridge. After three or four days of pleasant duty, my host, Mike Her Many Horses, and I headed for the airport in Rapid City. It was a cool fall day and the colors of the willows along the creeks and the chokecherry and serviceberry bushes in the draws and coulees were brilliant under a slanting sun. The secondary road had been newly and badly paved, with built-in washboards and instant potholes. Less than an hour from Pine Ridge, we found

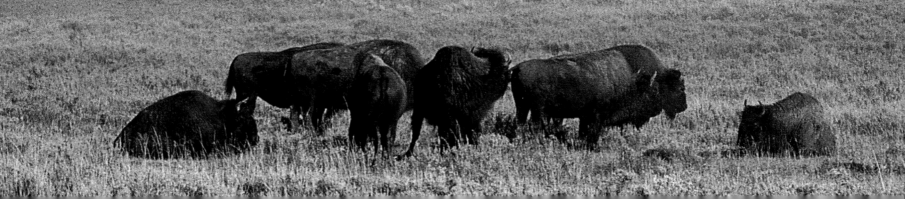

ourselves out in the badlands in the northwest corner of the reservation.
I was rather surprised when Mike pulled over to the shoulder of the
road and stopped. He wanted to stretch his legs, he said, so we both got
out of the car. It was an outrageous landscape we looked upon—deep,
steep-sided gullies and washes, almost canyons, cut crazily through hills,
outcroppings and buttes thrust up at impossible angles. We leaned
against the car for a few minutes, taking in the monumental view. Then
he pointed to a particular butte that seemed a bit more monumental
and fortress-like than the rest. "That's the Stronghold," he said. "That's
where my people danced the Ghost Dance back in the old days."

I knew about the Ghost Dance, and I think I had even read about
the Stronghold, where the Oglalas performed this sacred ceremony in
the manner that Wovoka, a Paiute visionary, had prescribed. Nevertheless,
I was stunned. It was almost like finding Crazy Horse's burial place
after all these years.

"They believed that if they danced themselves into a visionary state,
the *wasichus* would disappear and the ancestors and buffalo would come
back and the earth would be fresh again," Mike said.

I remember thinking then that this was one of the most bizarre and
desperate periods in American Indian history. Actually, it lasted less than
a year. On December 29, 1890, the last of the Ghost Dancers, Big Foot's
band of Miniconjous, were massacred at Wounded Knee. As we climbed
back into the car, I must have indicated my sadness at the tragic conclusion
to Wovoka's vision. "Not at all," Mike said, smiling. "There are many
who believe it all could happen yet. We Lakotas are patient people."

I don't know if all the elements of the Ghost Dance vision will
come true. What I do know is that the buffalo are coming back. In spite
of the hide hunters' attempt to fulfill General Sheridan's wish to
exterminate the great beast, they are here. Whether they are here to stay
is up to us. We must want them to stay for the sake of the many
generations to come, Indian and *wasichu* alike. Like the grizzly, the wolf,
the sandhill crane, and the condor, these buffalo are a part of us and we
are a part of them. We are all of the earth.

James Welch
Missoula, Montana, June 1998

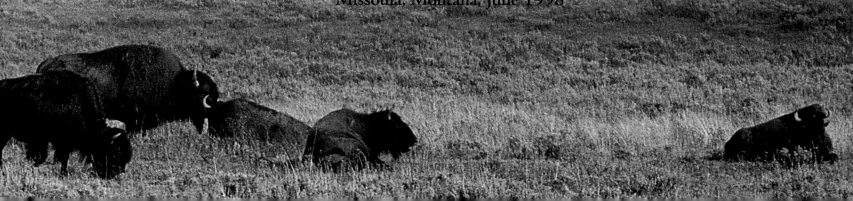

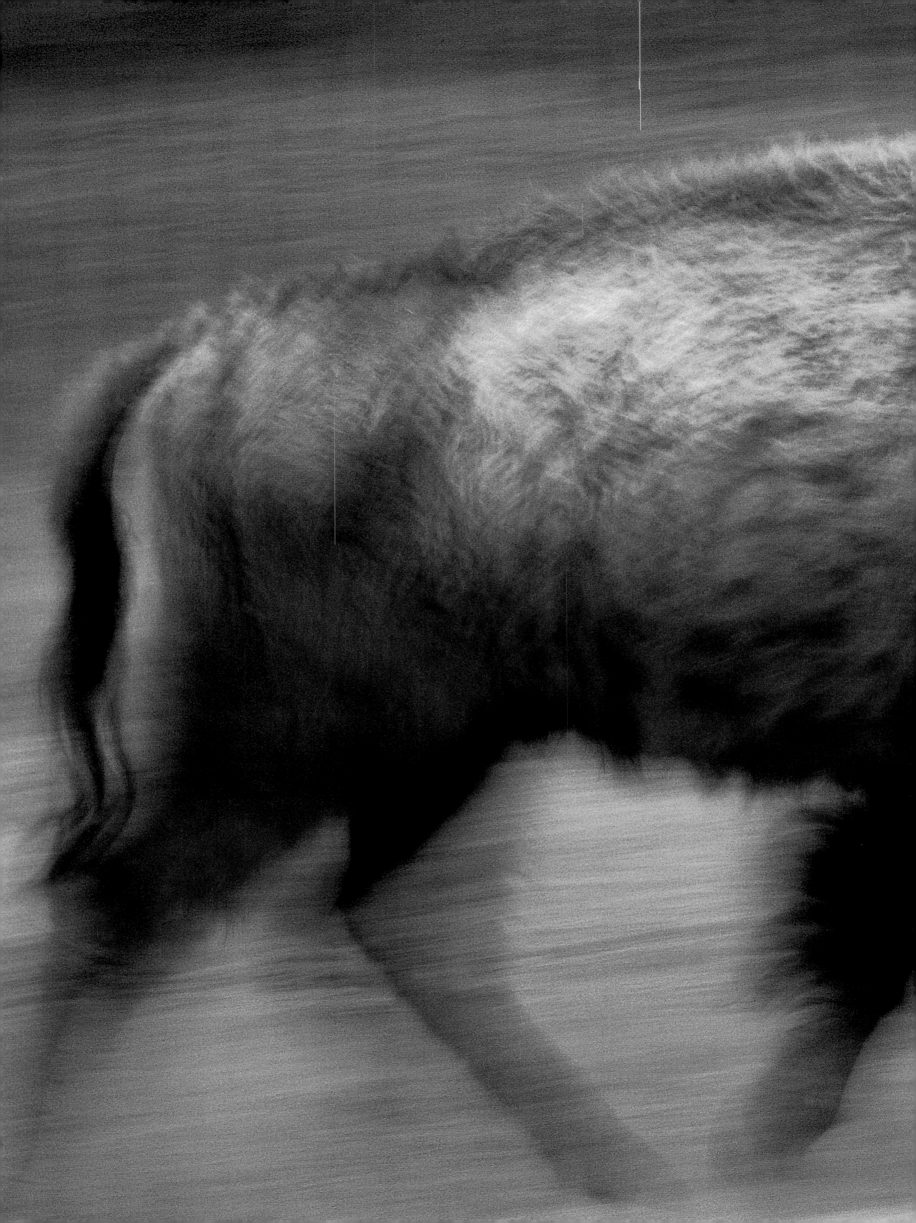

The whole world is coming,
A nation is coming, a nation is coming
The Eagle has brought the message to the tribe.
The father says so, the father says so.
Over the whole earth they are coming.
The buffalo are coming, the buffalo are coming,
The Crow has brought the message to the tribe,
The father says so, the father says so.

—Lakota Ghost Dance Song

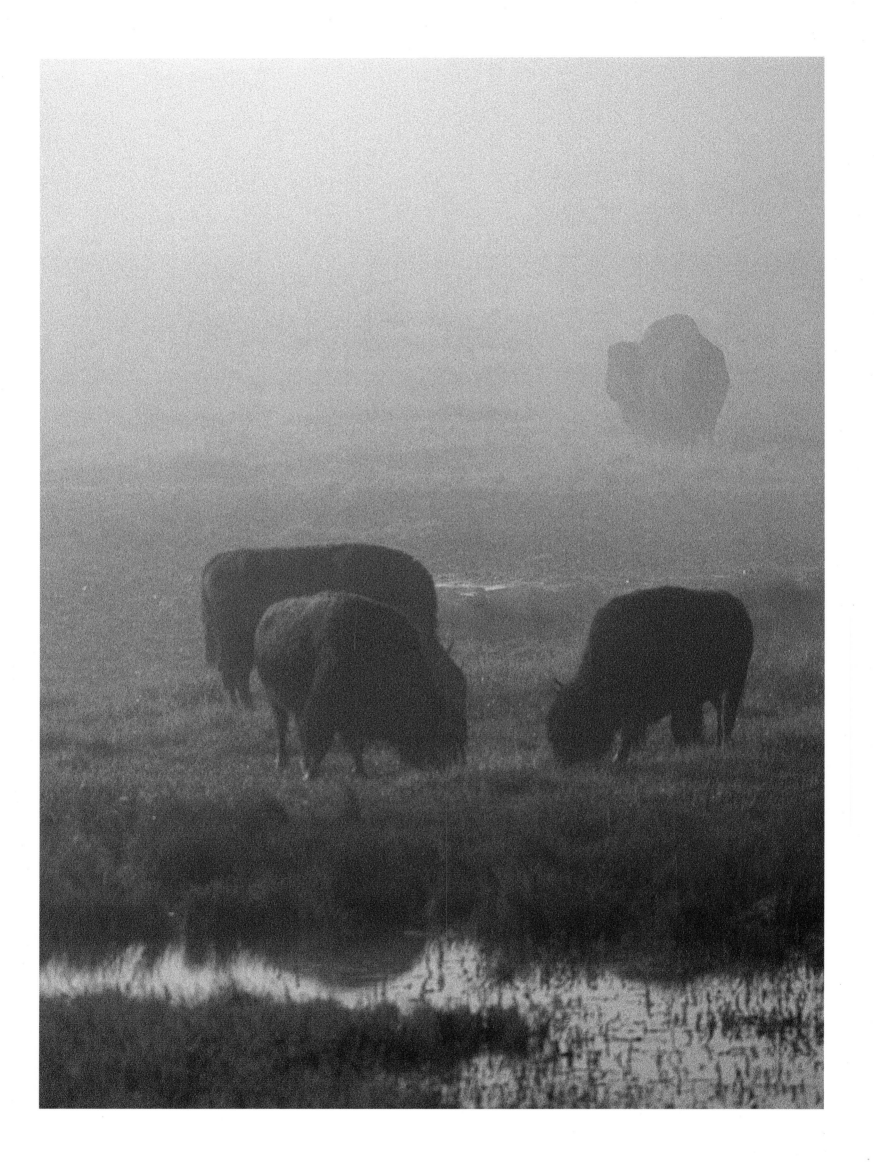

THE GHOST DANCE

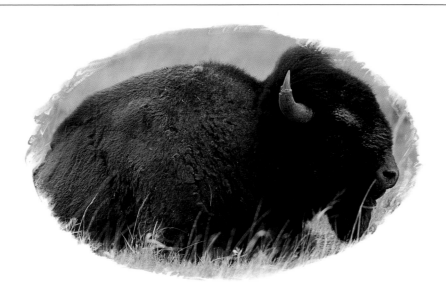

And there is happy hunting when the bison herds were wide as day, and meat was plenty, and the earth stayed young. That was before the rivers of Wasichus came in flood and made it old and shut us in these barren little islands where we wait and wait for yesterday. And there are visions to be seen again and voices to be heard from beyond the world.

—Eagle Voice, from *When the Tree Flowered*

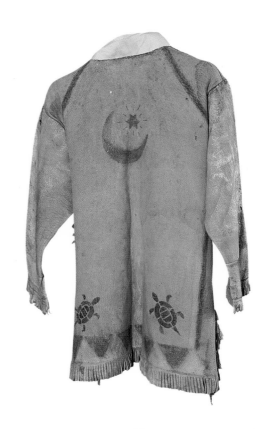

Plains Indians tell legends of the Buffalo Nation living in caves below the earth. Among them, the same beings in some legends, are people who can become bison. Above, the creator has prepared the grasslands for the beat of their hooves. Then a young woman walks among the herds, the animals rising with soft grunts to follow her into sunlight. Below the earth, some remain to host the Sun each night as he rests from his daily work. Always, some remain below, say the legends. Tribal buffalo dreamers learned to call the buffalo to give their bodies to people, who in turn learned to create from them an entire civilization.

Later, the blood of millions of bison and the people who depended on them soaked into the prairie grasses. The Plains tribes starved and

◄◄ YOUNG BISON RUNNING THROUGH SPRING GRASS.

◄ BISON GRAZING ALONG THE YELLOWSTONE RIVER IN FOGGY HAYDEN VALLEY MIGHT BE GHOSTS OF THEIR ANCESTORS FROM 30,000 YEARS AGO.

◄▲ BISON BULL WITH WINDBLOWN HAIR.

▲ LAKOTA GHOST DANCE SHIRT, CA. 1890.

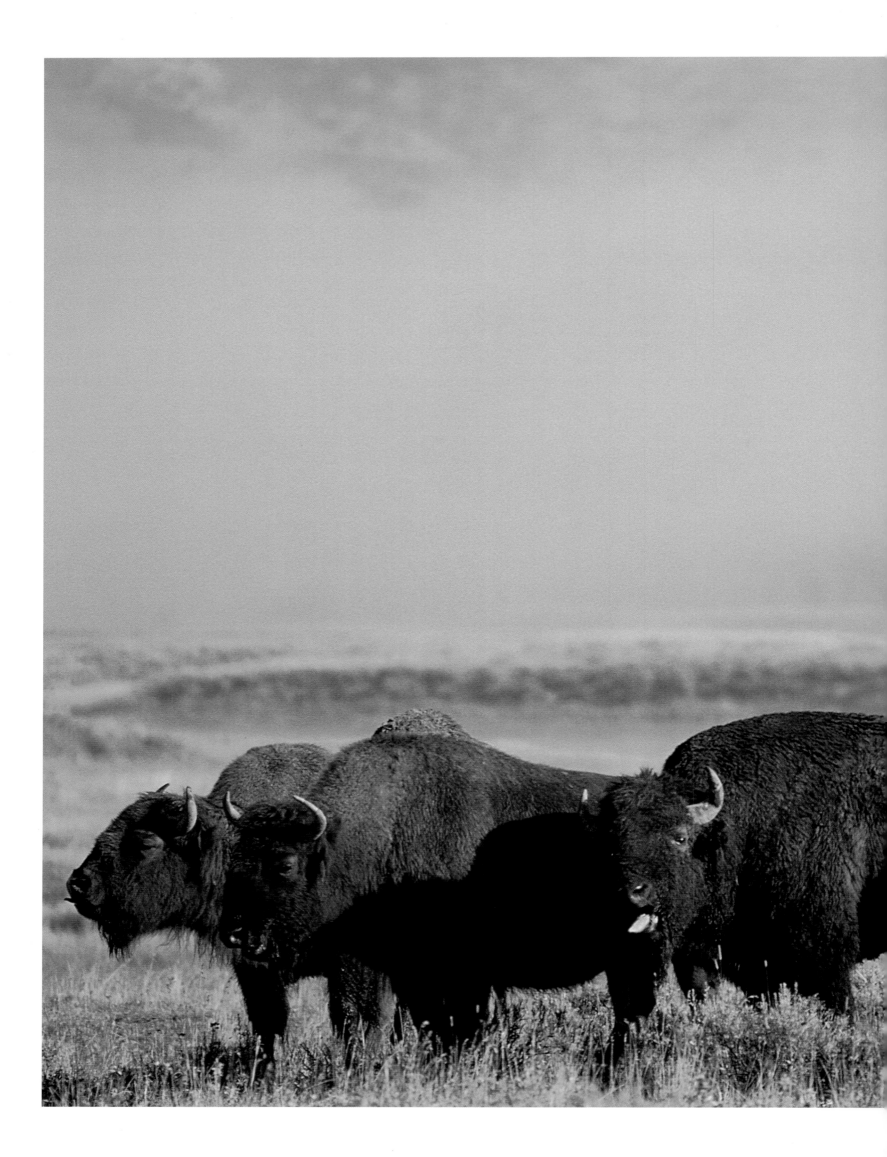

◄ A BIG BULL FOLLOWS TWO FEMALE BISON
THROUGH SUNLIT RANGE ALONG THE
YELLOWSTONE RIVER. DURING THE
RUTTING SEASON, THE BULLS' BELLOWING
AND FIGHTING CAN BE HEARD FOR MILES.

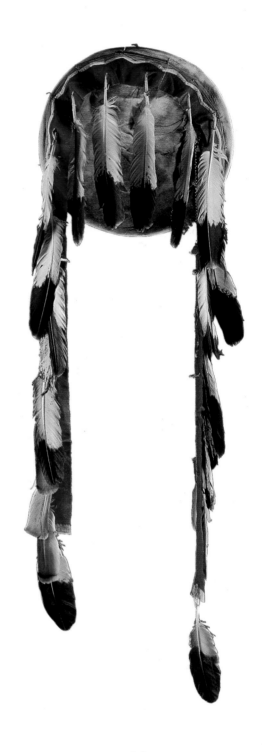

▲ Osage shield made from a bison's hump hide, eagle and hawk feathers, and beads.

▶ National Bison Range, outside Moiese, Montana. There are between 350 and 500 bison on this 18,500-acre site, which is part of the National Wildlife Refuge System.

mourned, gnawing on skinny Texas longhorns to survive. Below the earth, the buffalo waited for the summoning voices they might never hear again. Finally, in 1890 at the bitter end of the war between whites and Indians for possession of the prairies, a prophet arose, promising to bring the bison back with peaceful prayer and song, with the Ghost Dance.

Ben Black Elk, son of the Lakota holy man Black Elk, whose life story and mystical vision was recorded by author John Neihardt in *Black Elk Speaks: The Life Story of a Holy Man of the Oglala Sioux,* said the new prophet's message was easy to believe, so desperate were the people. "I'm Christ," said the Paiute Wovoka, called a new Messiah because he promised to eliminate sickness. He said the whites had sinned against him, so if red people danced and prayed, the buffalo would reappear and whites would evaporate.

"This would happen with no warfare," said Black Elk. Nothing but dancing and singing. Prayers expressed in the form of whole families dancing together unnerved whites, whose most energetic physical expression of worship was bowing heads or kneeling.

As the idea spread, more tribes performed, adapting the Ghost Dance to fit their own beliefs. The Oglala Lakota, for example, centered their version on the sacred tree banned with the Sun Dance in 1881. Though they were warned by Wovoka not to fight the white man, Black Elk created the *ogle wakan,* sacred shirt, believing it would deflect bullets. Fearful whites asked for government troops to protect them from the "savages."

"Instead of peace," said Ben Black Elk, "we had the Massacre at Wounded Knee." His father had told Neihardt, "When I look back now from this high hill of my old age, I can still see the butchered women and children lying heaped and scattered all along the crooked gulch as plain as when I saw them with eyes still young. And I can see that something else died there in the bloody mud, and was buried in the blizzard. A people's dream died there. It was a beautiful dream. . . ."

And though the Ghost Dance failed, say the chronicles, the buffalo waited still. Now, if we wander through the vast North American grasslands, we will once again see buffalo—more than two hundred fifty thousand living animals, promising a changed future. The most important animal in the history of any nation still thrives.

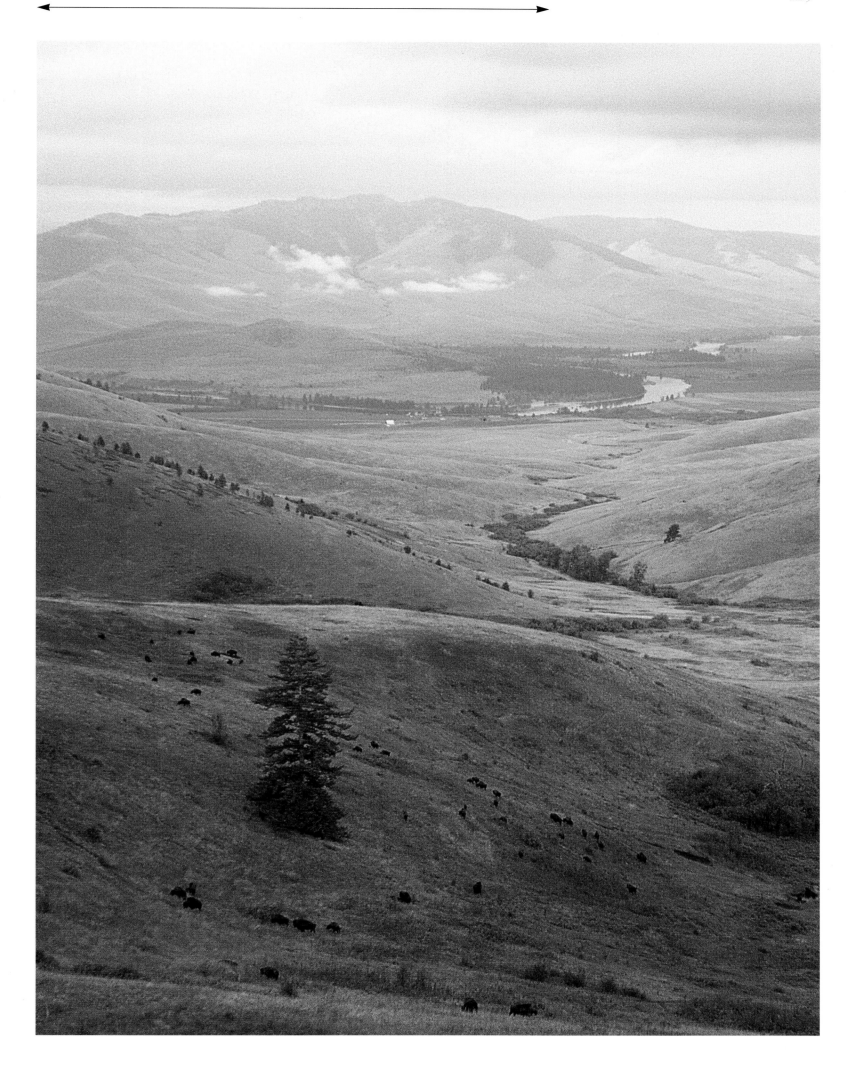

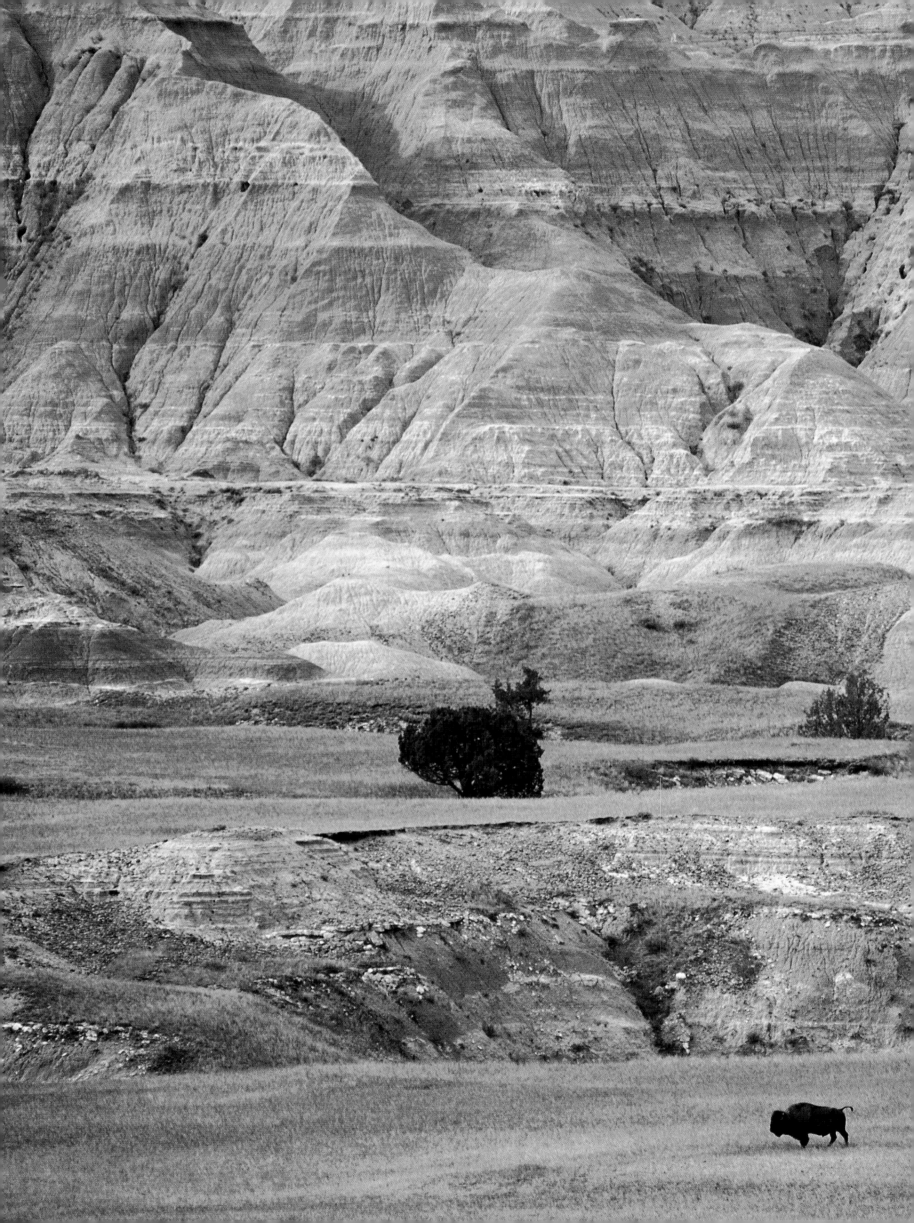

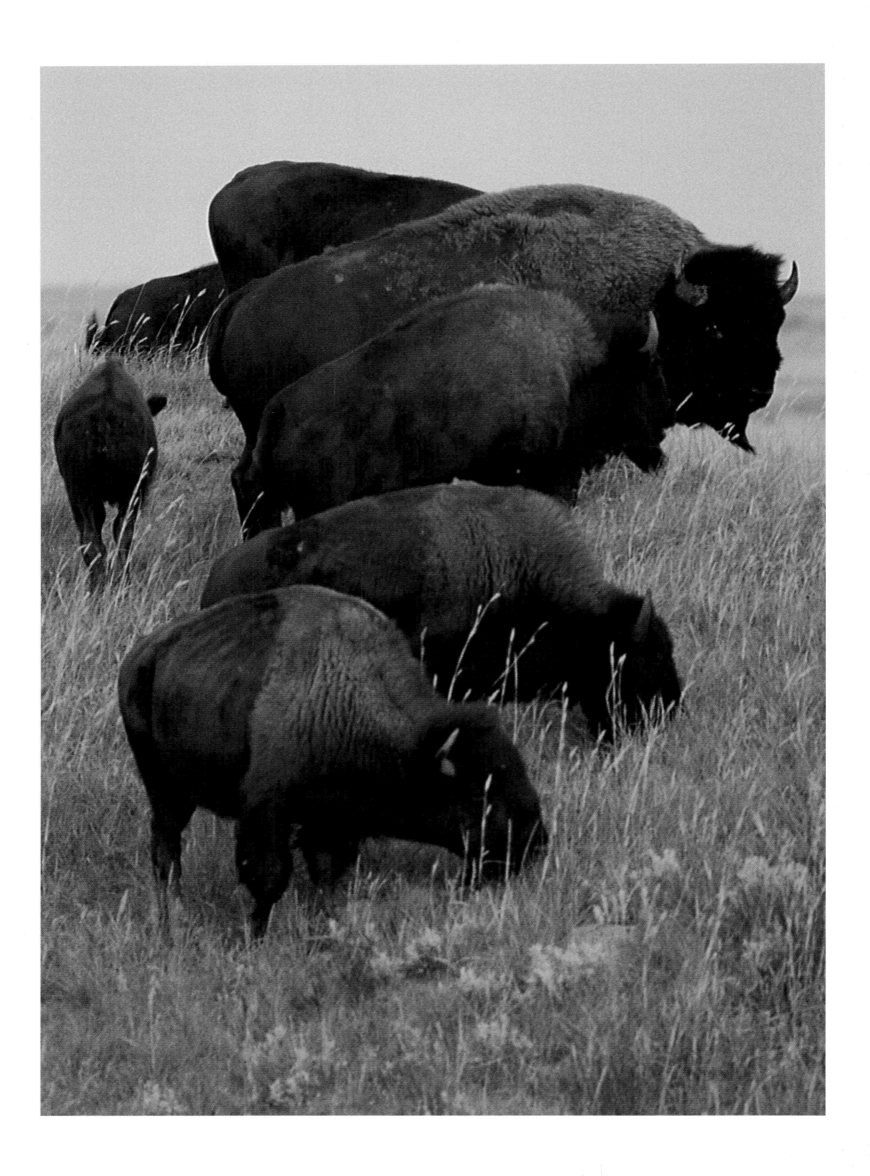

MONARCH
OF THE PLAINS

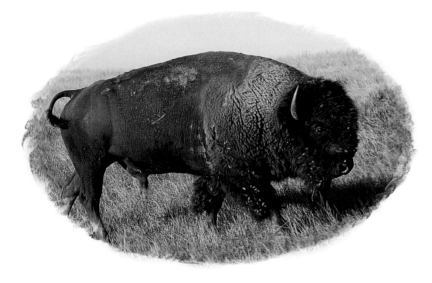

If the buffalo were here today, I think they would be different from the buffalo of the old days because all the natural conditions have changed. . . . We see the change in our ponies. In the old days they could stand great hardship and travel long distance without water. They lived on certain kinds of food and drank pure water. Now our horses require a mixture of food; they have less endurance and must have constant care. It is the same with the Indians; they have less freedom and they fall an easy prey to disease. In the old days they were rugged and healthy, drinking pure water and eating the meat of the buffalo, which had a wide range, not being shut up like cattle of the present day.

—Okute, Shooter, Teton Sioux, 1911

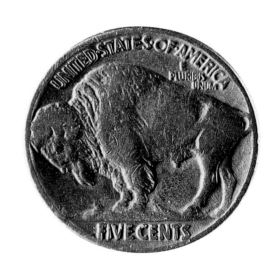

Grazing animals go where grass grows. Predators follow, including nomadic tribes. On the prairies, over 25 million years, aridity combined with other natural conditions to create an intricate community of native grasses like grama, needle grass, and buffalo grass that cured on the stem. Though leaves wither during dry seasons, deep root systems help these grasses survive drought and prairie fires.

Millions of acres of grass once grew on the Great Plains, laced by innumerable creeks and rivers, dotted with heavy growths of timber providing winter shelter when temperatures reached fifty below zero and

◄◄ OLD BISON BULL, BADLANDS NATIONAL PARK, SOUTH DAKOTA.

◄ BUFFALO GRAZE ON PLAINS GRASSES, PREFERRING GRAMA.

◄▲ BUFFALO BULL, SAGE CREEK WILDERNESS AREA, SOUTH DAKOTA.

▲ BUFFALO NICKEL, JAMES EARLE FRASER DESIGN, 1913.

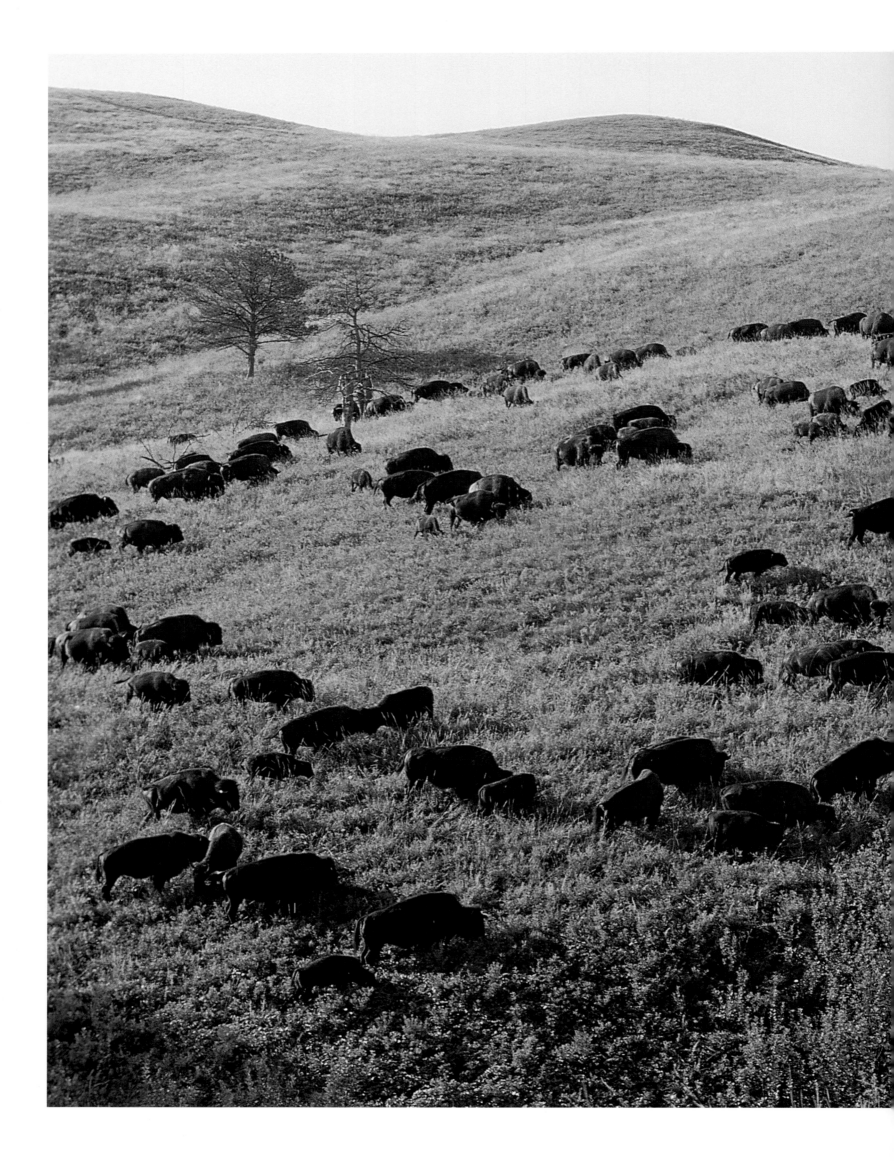

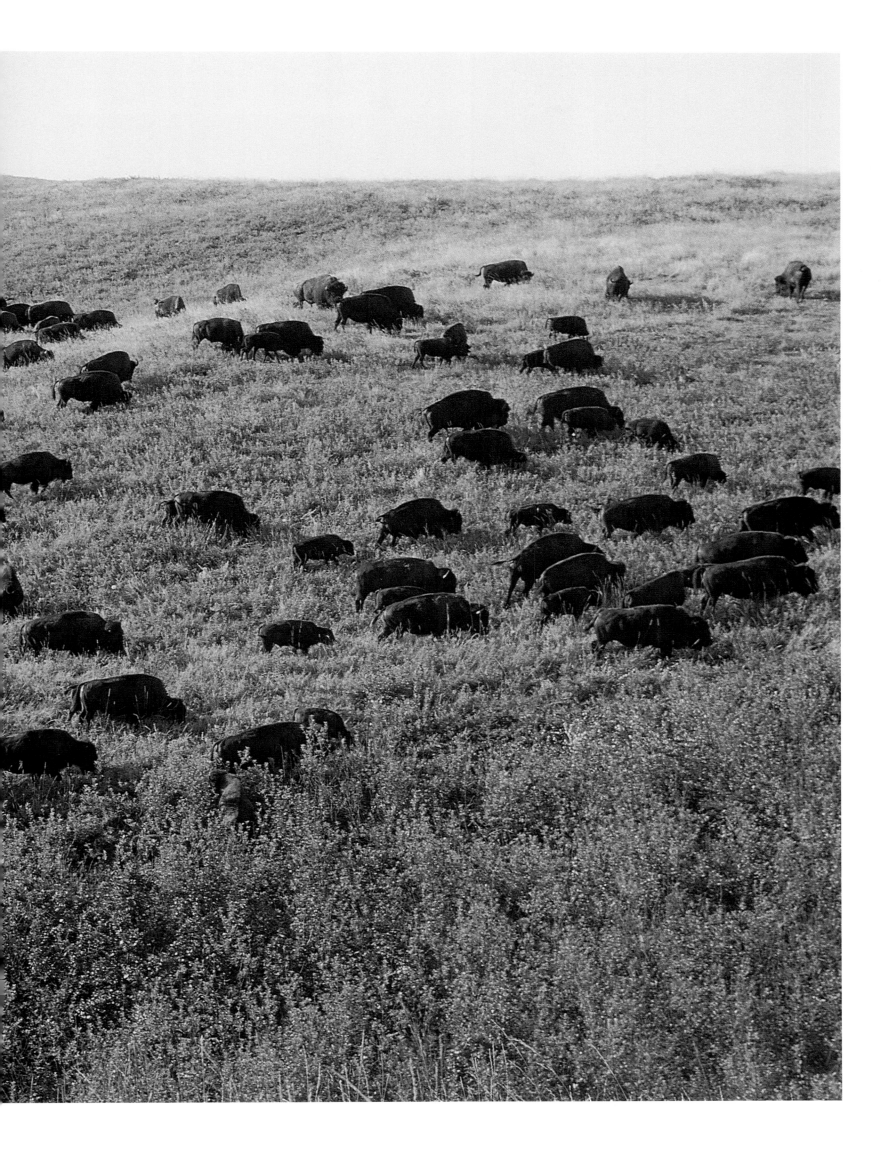

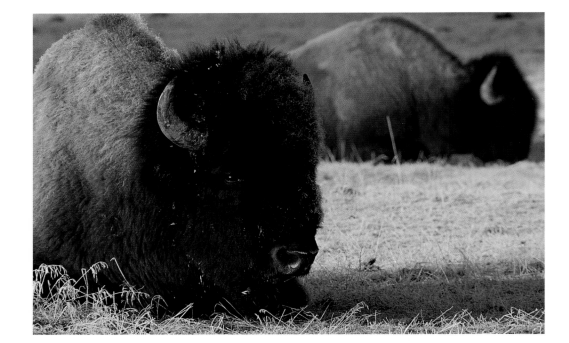

◄ SOUTH DAKOTA'S CUSTER STATE PARK,
A 7,300-ACRE REFUGE.

► IMPOSING BISON BULL.

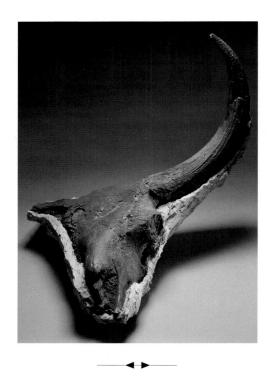

▲ 30,000-YEAR-OLD BISON SKULL, CALLED
BISON CHANEYI, FOUND IN OKLAHOMA.

► MATURE BISON BULL CHEWING HIS CUD
IN THE SUN.

winds blew ninety miles an hour. Rough country—badlands of buttes, bluffs, and hills—rolled like ocean swells, leading grazing animals to new forage, to creeks and river valleys lined with cottonwoods and willows where herds rested when summer temperatures reached as high as 120 degrees.

This unique place demanded and nurtured particular residents—large grazing animals like bison, elk, deer, and antelope, along with their natural prairie predators, grizzlies, wolves, coyotes, and man. While bison tolerated drought and cold, those harsh factors may have hastened the demise of the hairy mammoth, tapir, and huge ground sloth. Fossil remains of those beasts, mingled with artifacts of Stone Age hunters, have been found in scattered locations in the United States. Millions of years ago, at the dawn of their species, human and bison began a unique partnership.

Following the bison into the grasslands, successive waves of Algonquian peoples from Asia became American Indians. One group of migrants, probably composed of people we now know as Inuit, battled earlier tribes across Canada and may have built great earth mounds on the Plains and eastward. Forebears of Siouan stock, they were ancestors to most of the Indian tribes found in the entire Missouri Valley.

Though they shared a common linguistic heritage, the groups separated so early that such related peoples as Crows, Mandans, and Hidatsas did not recognize each other. In the Holy Land, a prophet named Jesus was alive during the invasion of the fierce Athabascans, so warlike they attacked both the Algonquian and the Inuit, exterminating some, intermingling with others. Their descendants are the Navajo and Apaches. From three major Asian invasions and countless lesser ones

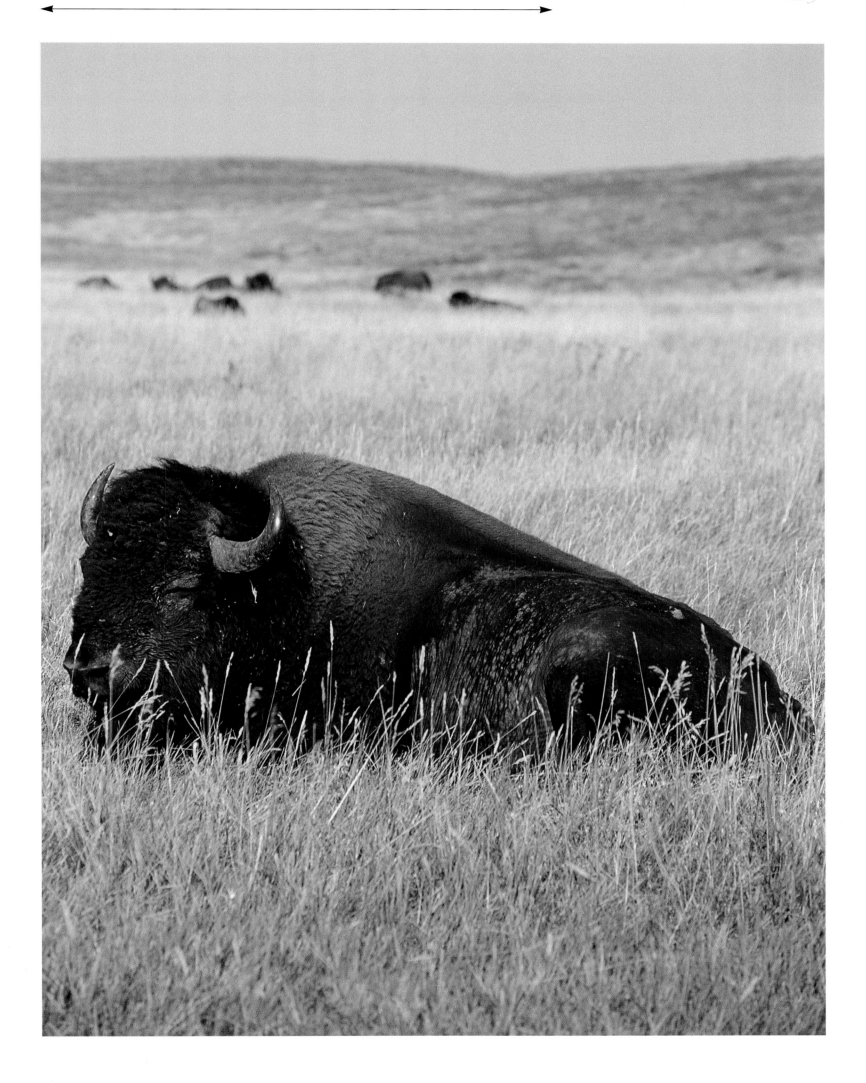

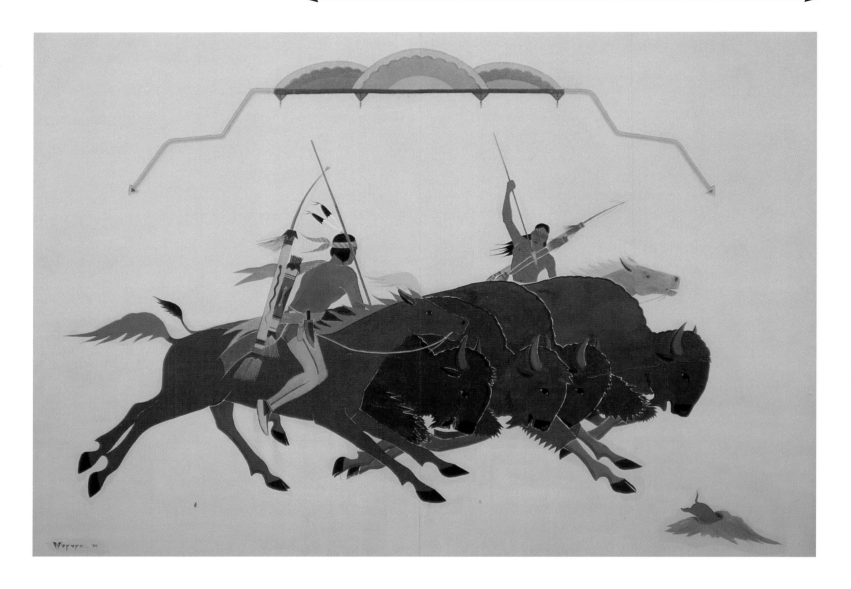

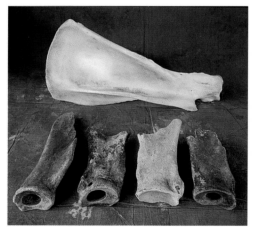

▲▲ "BUFFALO HUNT," 1934, PAINTED BY
KIOWA ARTIST STEPHEN MOPOPE IN THE
STYLIZED LEDGER DRAWING MANNER.

▲ BISON SCAPULA USED AS A GARDEN HOE,
AND OTHER PLAINS VILLAGE INDIAN BISON
BONE DIGGING TOOLS.

came hundreds of American Indian tribes with sixty linguistic stocks
and hundreds of dialectic variations.

Once the saber-toothed tiger disappeared, predators capable of
pulling down a bison were few. Most were defeated by the shaggy
beast's habit of facing danger with sharp horns and a ferocious lust for
battle, as well as by his natural shield of thick hide and dense hair. No
cat remained larger than a mountain lion, which seldom hunted the
treeless Plains. Wolves following the herds usually pulled down the
weak, the injured, and lone old animals. Coyotes, buzzards, ravens, and
magpies cleaned up the leavings. Archeological sites have taught us most
of what we know about human life between 15,000 and 5,000 B.C.
There paleontologists have found more bison bones than those of any
other prehistoric animal. Only one hunter killed bison—humans. So
bison reveled in their paradise, increasing until they covered the Plains
in numbers we can only imagine. Sixty million? Seventy-five million?

Some pioneers, historians, politicians, and religious leaders have
viewed evolution as a staircase, putting hunters and gatherers at the

THE EVOLUTION OF TODAY'S BISON

◄◄◄ ►►►

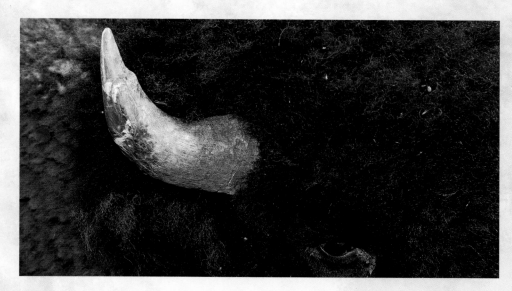

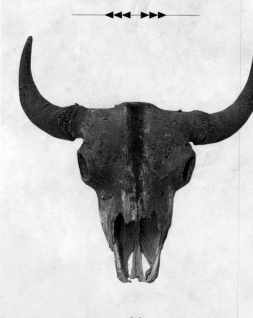

◄

▲ BISON SKULL USED IN SUN DANCE CEREMONY.

▲ ► BISON BULL WITH SCARRED HORN.

B. bison

Theories about the evolution of bison into the creature we know today are abundant and varied. Like humans, different types of bison probably reached North America in successive waves. A descendant of the ancient wisent of the Mongolian Steppe, *Bison latifrons,* probably came first, around 700,000 years ago. Twice the size of a modern *Bison bison,* this monster had horns that spread seven feet. Smaller bison followed, including *Bison alleni,* hunted by early man on the Great Plains during the Wisconsin ice age, around 125,000 to 25,000 B.C. Evolution to fit the animals to their grazing grounds resulted in *Bison occidentalis,* immediate ancestor of modern bison.

A second surmise says that, about 50,000 years ago, the genus started to shrink to fit the available food supply. Still another group believes *B. latifrons* developed on the Great Plains. We can only estimate the size of ancestral bison, but the smaller modern animal was still formidable. John James Audubon, who traveled the Great Plains in the early 1800s studying its wildlife, once killed a bull more than 65 inches (five and a half feet) tall at the hump and 111 inches (nine and a quarter feet) from nose to tail. The animal's skin, head, and leg bones alone weighed 290 pounds. His assistant, Edward Harris, wrote that the animal was moved by 35 trappers pulling on a long rope. With richer grazing, the bison evolved huge horns as an aid to competition with larger mammals like the mammoth, and to fight off native carnivores like the saber-toothed tiger and dire wolf. Its thick neck and hairy head and mane made the bison look even larger. Even today, when confronting each other, bison stand semi-broadside.

All three theories agree that while the remains of *Bison antiquus* have been found from the Pacific to Atlantic Coasts and from the Missouri to central Mexico, *B. occidentalis,* sire of our modern species, lived only on the Great Plains. Small herds of one heir, the slightly larger wood (or Pennsylvania) bison, may survive in the eastern United States and Canada, though no one is sure they haven't crossbred with *B. bison.* In 1958, after scientists had concluded the two types had interbred, a remnant group was discovered and moved into a Canadian wilderness. The mountain bison, once found in the Rockies and along the Pacific Coast, was said to be smaller and faster, but it was extinct before scientists could study it. *Bison bonasus,* the European wisent, survives in preserves in Poland and Russia.

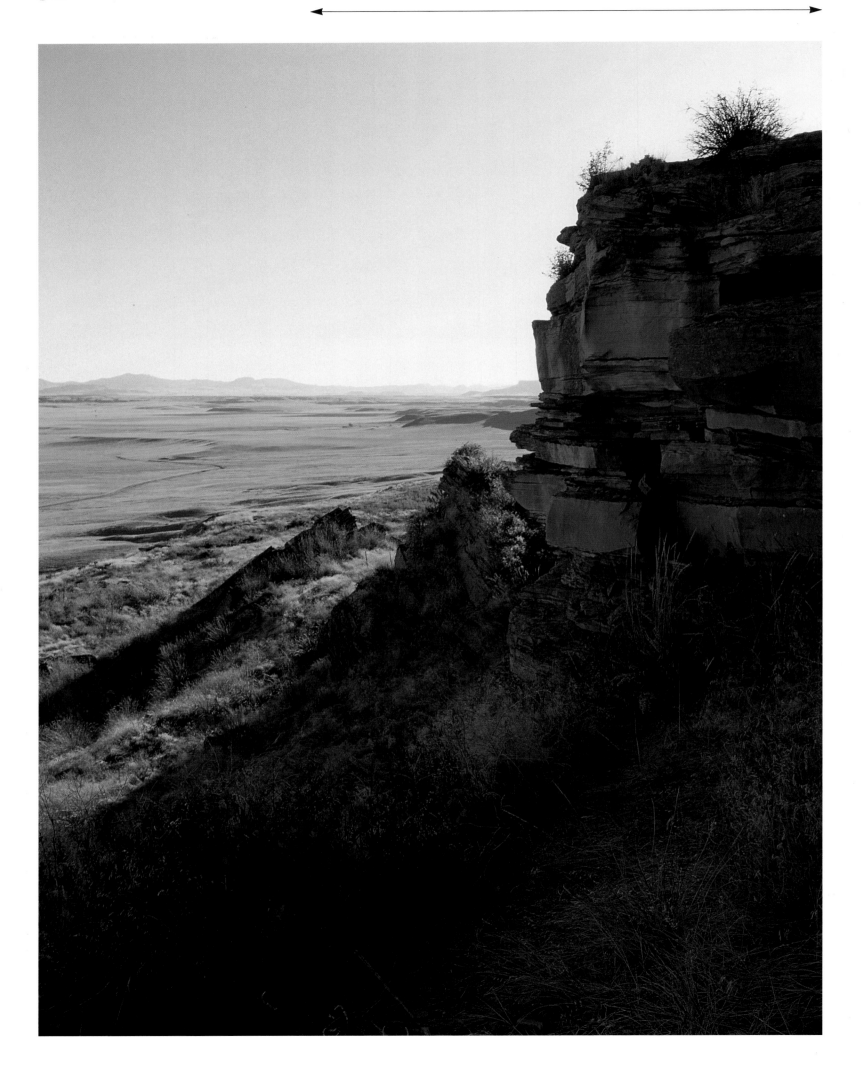

bottom and cities at the apex of progress. Nomads travel with few possessions, runs this theory, because they lack the skills or inventiveness to become farmers, engineers, and bridge-builders; because they aren't smart enough to climb the ladder. Only poverty and ignorance keep nomads from trading in their tents for houses, their horses for bank accounts and debt.

A careful look at the history and culture of nomadic Plains Indian tribes who followed the Buffalo Nation suggests otherwise. They studied their terrain, and as their understanding of its capabilities and limitations grew, they devised ever more sophisticated ways of living on the grassland in cooperation with its demands.

Many Indians preferred deer meat—venison—to bison and found deer hide easier to work. But they made a practical adjustment. The habits of the bison herds made them easier to hunt, so the tribes studied the great beasts, learning to work with their natural behavior. Gradually the nomads shaped their lives around the animal, learning to make from it everything they needed—food, clothing, and shelter.

Observing the bison herd instinct, for example, Indians who had no bows and arrows or other long-range killing weapons concocted complex techniques to decoy the animals into running headlong over cliffs to die. Injured or stunned animals could be killed with sharp flint knives. Faced with huge piles of meat that would rapidly draw predators and rot in prairie heat, nomadic women invented efficient routines that enabled them to dismember many animals in a short time. They learned how to dry meat for storage, how to use what was available, even the contents of the bison's stomach, to yield a healthy, rounded diet.

As Indian culture developed, the people used their leisure time to build on the bison economy they had learned, modeling their society's

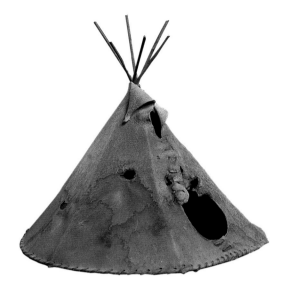

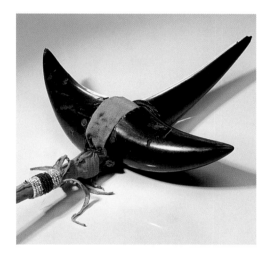

◀ ◀ PREHISTORIC BISON KILL SITE, ULM PISHKUN STATE PARK, MONTANA.

▲ ▲ KIOWA MINIATURE TIPI.

▲ CEREMONIAL PLAINS BUFFALO HORN WAND.

◀ MINIATURE TIPI USED AS TOY. THIS IS A COPY OF ONE OWNED BY THE KIOWA FAMILY NAMED NEVER GOT SHOT, ALWAYS ERECTED IN THE NORTHWEST SEGMENT OF THE SUN DANCE CAMP CIRCLE.

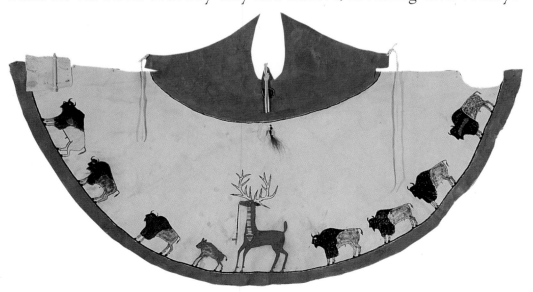

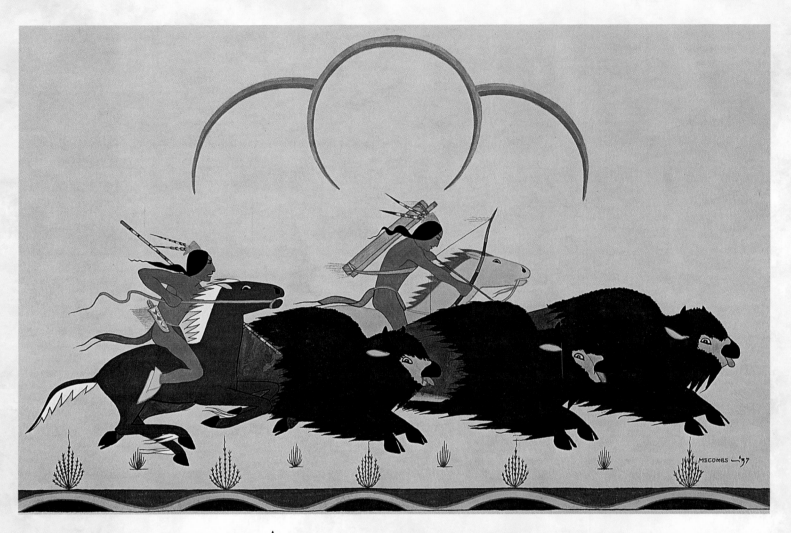

BISON
TRAVEL AND
MIGRATION

◄◄◄ ▶▶▶

▲ "BUFFALO HUNT," 1937, PAINTED BY
CREEK ARTIST SOLOMON McCOMBS IN THE
LEDGER ART MANNER.

Migration

Archeologists believe that ocean water trapped in far northern ice fields caused the oceans to recede about 30,000 years ago, uncovering the floor of the Bering Sea. (Even today, if the water level fell 120 feet, the Bering Strait would become a land bridge.) Vegetation growing on the new land lured Arctic mammals such as the musk ox and a big bison, ancestor of the bison we know, to feed there and gradually move south.

At the same time, grasslands proliferated elsewhere on earth, boosting the numbers of mammals which converted grass protein into flesh that could feed a skilled hunter. In response, human numbers grew, pushing northward bold hunters carrying stone-tipped spears. Following game trails, these people, called Llano man, crossed the Bering Isthmus about 25,000 to 40,000 years ago, moving east along the northern edge of the continent past Mackenzie Bay and then south, eventually to the grasslands of North America.

Habitually grazing into the wind—so they could scent predators—wild herds moved in informal annual circles three or four hundred miles across. Sometimes several herds mingled as they ambled, feeding on late grama grasses, following no particular trail, no rigid yearly route. Scientists who want to create a specific map of bison migrations are forced to rely on guesswork and conjecture.

Once they were established in the American Great Plains, the herds generally traveled south before the winter months, seeking rich grassy stream bottoms. As summer came, they headed north. (See map, page 7, for original range of herds.) A herd might winter along the Milk River in present-day Montana, then mosey north a couple of

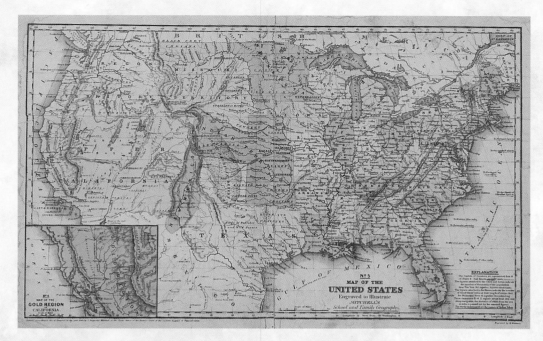

◄ IN EARLY HISTORY BISON ROAMED ON THE PLAINS FROM NORTH OF GREAT SLAVE LAKE TO SOUTH OF THE RIO GRANDE.

▼ "COMANCHE INDIANS HUNTING BISON," GEORGE CATLIN, 1847 COPPER ENGRAVING, FROM 1834 ON-SITE SKETCH.

hundred miles to graze along Alberta's Bow River for the summer. Bison from Saskatchewan probably never walked to Texas, despite the adage that a bison could "eat breakfast in Texas, dinner in Oklahoma, and supper in Kansas."

Still, bison filled the continent from Great Slave Lake south beyond the Rio Grande, where the Spaniards encountered them in the sixteenth century. Other Spaniards met them in Florida; the Dutch found them along the Niagara River; and the Scots found them along the Cumberland River.

Even experienced bison hunters were never sure where the bison might be at any moment. The Pawnee, discouraged by a bad winter hunt, once returned to their villages to find bison everywhere. A trapper told of riding from Manitoba to Rocky Mountain House, through prime bison country, seeing nothing but dried bison dung, called chips.

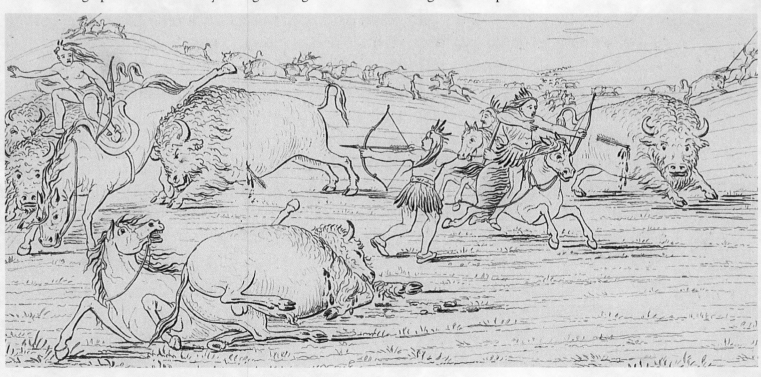

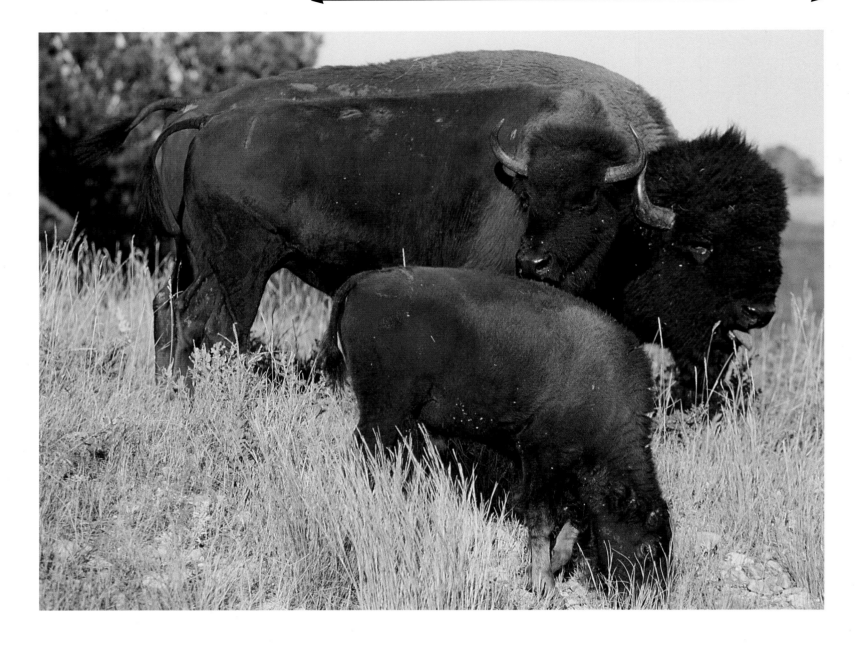

▲ A BISON BULL AND COW GRAZE WITH A CALF THAT IS BEGINNING TO GROW HORNS.
▶ PREHISTORIC BISON KILL SITE, MADISON BUFFALO JUMP STATE PARK, OUTSIDE THREE FORKS, MONTANA.

philosophies and religious beliefs around bison behavior. Related tribal groups developed different rituals, but most were structured around patterns dictated by bison. The story of bison could not be told without the story of their prairie landscape and their most dangerous predator. Prairie, nomads, and bison were woven together tighter than a Navajo rug, linked as closely as they would later be on a nickel coin. For at least twenty-five thousand years—possibly forty thousand—man and bison schooled each other, sharing the continent in balanced compatibility.

> *See where the sacred sun is walking!*
> *In the blue robe of morning, he is walking,*
> *With his power, greenward walking,*
> *Hey-o-ha, hey-o-ha*
> *Hey-o-ha, hey-o-ha.*
> —Bison song, Sun Dance ritual

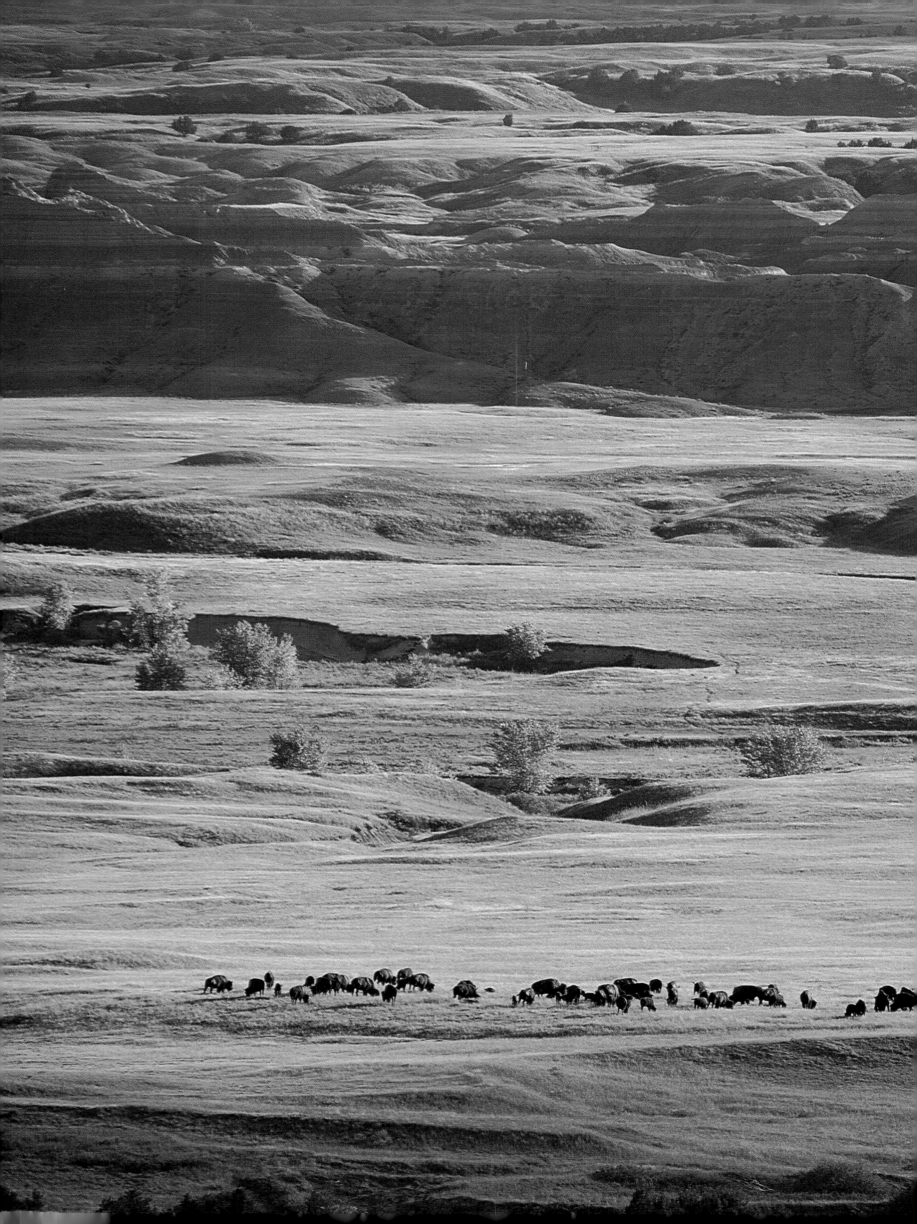

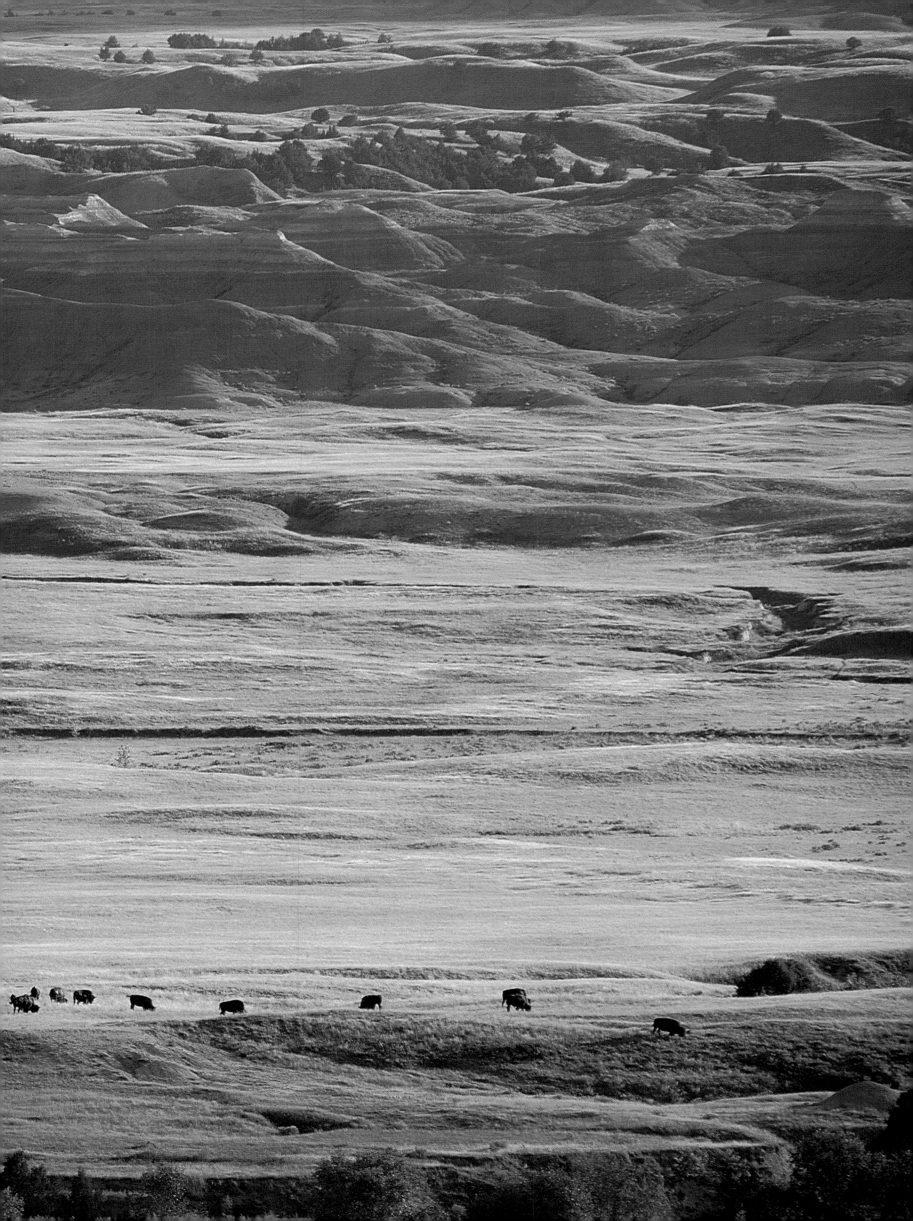

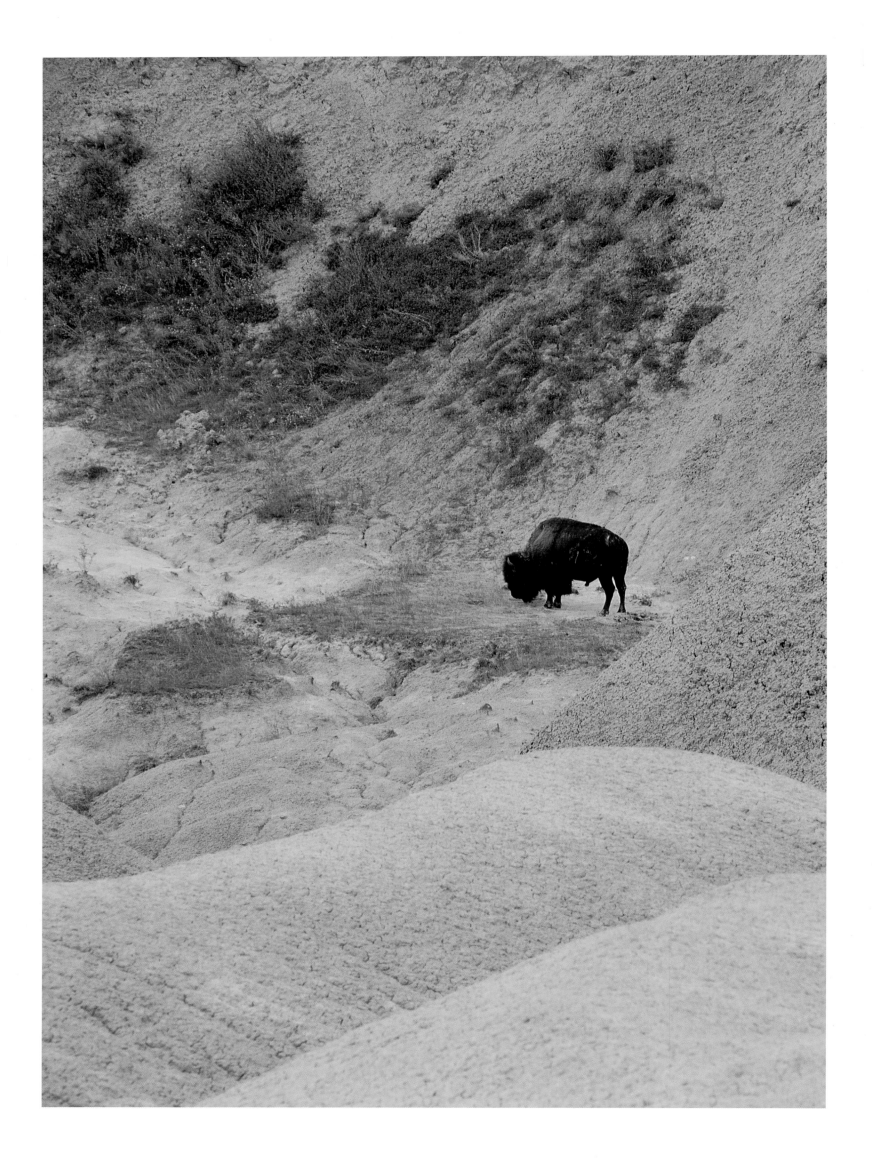

In the Time of the Buffalo Nation

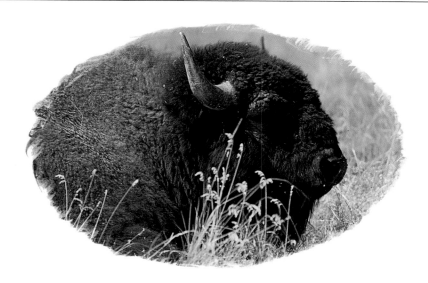

We were lawless people but we were on pretty good terms with the Great Spirit, creator and ruler of all. You whites assumed we were savages. You didn't understand our prayers. You didn't try to understand. When we sang our praises to the sun or moon or wind, you said we were worshipping idols. Without understanding, you condemned us as lost souls just because our form of worship was different from yours.

We saw the Great Spirit's work in almost everything: sun, moon, trees, wind, and mountains. Sometimes we approached him through these things. . . . Indians living close to nature and nature's ruler are not living in darkness.

—Tatanga Mani, Walking Buffalo

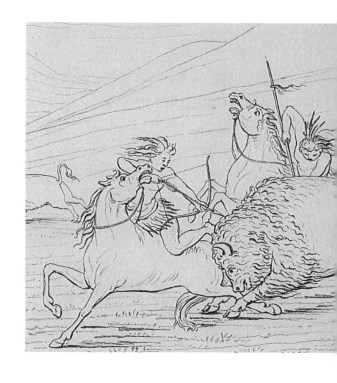

Adapting to bison culture, the Lakota and other nomadic tribes of the northern Plains adjusted their hunting techniques to fit their changing resources. Moving from the woods to open prairie, some hunters continued to drive bison over cliffs to kill them, a savings in ammunition (arrowheads) and perhaps safer for the hunter. Others, learning to use horses once they became available, might drape a bison hide over mount and rider to stalk closer before the kill. These hunters

◄ ◄ Bison in Badlands National Park, South Dakota.

◄ Elderly bull in the Badlands.

▲ ◄ Bison bull dozing.

▲ Engraving (detail), "Comanches Hunting," George Catlin, 1847.

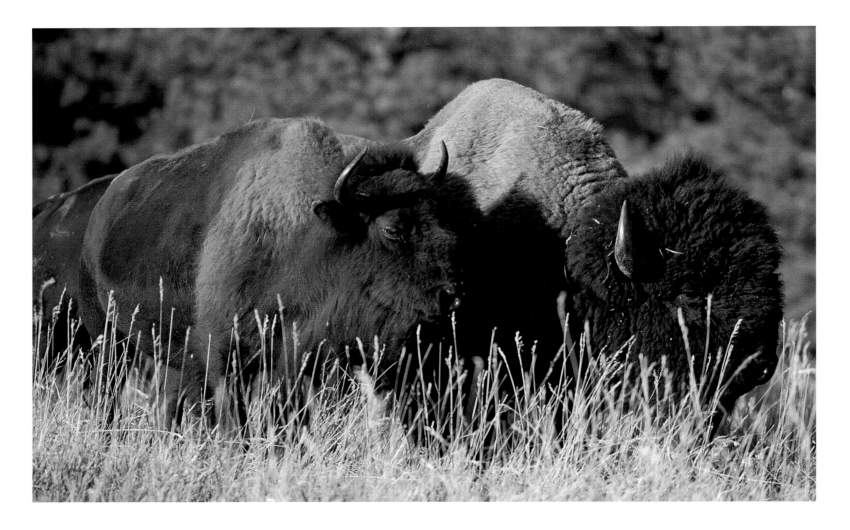

▲ Bison cow grazes beside an older bull. A bison's horns gently curve inward as it ages. A bull's head is broader than a cow's, his horns stouter, more evenly curved, and his beard longer.

also organized tribal laws and customs around hunting bison. The Lakota are widely acknowledged as typical of these Plains tribes. Since a nomad's camp was always ready for siege, a warrior's first responsibility was protecting women and children. Once they learned to sustain themselves easily by hunting bison, warriors had leisure to study and practice warfare, developing complicated customs and rituals. Besides providing food and material goods—the Blackfoot word for bison meat was *nitaniwaksim* ("real food")—bison were connected to every phase of Indian life, from their calendar ("thin buffalo moon") to their history and spiritual life.

Lakota society, typical of American tribalism, was founded on small, close-knit family hunting groups called *tiyospe*. Each group was led by its elders, its grandfather and grandmothers, not because they were the most powerful but because they were the most experienced. While Grandfather taught his sons and sons-in-law methods of hunting and warfare, Grandmother taught the women important survival knowledge like how to make useful tools and process food. Family membership constantly shifted through birth, death, and divorce, and as young women brought husbands from other clans. But the family unit continued

to operate. "The Sioux family," says author Royal B. Hassrick, "had no beginning and no end."

Living in close quarters requires harmony, so in a traditional extended family, each member contributed work to benefit the group, as well as adhering to customs governing behavior. More importantly, the Lakota believed that all four-legged and two-legged inhabitants of the earth are part of the same world, and understood that the actions of one affect the entire community. The Lakota phrase *Mitakuye oyasin* translates literally as "All my relatives." In its broader meaning, it is a reminder that all beings should be treated as if they are kin.

Each aspect of tribal culture on the Plains reflected an awareness of relationships between people and other creatures. Black Elk said the Lakota regarded all created beings as sacred because everything has an influence, a power, which can be given to humans. Attentive people gain more understanding of their world. Further, since God (referred to as either Father, *Ate,* or Grandfather, *Tunkashila*) created everything, he is within all things.

But the bison was most important. Little Wound, an Oglala Lakota, said simply that the buffalo gave all game to his people. Short Bull, also Oglala, said, "The buffalo were given by the Spirit of the Earth to the Indians. The Spirit of the Earth and of the Buffalo are the same." Most Plains tribes held similar beliefs. Even the Arikara, a farming tribe, believed the buffalo had given them corn.

Besides spiritual beliefs, the Oglala devised sensible solutions as part of their buffalo culture. A hunter might shoot ten bison in a single hunt, too many for a single woman to butcher and prepare for storage and for use. Multiple wives were the answer. A Blackfoot chief noted that while a single wife could only dress ten bison hides in a year, his eight wives could dress 150. In order to harvest more game, a man needed horses for hunting and to trade for wives.

The needy became important members of society because a leader was expected to be generous to those less fortunate, inspiring him to obtain more goods that he might give more away. Everyone who obeyed tribal law enjoyed roughly equal status. Horses equaled wives, and more bison equaled benefits for individual and tribe alike.

We work as hard as you do. Did you ever try skinning a buffalo?
　　—Ouray, Uncompahgre, Ute chief in Colorado,
　　　　after a white man called his people lazy

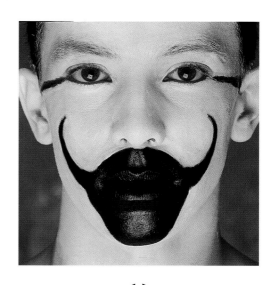

▲ Harvey Pratt, an artist of Cheyenne, Arapaho, and Lakota descent, painted the face of his son Nathan with an ancient design used by dancers in buffalo-calling ceremonies before a hunt. The design was also painted on hunters' horses.

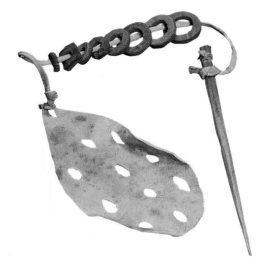

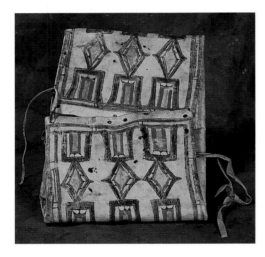

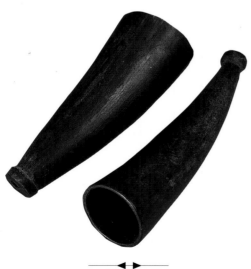

▲ ▲ ▲ LAKOTA GAME PIECES, OF BISON HIDE
AND BONE.

▲ ▲ CHEYENNE PARFLECHE, A 12-BY-
18-INCH ENVELOPE MADE OF PAINTED
BUFFALO RAWHIDE.

▲ GUN POWDER HORNS MADE FROM BISON
HORN, CA. 1850S.

When bison were available, Indians killed as many as possible, thriftily devising ways to use nearly every part. After the hunt, most of the men retired to a nearby bluff to clean their weapons and keep watch for enemies—and probably boast of their exploits. Meanwhile, the women butchered, catching blood in rawhide containers or the bison's stomach paunch. They mixed it with fresh bone marrow for a nutritious soup eaten raw or heated. Along with the bison's lungs and pancreas, this soup was especially prized by old people with few teeth.

Women cut long strips of fat from along either side of the bison's spine to be dipped in hot grease and dried for a snack so esteemed that one Blackfoot leader was named Buffalo Bull's Back Fat. Fur trappers, who often learned survival from their Indian wives, made sandwiches with a strip of dried meat between two slices of fat.

The women might stretch the stomach paunch on four sticks pounded into the ground, thus creating a bag to fill with water. Small children might bring stones to a fire kindled with bison chips. Red hot, the stones were put into the impromptu stew pot with forked sticks. Once the water began to boil, the women tossed in scraps of meat and dipped up the soup with cups or bowls made of bison horn. A paunch also made a dandy water bucket.

Removing the small intestines, some left the bison's last meal inside and wrapped them around a stick propped up by the fire to create a hot snack complete with salad. Others turned them inside out to expose the fat lining and filled the long tubes with bits of meat, before roasting or boiling them. When I participated in a bison hunt with buckskinners, the modern imitators of 1840s trappers, our host used this method before tossing the *boudins* onto a woodstove. I resolved to eat one bite. My husband speared a piece and held it out on the tip of his knife—the same way the Lakota ate strips of meat, with one end in their mouth, slicing off bites. Flavorful, crisp with sweet fat: I ate all I could get, snarling at the other hunters for more.

Particular delicacies to the Lakota, often boiled together, included brains, the gristle around the bison's nostrils, and the tongue, which might also be baked, boiled, or smoke-dried. An entire calf might be baked in hot embers, or an unborn calf cooked in the liquid from the womb. Marrow from boiled bones, also used for hair grease and to waterproof leather, was spread on dried meat.

Back in camp, the women cut thin strips of flesh long as their arms and three hands wide, hanging it on drying racks too tall for the camp

dogs to reach. In wet weather or when flies were thick, they stretched a rawhide rope between lodge poles and dried the meat more slowly over a smoky fire inside the lodge. If it stayed dry, this "jerked meat," or jerky, kept for years in parfleches—envelopes or boxes made of stiff untanned leather, or rawhide. It could be eaten as it was, boiled for soup or stew, or broiled over the coals, pulverized between two stones, and mixed with fat and sometimes nuts or dried cherries or grapes (including the pits) for pemmican, a well-rounded, portable food needing no further preparation. Some white visitors to Indian camps called this "Indian bread" and liked it best dipped in honey. (For authentic fare in buckskinning camp, I ground raw dried meat, adding nuts for extra protein and dates for flavor and binding.)

Besides preparing meat for storage, the women tanned hides, leaving the hair on for mittens, bedding, coats, and robes worn over the shoulders so the hump hide covered the neck and head. Hide from the hind leg, cut off between hock and pastern, made a tough boot or moccasin.

With the hair removed (and twisted or woven for belts or ornaments, or used to stuff toy balls, for decoration on clothing, or as false hair for men or women), women could tan a hide soft as velvet (using bison brains as a softener) to make breechcloths, dresses, and shirts; summer blankets or winding sheets for the dead; and leggings, saddles, blankets, knife sheaths, quivers, and bow cases. Tanned unborn calf hide became underclothes. Specific parts of the hide were reserved for particular uses: neck hide, sometimes two inches thick, could be shrunken into a circular shield that could turn the sharpest lance or arrow, or used for belts and moccasin soles. A bull hide might be stretched over a light circular frame of green willows to create a bullboat, used to transport family, goods, and gear across rivers. The craft was hard to steer but harder to sink.

Damaged hides (with too many arrow holes or scars) might be left untanned, the rawhide used for canoes, stirrup covers, snowshoes, straps for carrying burdens, bridles, and other horse gear, including horseshoes, or for linings and covers over pits where pemmican was cached. A dried bison scrotum, filled with seeds, sand, or small stones from an anthill, made a fine rattle. The bison's skull was used for an altar, sometimes at the spot where the kill took place. Small bones made needles, awls, tops, dice, and sliding toys for children's ice races. Backbones and ribs might make sleds, or be turned into scrapers and fleshers for cleaning hides. From shoulder blades came hoes, axes, and paintbrushes.

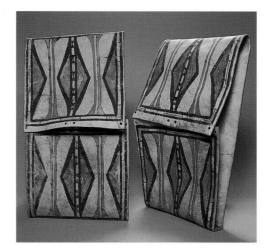

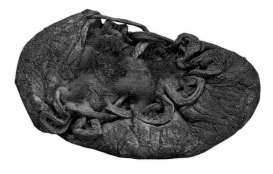

▲ ▲ ▲ Bison tendon used for sewing.

▲ ▲ Crow painted parfleches.

▲ Buffalo hide overshoe.

▶ Bison graze while bull at center stares at photographer.

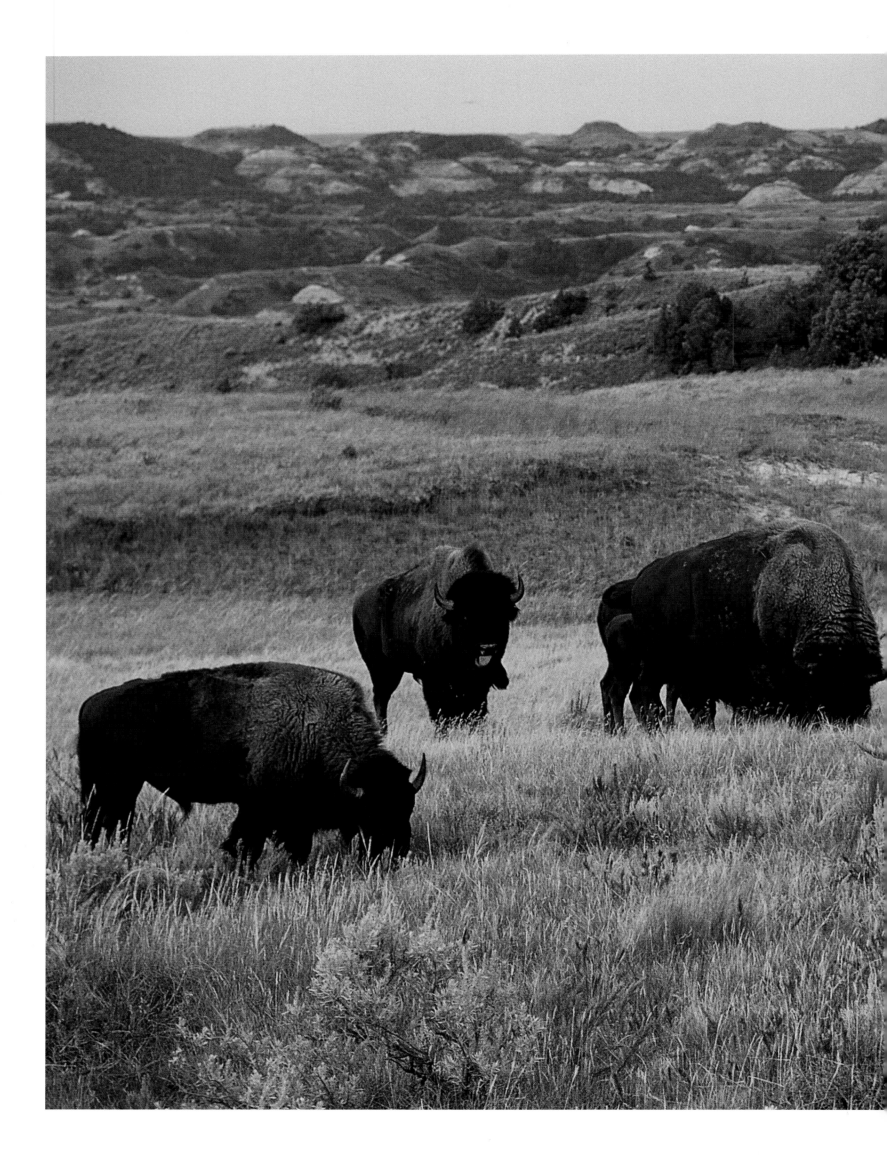

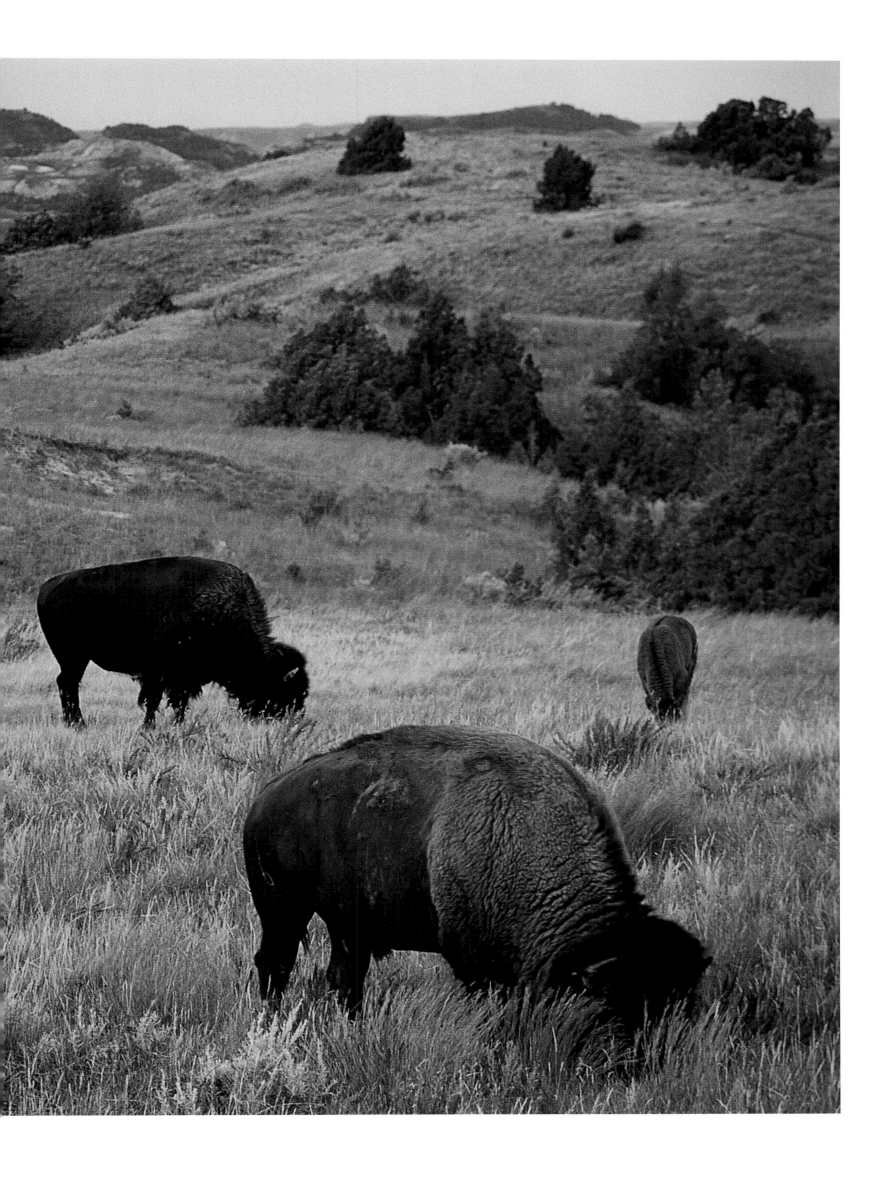

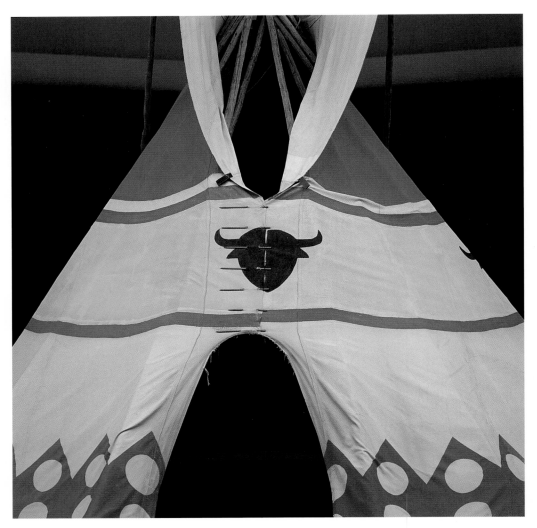

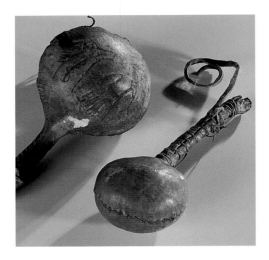

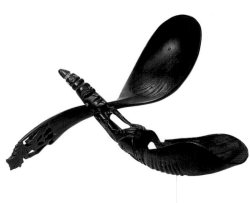

▲ ▲ ▲ BUFFALO RAWHIDE PAIL.

▲ ▲ PLAINS CEREMONIAL RATTLES MADE OF BUFFALO SCROTUM, 1800S.

▲ CARVED BUFFALO HORN SPOONS.

▲ ▶ BISON HEAD ON CANVAS REPLICA TIPI.

Boiled hooves made glue for feathering arrows and fastening arrowheads to their shafts, while anklebones were strung on sinew as bone rattles. The same sinew furnished thread and bowstrings and was webbed for snowshoes. The horns, peeled and polished, made ornaments, cups, spoons, and ladles, and later powder horns. A bison's tongue made a good comb, while the tail could be used for soup, as a fan to keep insects away, or to sprinkle water over hot stones in the sweat lodge. The bladder was dried for a storage container, and the bison's gall made bright yellow paint.

The Indian tipi, probably the most efficient portable shelter ever invented (and used as a model for the army's Sibley tent), was made of bison cowhide, easier to sew and lift. Each tipi contained fifteen to eighteen hides, cut and shaped to form a cone wrapped around a framework of twenty-eight poles nearly twenty-five feet long, set in a circle and tied at the top. A tipi's size was limited only by how hard the lodge was to pack and lift. Indians said the man with the fastest horses lived in the biggest tipi.

Central to the Lakota is the story of White Buffalo Calf Woman,

who gave the Lakota the sacred pipe, their movable altar carved with a bison calf to represent the four-legged beings. Since the bison provided food, clothing, and shelter to the Lakota and other Plains nomads, the animal naturally became central to their spiritual lives as well. *Tatanka* symbolically contained and symbolized all that was important, the earth and all that grew from her, as well as the connections between all beings.

Let us honor the bones
of those who gave their
flesh to keep us alive.
 —Chant while setting up a buffalo altar

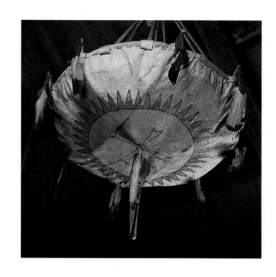

Each part of his body came to embody part of creation, his four legs representing the four ages of the earth, of man, and of the bison himself. A particular cut of meat from the shoulder is regarded by the Lakota in much the same way as Christians regard the Holy Eucharist. A dried bison skull became part of the Sun Dance ritual to remind people that they would become bones when they were ready to walk the sacred path of death. Each man in the Sun Dance wore a bison silhouette cut from rawhide as a reminder of the wisdom of *Tatanka*, his creation of their lives, and the offering of his body as a sacrifice on behalf of all the people.

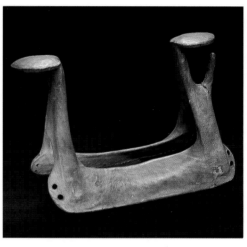

▲ ▲ Mandan buffalo hide boat.
▲ Blackfeet wood saddle covered with bison rawhide, which would be padded with a buffalo robe.

A man's body is his own, and when he gives his body or his flesh he is giving the only thing which really belongs to him. . . . I might give tobacco or other articles in the Sun dance, but if I have these and kept back the best no one would believe that I was in earnest. I must give something that I really value to show that my whole being goes with the lesser gifts; therefore I promise to give my body.

 —Mato-Kuwapi, Chased by Bears,
 Santee-Yanktonai Lakota, 1915

In various tribes, individuals expressed their connections with bison in many ways, often forming societies to create formal rituals intended to please the animals so they would allow themselves to be killed. People performing such ceremonies always included imitations of bison behavior, in some cases indicating extremely careful observation. The purposes of other clubs might include keeping order in the tribe,

The Indian Calendar: Winter Count

◀◀◀ ▶▶▶

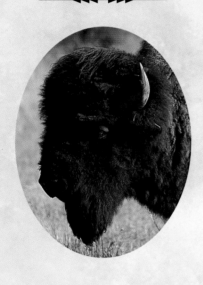

◆▶◆

▲ Bison bull's beard probably helps protect his vulnerable windpipe.

▲ ▶ Sam Kills Two, Lakota, paints a final picture on Big Missouri winter count calendar, 1926.

Calendar

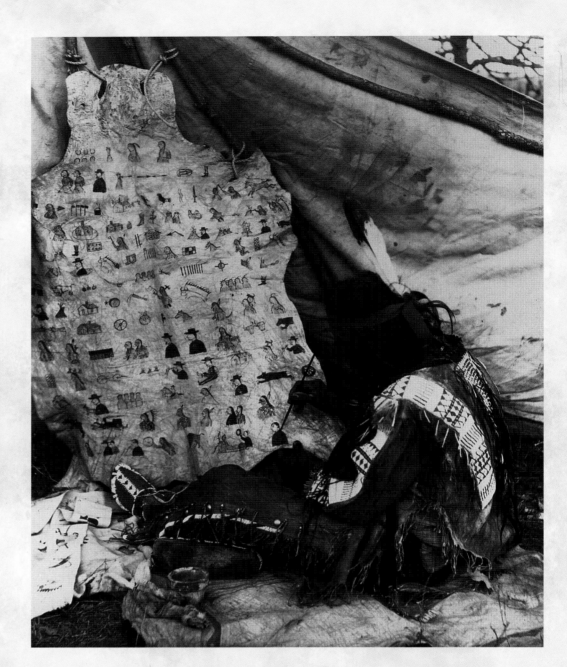

Individuals in many Plains tribes kept track of passing years with a "winter count," a buffalo hide painted with symbols to represent each year. Typically, the first symbol was painted in the center and others arranged in a spiral toward the outside edges. No general rule governed the keeping of a calendar. The choice of what to include depended on the individual, usually a man, who began the calendar and accepted the responsibility of maintaining it for many years. In some cases, a complete year's moon cycles were named for the Indians' relationships with buffalo, such as buffalo moon, thin buffalo moon, moon of much buffalo hair, and moon of hair gone.

The Big Missouri winter count, kept by a family of Rosebud Lakota, was begun while George Washington was president of the United States. The first symbol, for the year 1796, shows two sets of hoof marks, three on each side pointing toward each other. The message is interpreted as follows: "This is the winter known as the winter of horse-stealing camp because two enemy camps were close to each other. A deep snow

fell and neither camp was able to move, so during the winter they stole horses from each other." One of the last pictures shows an Indian and a white man at each end of a bridge over a river. In 1925, a bridge was built across the Missouri River in South Dakota, connecting the Rosebud country with the eastern part of the state. Now owned by the U.S. Office of Indian Affairs, the winter count is displayed at a museum in Rapid City.

A Lakota named Iron Shell began a winter count in 1807 when he lived among the Miniconjou Lakota, continuing it when he joined the Brules. His sons kept the count until 1883. Iron Shell's record says a "Good White Man Came" in 1807. "Credit Winter" is Iron Shell's term for 1812, explained by the Big Missouri tally as the year when a trader peddled goods among the Lakota. In 1815, three headmen went to Washington, D.C., on horseback but failed to return. Iron Shell refers to 1830 as "Killed Many White Buffalo," indicating that all of the albinos were bulls, but Battiste Good's count shows cows killed and the Big Missouri count shows four white buffalo killed, the largest number ever recorded.

Iron Shell's 1832 is the year "Ties His Penis in a Knot Dies," and 1846 is the year a man found his unfaithful wife in the tipi of another man, brought her home, and shot her: "Woman Shot in Vagina." In 1871, "Buffalo Ceremony Failed." With herds few and scattered, a Buffalo Dreamer prayed for good hunting but was unsuccessful. The Black Hills Treaty was signed in 1875, and in 1879 "Children Went to School," a white man took the first group of Lakota children to Carlisle Indian School in Pennsylvania.

Significantly absent in these accounts is any mention of battles with the U.S. Army, not even the fight at the Greasy Grass (Little Bighorn). The keepers, informal historians for their tribal bands, emphasize the loss of great leaders, winter hardships, and internal strife, all tribal matters. Whites are mentioned only if they are traders or in reference to treaties, events affecting Lakota economic and political life. Another Lakota, Lone Dog, kept an account covering the major period of white invasion of the Plains, 1800 to 1871. His calendar includes seven references to trade with the white man, four to epidemics of measles and smallpox, twenty-four symbols of intertribal conflict, and no reference to battles with whites.

▼ A Comanche prepares to shoot an arrow into a running bison, while another drives his lance into the bison's shoulder, aiming for the heart. George Catlin made this copperplate engraving in 1947 after observing a hunt in 1934 near Fort Sill, Oklahoma.

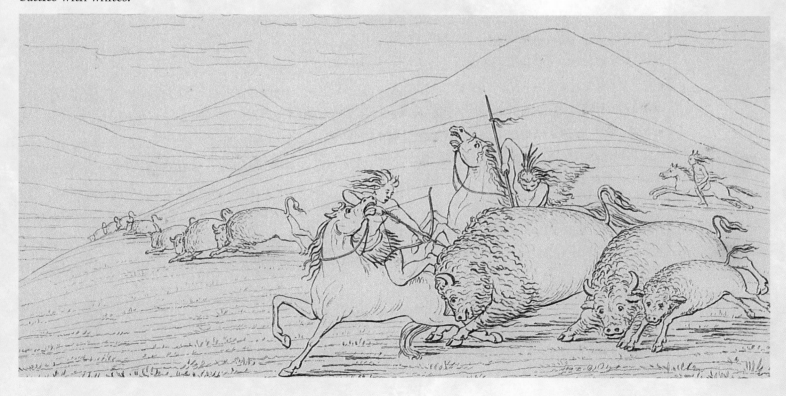

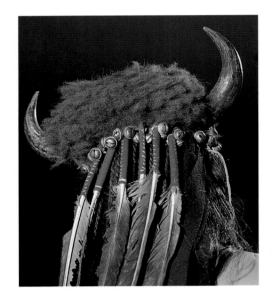

▲▲ GROS VENTRE BUFFALO HEADDRESS,
CA. 1880.

▲ CREEK HEADDRESS OF BUFFALO HORNS
AND EAGLE FEATHERS, LATE 1880S.

teaching the moral standards necessary for a good life, recognizing leaders, and teaching particular skills. Sometimes groups organized for other purposes were named for the buffalo, including the Blackfoot societies created to improve child-rearing and order, called the Tails, the Horn, Ugly Horn, and Buffalo Cow.

Among the Blackfoot, each member of the Bulls Society wore a warbonnet representing a bison's backbone or a bison robe with the hair side exposed, painted with white earth spots to represent mud—because bison love to play in muddy water. When the Bulls prepared to dance, the rest of the tribe moved about a mile away. Dressed and painted, wearing their bison robes, the Bulls lay down near water in random order—the way bison rest. A distinguished young warrior attempted to drive them to the hunters, always failing the first three times. When the group eventually entered camp, the herder recounted four *coups.* (Taken from the French, to Plains Indians *coup* meant "to demonstrate courage by striking an enemy, living or dead, with a hand or short stick." After a battle, when warriors reported their *coups,* a witness had to confirm the act or it didn't count. Since honors were based on bravery, these men were baffled by whites who killed at a distance without looking the enemy in the eye.) After the warrior finished giving gifts to four old people in need, he related how he had found the bison, and the society sang four songs and danced, behaving as much as possible like bison.

Both the Mandan and Arikara had a White Buffalo Cow Women's society, charged with attracting bison for the hunters. The Black Mouths took on the task of stopping people from chopping trees in winter because the sound frightened the animals away in a time of need. They beat anyone who disobeyed.

The Omaha Buffalo Society was composed of men and women to whom the buffalo had shown compassion, coming to them in a vision to confer power. The membership was dedicated to studying and applying medicines for curing wounds. The Ponca Buffalo Doctor cult healed wounds by squirting water on them and—if time and conditions permitted—dancing in imitation of the bison, wearing decorations made from horn, hair, hides and tails. A similar society existed among the Assiniboine.

The ways in which nomads approached their spiritual beliefs differed widely, but often involved observation of the details of an animal's life. The Lakota, noticing that bison left hair on the bark of the cherry tree when scratching, interpreted this as the buffalo's offering to the tree.

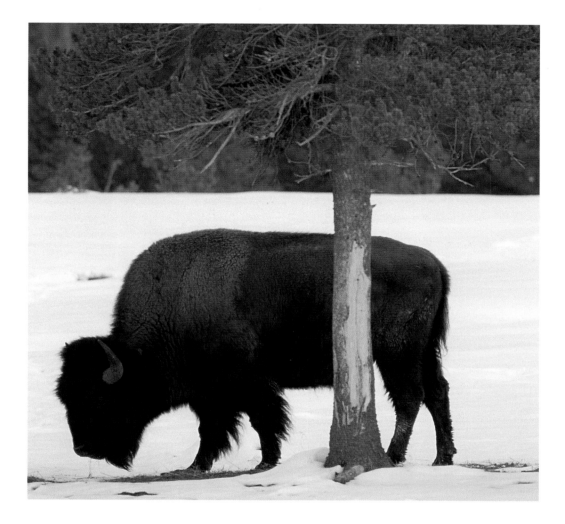

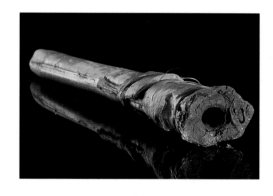

◄ Lone bison ambles through snow near Old Faithful in Yellowstone National Park. Bison have rubbed their heads and horns against the tree's bark until it was stripped away.

▲ This small pipe was made of bison bone and sinew, probably during the late 1900s. Its rough design suggests it was made for brief use, perhaps on a hunt.

The Lakota offer tobacco by tying it in tiny bundles of cloth, hundreds of them fluttering from trees in sacred sites like Bear Butte. Other prayers included the smoke from a pipe, visible prayer rising and spreading to carry prayer to spirits everywhere.

When the Oglala Plenty Wolf prayed, he called first upon *Tatanka Oyate,* the Buffalo Nation living in the north among the pines in a place of life and breath, to give him knowledge. Then he acknowledged the Thunder-Beings of the west; Morning Star, Moon, and the Sun in the east; the Animals who come from the south; the Above ones between sky and earth; and the powers of the earth, including medicine, rock, and wood. Finally he offered the pipe in outstretched hands to Spotted Eagle, chief of the Bird Nation, who flies highest and carries prayers to *Wakan Tanka,* the Creator. In addressing all six directions, simultaneously saluting their power and asking their help, Plenty Wolf was following a custom repeated all over the world in different eras. Many creeds established by people who lived close to nature included similar practices.

You, O buffalo, are the earth! May we understand this!
—Lakota Sun Dance prayer

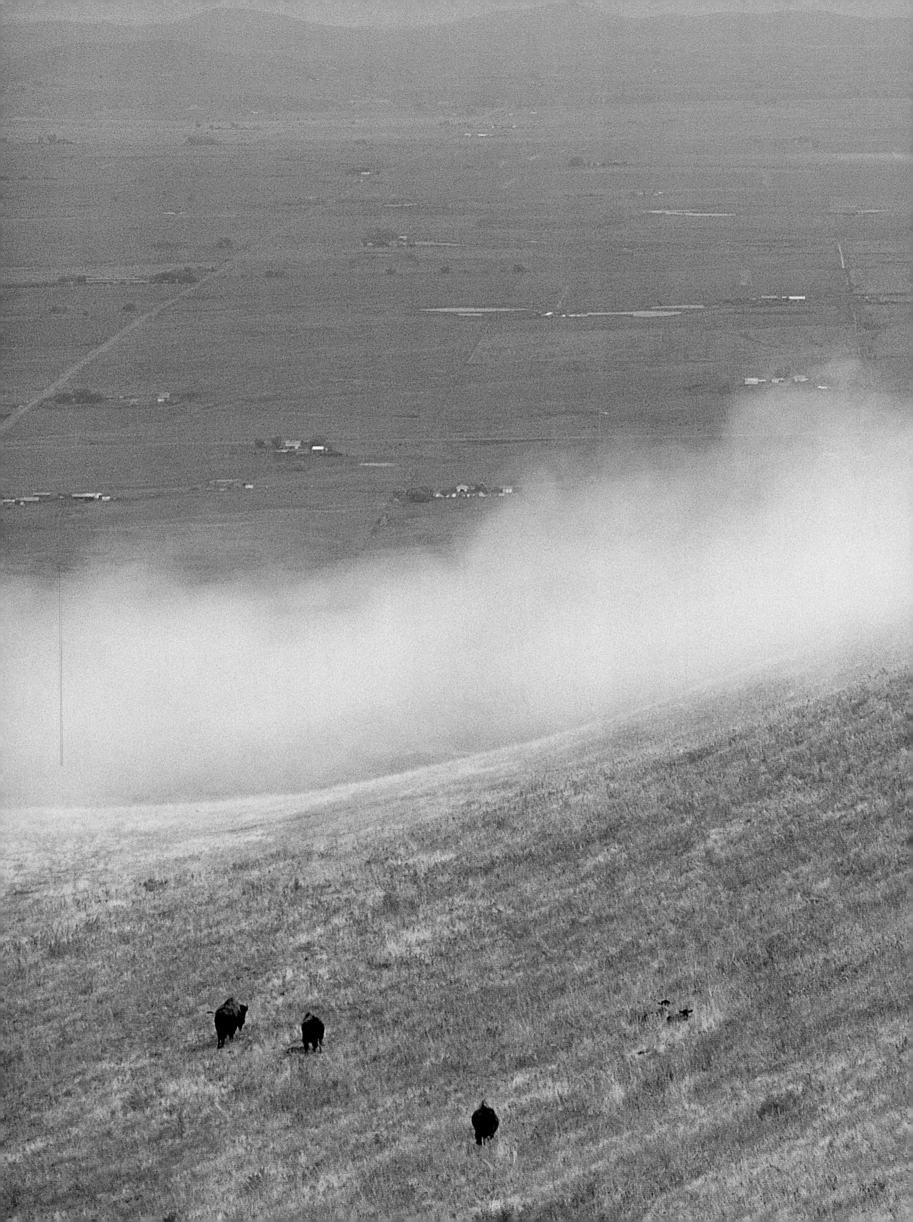

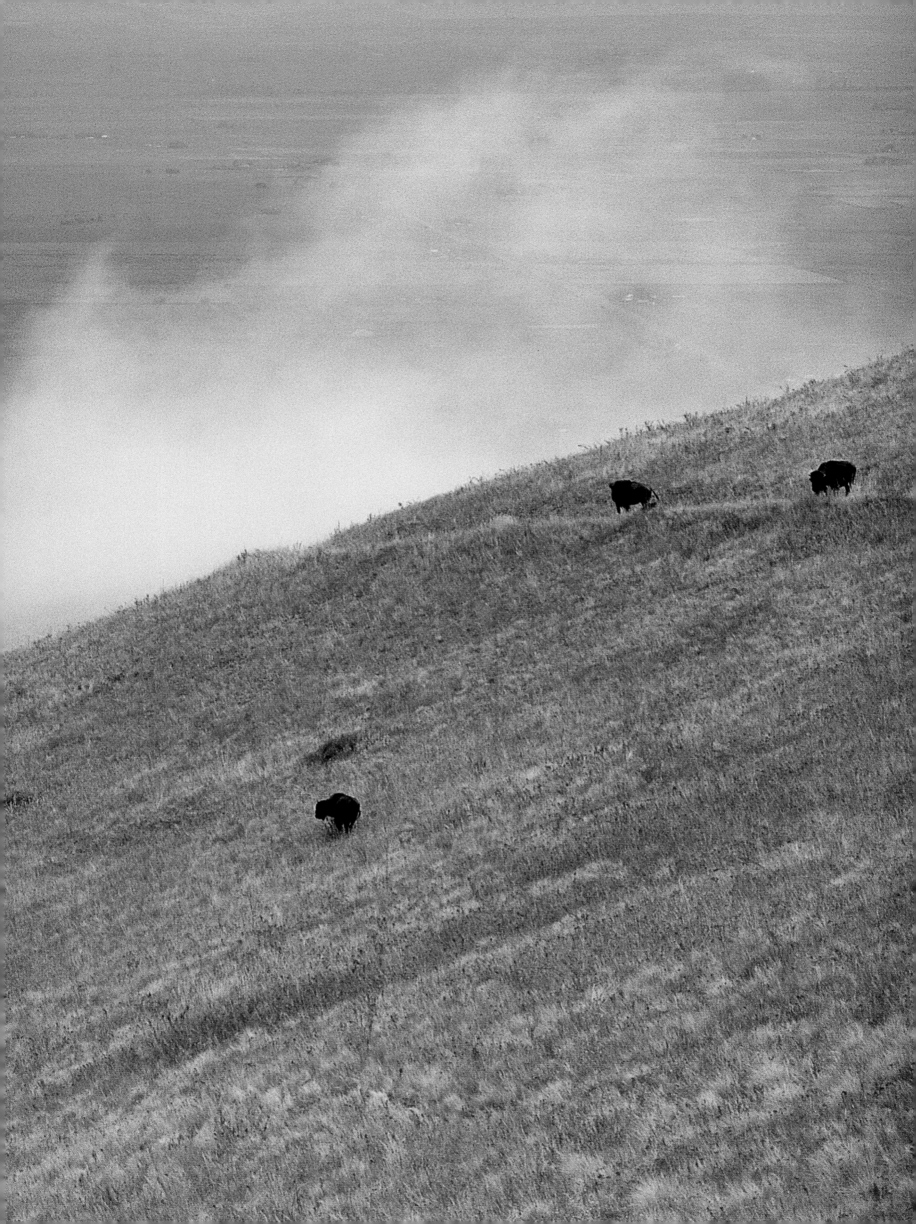

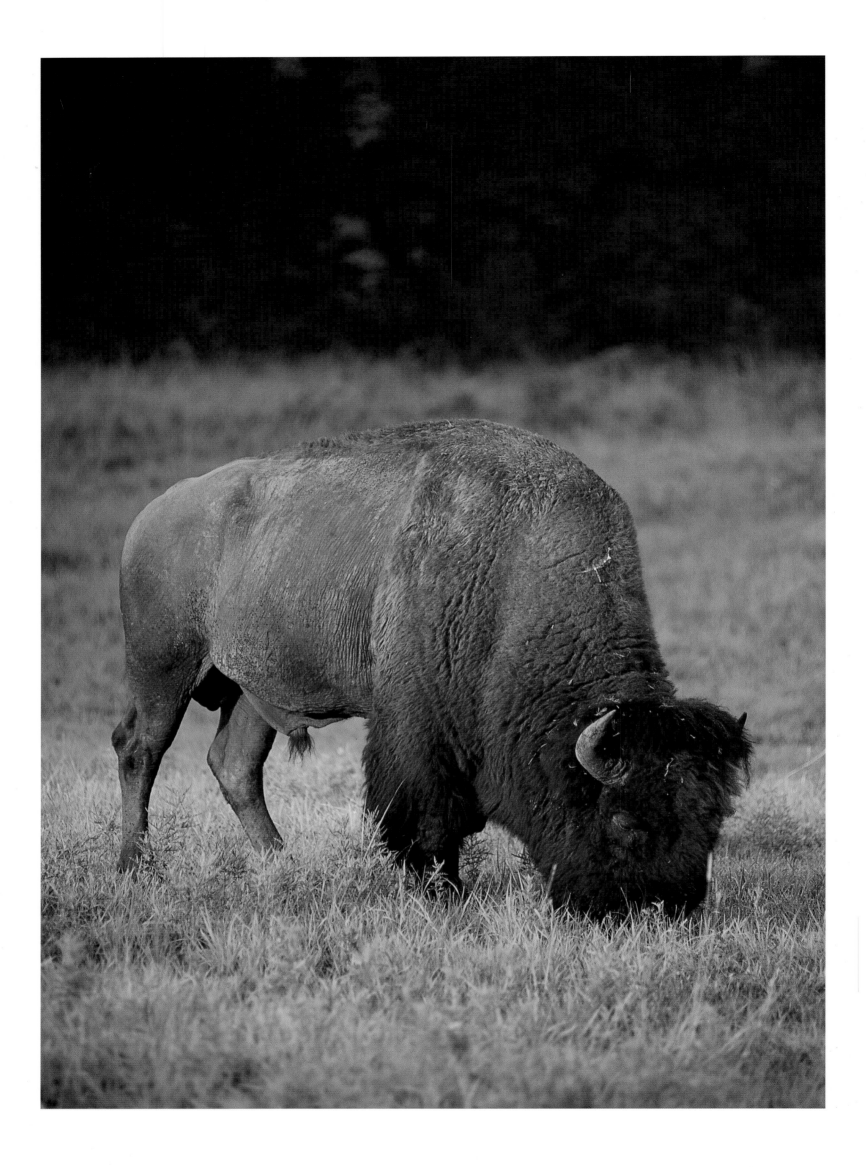

THE LAND OF BONES

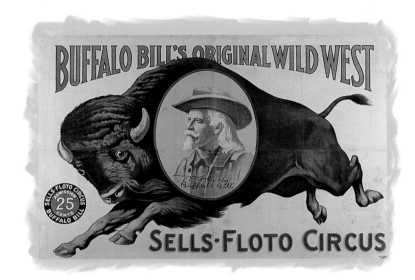

We did not think of the great open plains, the beautiful rolling hills, and winding streams with tangled growth, as "wild." Only to the white man was nature a "wilderness" and only to him was the land "infested" with "wild" animals and "savage" people. To us it was tame. Earth was bountiful and we were surrounded with the blessings of the Great Mystery. Not until the hairy man from the east came and with brutal frenzy heaped injustices upon us and the families we loved was it "wild" for us. When the very animals of the forest began fleeing from his approach, then it was for us the "Wild West" began.

—Chief Luther Standing Bear, Oglala Lakota

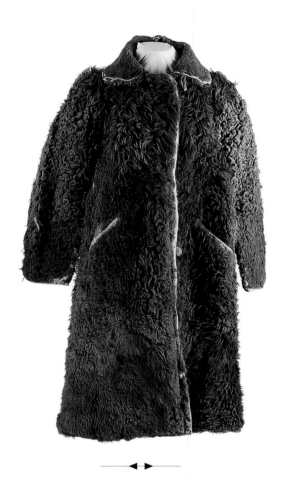

In 1840, St. Louis trader Pierre Choteau (for whom the capital city of South Dakota is named) ordered 300 dozen butcher knives, 500 pounds of pigeon-egg beads, and 9,000 pounds of blue and white chalk beads. In return, he took 67,000 tanned bison robes from Indians on the upper Missouri. He gave the equivalent of $1.50 in goods for each robe, worth about $3 in eastern markets.

Merchants shipped about 850 tanned bison robes east in 1803, before the demand for beaver pelts began about 1807. Men like William Bent, Jim Bridger, Kit Carson, Joe Meek, and Jedediah Smith

◄◄ 19,000-ACRE NATIONAL BISON RANGE, NEAR MOIESE, MONTANA, ESTABLISHED 1908.

◄ BISON BULL WITH CHARACTERISTIC PROTECTIVE THICK, WOOLY HAIR ON HIS NECK, SHOULDERS, AND FRONT LEGS.

◄▲ BUFFALO BILL SHOW POSTER WITH GALLOPING BISON.

▲ BUFFALO COAT, 1889.

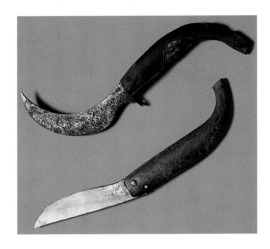

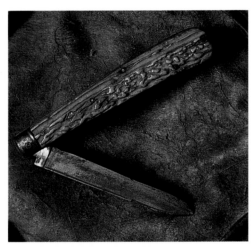

▲▲ SPANISH-STYLE FOLDING BUFFALO-
SKINNING KNIVES, OF BISON HORN, 1880S.
▲ FOLDING BUFFALO BUTCHERING KNIFE OF
STAGHORN, TEXAS, 1870S.

pushed into the continent's unknown interior, searching for adventure as well as for beaver and otter demanded by fashionable folks in London. Even then, they sometimes traded for tanned bison robes. By 1815, about 26,000 robes a year left the prairies.

In 1835, D. Lamont arrived at Fort Union, on the Missouri, with 4,200 bison robes, 390 bison tongues, 3,500 pounds of salted and 3,000 pounds of dried bison meat, plus pelts of smaller animals. By 1870, a trader on the upper Missouri could get a bison robe for 3 cups of coffee, 6 cups of sugar, or 10 cups of flour. In the Northwest one saying advised: "10 cups of sugar make one robe, 10 robes make one pony, 3 ponies make one tipi."

At first, Plains tribes saw trading hides to whites as good business, a way to use extra hides and obtain small luxuries: beads, decorative cloth, a little tobacco. Jacques Marquette noted in his 1675 journal that he traded a cubit of tobacco to the Illinois Indians for three tanned robes that kept him warm all winter. By the 1840s, the tribes were delivering at least 100,000 hides a year to traders, who shipped the pelts to eastern markets to be sold as lap robes for buggies.

Liquor was universally prohibited as a trade item on the Plains—and often smuggled in by traders, who knew their customers were unused to alcohol. They considered liquor simply part of sharp trading: liquor produced more pelts at a lower price. And since Indians didn't know how it was supposed to taste, traders weakened the liquor and disguised the fact with flavorings. One recipe called for 1 quart pure alcohol, 1 pound black chewing tobacco, 1 bottle Jamaica ginger, 1 handful red pepper, 1 quart black molasses. and river water. Depending on the trader, some of these concoctions were actually lethal. In 1822, Congress enacted a measure making it illegal to trade liquor to Indians or take it into Indian country, but traders hid it in bales of goods. Some built stills in distant spots like Fort Union, at the mouth of the Yellowstone.

The days of the fur trappers, of yearly rendezvous along Wyoming's Green River, ended in 1840, though modern mountain men, called buckskinners, often recreate the era. Soon after, the first big train of white immigrants left Missouri for Oregon. Within two years, more than one thousand whites had crossed the Plains. By 1845, white leaders spoke of a "Manifest Destiny" to occupy the continent, seeing no immorality in shoving Indians aside. Missionaries, miners, farmers all came to the prairie to establish what they perceived as a superior

THE COST OF A BUFFALO HUNT

◀◀◀ ▶▶▶

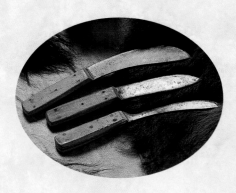

——◆——

▲ GREEN RIVER, WYOMING, SKINNING
AND BONING KNIVES FOR BUTCHERING
BUFFALO, 1870s.

▲ ▶ NO EXPERIENCED HUNTER USED
A RIFLE WITH A CALIBER SMALLER THAN
.50 TO KILL BUFFALO. THIS CAP AND BALL
BREECH-LOADER DISPLAYS ADJUSTABLE
SIGHTS FOR IMPROVED ELEVATION.

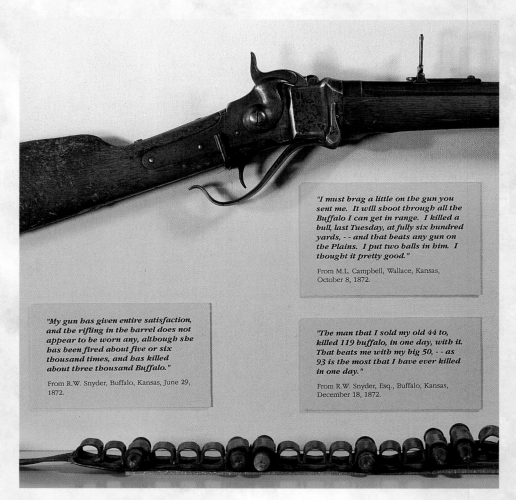

"I must brag a little on the gun you sent me. It will shoot through all the Buffalo I can get in range. I killed a bull, last Tuesday, at fully six hundred yards, - - and that beats any gun on the Plains. I put two balls in him. I thought it pretty good."

From M.L. Campbell, Wallace, Kansas, October 8, 1872.

"My gun has given entire satisfaction, and the rifling in the barrel does not appear to be worn any, although she has been fired about five or six thousand times, and has killed about three thousand Buffalo."

From R.W. Snyder, Buffalo, Kansas, June 29, 1872.

"The man that I sold my old 44 to, killed 119 buffalo, in one day, with it. That beats me with my big 50, - - as 93 is the most that I have ever killed in one day."

From R.W. Snyder, Esq., Buffalo, Kansas, December 18, 1872.

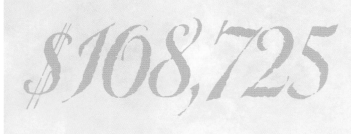

Settlers along the Red River on the plains of Manitoba and Dakota Territory often hunted in groups, working together to make the hunt more efficient. On June 15, 1840, a group of 1,630 people set out on such a hunt: four hundred hunters, accompanied by their families to help butcher the animals. When the group returned from the hunting grounds in August with a million pounds of buffalo meat, they sold some to traders at the Hudson's Bay Company to pay for their expedition and for extra money, and used the rest themselves. They itemized the expedition's cost as follows:

620 hunters @ $0.23 per day	$ 8,556
650 women @ $0.18 per day	7,020
360 boys & girls @ $0.08 per day	1,728
1,210 carts @ $6.75 each	8,167
403 buffalo-running horses @ $67.50 each	27,202
655 cart horses @ $36 each	23,580
586 draft oxen @ $27 each	15,822
Saddlery	3,810
740 guns, with ammunition	7,550
Sundries, "too tedious to be enumerated"	5,290
TOTAL COST:	$108,725

$108,725

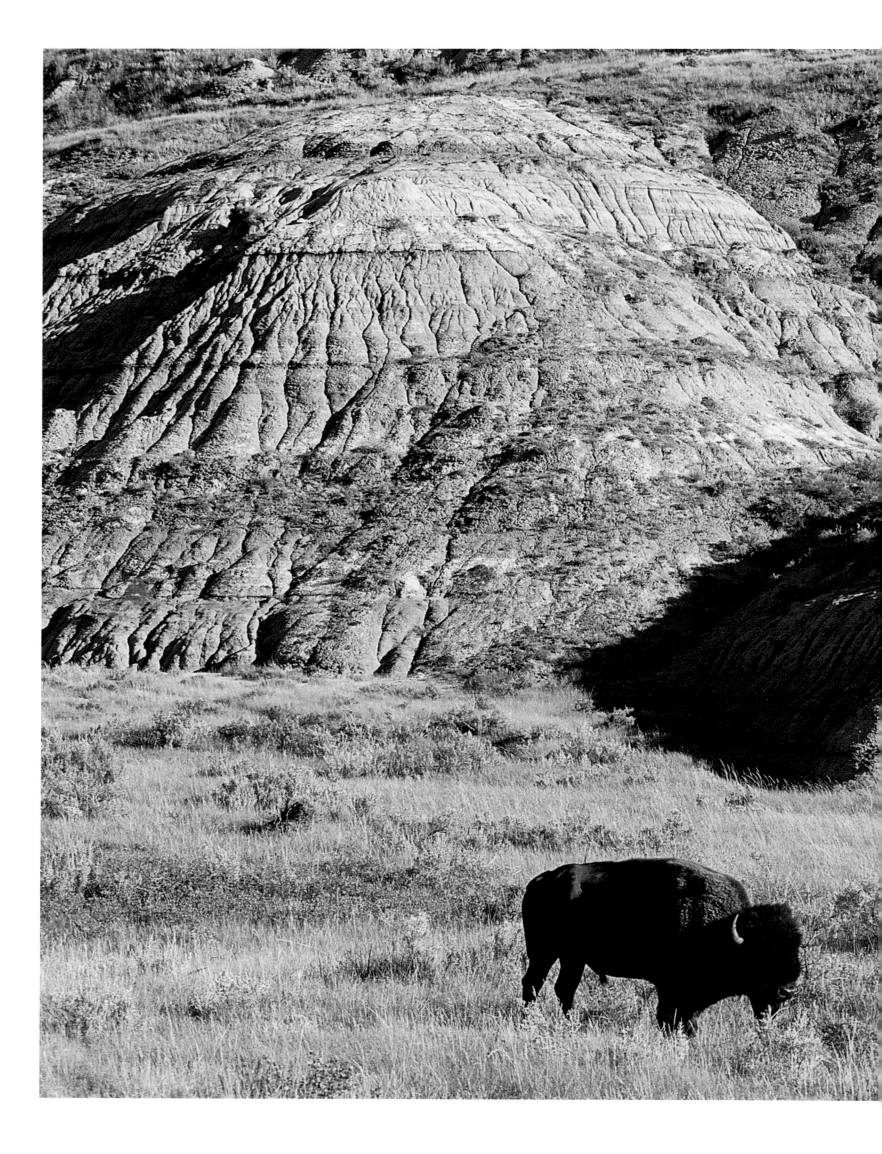

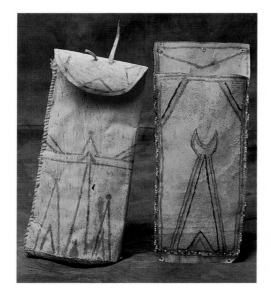

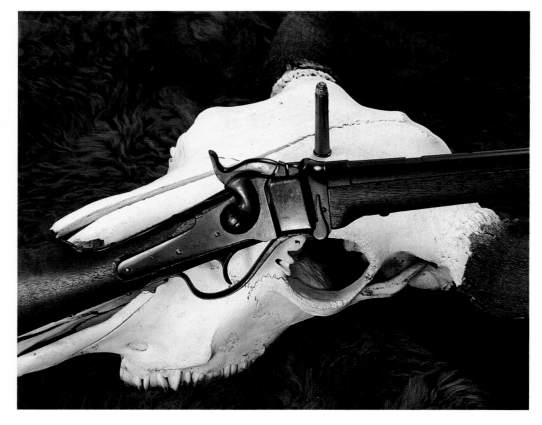

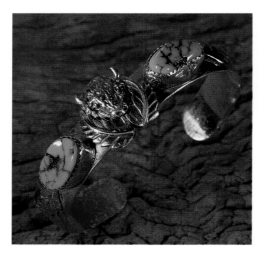

◄ LONE BULL, THEODORE ROOSEVELT
NATIONAL PARK, NORTH DAKOTA.
▲ ▲ KIOWA BUFFALO RAWHIDE POUCHES.
▲ CONTEMPORARY NAVAJO TURQUOISE
AND SILVER BISON HEAD BRACELET.
▲ ► SHARPS MUZZLE-LOADING RIFLE
DISPLAYED WITH A .52-70 CALIBER BULLET,
1863, FOR BUFFALO HUNTING.

civilization—including such benefits as cholera, which killed half the Cheyennes on the upper Arkansas River. The next two decades brought eight million whites through or into the Plains. Steamboats chugged up the Missouri, and ox trains wound along the Platte River.

Kill the buffalo, kill the Indians.
—General Philip Sheridan, 1866

When white hunters decided to cut themselves in for a share of the profits by killing bison with rifles more efficiently than the Indians could, an estimated fifty million bison still existed. The hide hunter wanted the bison to stay calm and die close together so he didn't have to drive miles to skin them. With a rifle too heavy to carry easily on horseback, he could conceal himself a few hundred yards away and shoot grazing animals without alarming the herd. Some used two rifles, letting the barrel of one cool while using the other. In 1872, Kansas marksman Thomas Linton killed more than 3,000 bison, while George Reighard set a record of nearly 100 a day for a month. During the last four months of the year, the three Clarkson brothers killed about 7,000, so many their employees had to skin 150 to 200 a day.

While the bison hunters did their dangerous, dirty work, other hunters were busy stripping the continent of other game, making more

money faster. In five weeks, a skilled pigeon-netter could capture enough barrels full of the birds to earn a year's wages.

Hide hunters took only enough bison meat to sustain them and left the rest to rot. Travelers who saw thousands of rotting animals reported that they might have walked from the Dakotas to Texas without stepping on the ground. Without fast transportation, the meat couldn't be taken to market, though tongues were sometimes smoked for eastern sale at 20 to 30 cents per pound. During 1872, 200 railroad carloads of hindquarters went east, with two carloads of cured tongues.

During the last big hide-hunting year, 1844, a New Orleans market received 54,450 robes worth an average price of $4.43. The price reached $7.50 in 1852 and hit a peak at $8 two years later, with robes becoming scarce. In 1881, white hunters sold 14,000 hides for $3.50 each. The market also took in 12,000 robes tanned by Indians at $7.50 each. In 1884, fewer than 2,500 hides were sold, and those were thought to be holdovers from the previous year.

By the 1860s, professionals and pioneers who killed as they moved through the herds were disrupting migration patterns, forcing Plains tribes to follow as the herds withdrew to today's Montana and Wyoming. This was traditionally Crow territory, but tribes who depended on the beasts, notably Lakota and Cheyenne, were forced to follow. Conflict ensued between the tribes, worsened by hostility with hunters, soldiers, and pioneers.

Thomas Fitzpatrick, a former fur trapper turned agent for the tribes of the Arkansas, Platte, and Kansas Rivers, watched 50,000 gold seekers move west past Fort Laramie in 1850. He asked the government to compensate the Indians for damages—dying grass and dead bison, as well as unfamiliar diseases that were decimating the Indians. When Congress authorized funds for a conference, Fitzpatrick, known as "Broken Hand," collected 10,000 tribal representatives of nine nations. The treaty they signed guaranteed tribal rights and promised annuities (food and tools) worth $50,000 per year for fifty years. Though the treaty allowed the government "to establish roads, military and other posts," many Indians apparently believed the agreement would keep whites out. During the ratification process, the Senate cut the time annuities were to be provided from fifty years to ten.

In 1862, when gold was discovered in southwestern Montana, John M. Bozeman pioneered a wagon road from the Oregon Trail to the northern mountains. Between 1864 and 1868, government troops lost

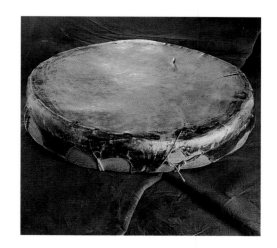

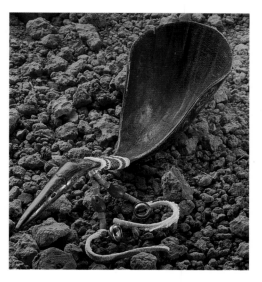

▲▲ KIOWA BUFFALO RAWHIDE DRUM, CA. 1900.

▲ REPLICA, KIOWA CARVED BUFFALO HORN SPOON, DECORATED WITH BEADING, MESCAL BEANS, AND BELLS.

► WILLIAM FREDERICK CODY, BETTER
KNOWN AS "BUFFALO BILL," CALLED HIS
1886 HOME "SCOUT'S REST." IT IS NOW
LOCATED ON THE BUFFALO BILL RANCH
NEAR NORTH PLATTE, NEBRASKA.

some of the most dramatic battles with Indians in our history in this
region. At some sites, wagon ruts are visible and little has changed,
notably at Fort Phil Kearney, so that one can hear the ghost of Captain
William J. Fetterman declare again that he could ride through the whole
Sioux nation with eighty soldiers. Squint, and you'll see Crazy Horse
pretending his horse is lame to decoy the soldiers out to die. The fight-
ing ended only because the Union Pacific Railroad promised a faster
and safer route to the gold fields.

By 1871, European and American tanneries had devised new methods
of treating dried bison hides to expand their uses. With the hair on, the
hides were used as robes in buggies, for coats, and for overshoes. With
the hair off, the fine and durable leather made the belts needed for
machinery as the world entered the industrial age, as well as seats in
carriages and sleighs, and cushions, linings, and roofs for hearses. The
British army considered bison leather more flexible and elastic than cow-
hide, using it to replace many of the standard articles of a soldier's outfit.
Padded leather furniture was made from bison hides, as were textured
wall coverings for the homes of the affluent. By 1881 the Northern
Pacific tracks had reached Miles City, Montana, and a year later
5,000 bison hunters and skinners were operating in the northern range.

Bison were the Plains tribes' whole existence. In 1887, when the

Kiowas failed to find a wild bison for their Sun Dance, they bought one from a Texas herd. White settlers saw them as dangerous animals that trampled crops and fouled water, and hindered travel by stagecoach, train, and steamboat. Ironically, railroad workers and cavalry, whose job was to turn the Plains into a "civilized" place where no bison would roam, ate largely bison meat. Hide hunters who killed bison in assembly-line fashion saw the animals as pure profit. As the railroad lines crawled west, hunters didn't need to wait for hides to be prime. About 3,700,000 bison were killed between 1872 and 1874—only 150,000 of those by Indians.

The earth and myself are of one mind. The measure of the land and the measure of our bodies are the same. . . . If I thought you were sent by the Creator I might be induced to think you had a right to dispose of me. Do not misunderstand me, but understand me fully. . . . I never said the land was mine to do with as I chose. The one who has the right to dispose of it is the one who has created it. I claim a right to live on my land, and accord you the privilege to live on yours.

—Chief Joseph, Hinmahtooyahlatkekht,
Thunder Traveling to Loftier Mountain Heights

Once the bison were virtually gone, disagreement between Indians and whites was reduced to different attitudes toward land. Americans view land as real estate—property owned by an individual, to be bought and sold, farmed, mined, grazed, or occupied. To Indians, land was community property, to be cherished because it provided a living. It could be held but not owned, either by the tribe or by individuals.

At an 1885 conference addressing "Indian problems," reform Senator Henry Dawes of Massachusetts told of visiting one of the Five Civilized Tribes in what later became eastern Oklahoma. The tribe contained no poor people, owed no money, and ran its own schools and hospitals, yet Dawes concluded their system of government was defective. "They have got as far as they can go, because they own their land in common," he said, adding, "There is no selfishness, which is at the bottom of civilization."

Two years later he helped pass the General Allotment Act, which divided tribal lands into units owned by individuals. Remaining lands were opened to white settlement. The effect was to deprive tribes permanently of even more land. Lakota Vine Deloria, Jr., later wrote

▲ THIS ANTIQUE BOTTLE, DATE UNKNOWN, ADVERTISES "BUFFALO AMMONIA," MANUFACTURED IN BUFFALO, NEW YORK, BY THE AMERICAN BLUING COMPANY, ESTABLISHED IN 1872.

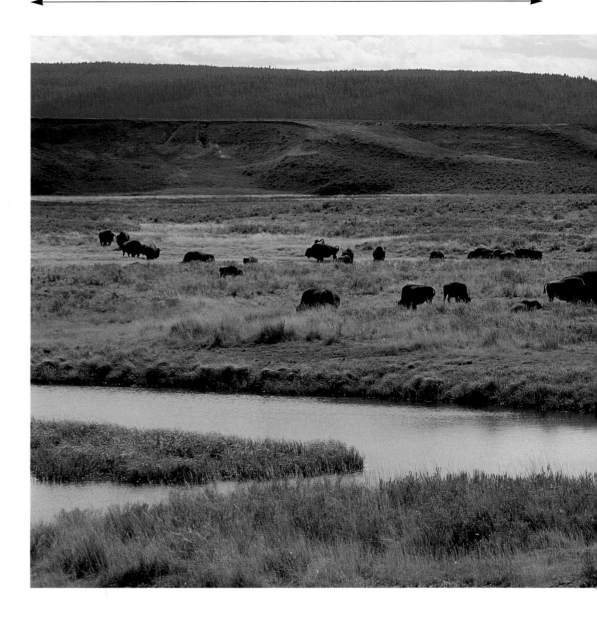

that a 320-acre tract on his Standing Rock Sioux Reservation in the Dakotas was owned, in 1959, by 183 heirs. Helen White Bird held one of the smallest shares, about .4 square foot.

Advised to become farmers, the nomads attained new heights in scornful oratory, reminding whites that their culture was based on hunting first, gathering second, and farming never. When Washakie, a Shoshone leader, was asked why he shouldn't farm on his Wind River Reservation in Wyoming, he said, "God damn a potato!"

Despite their attitude toward ownership and against advice from their leaders, Indian tribes transferred to whites title to 174 million acres between 1853 and 1857. In many cases, individuals labeled "chiefs" by whites signed documents in a desperate trade for food or shelter, without any tribally granted right to do so. Some believed they were only allowing whites to hunt, fish, graze their livestock, or pass through their territory. The resulting conflicts within the tribes helped destroy their centuries-old civil organization.

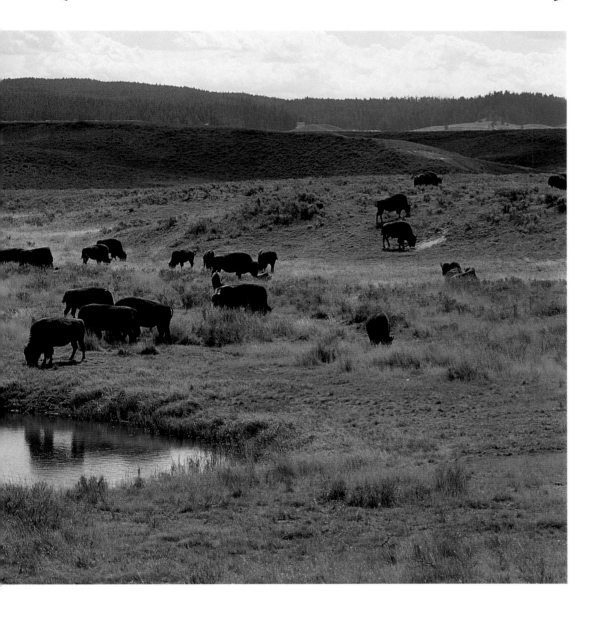

In 1871, Congress declared that the United States would no longer view Indian tribes as separate nations and would sign no more treaties. By then Indians, who had once held all the land in America, retained only about 200,000 square miles. Whites signed the first of 370 treaties in 1778, when the Indian population numbered around 4 million scattered along the eastern seaboard. By 1829, 12.5 million white people lived in America and, by 1871, held nearly 3 million square miles.

Indians starved on the Texas beef driven north to the reservations, complaining the animals were so thin they barely made soup. White men observing the beef issue said that the beef would not have been salable for any use. Often, reservation Indians were given no corn, hard bread, hominy, rice, beans, or salt. They received yeast and soap only rarely. Sugar and coffee issued for seven days lasted three. Used to a healthful diet and open space, tribal peoples sickened and died by the thousands. Mosquitoes brought illness and measles epidemics killed children. When one group finally got permission to hunt and found

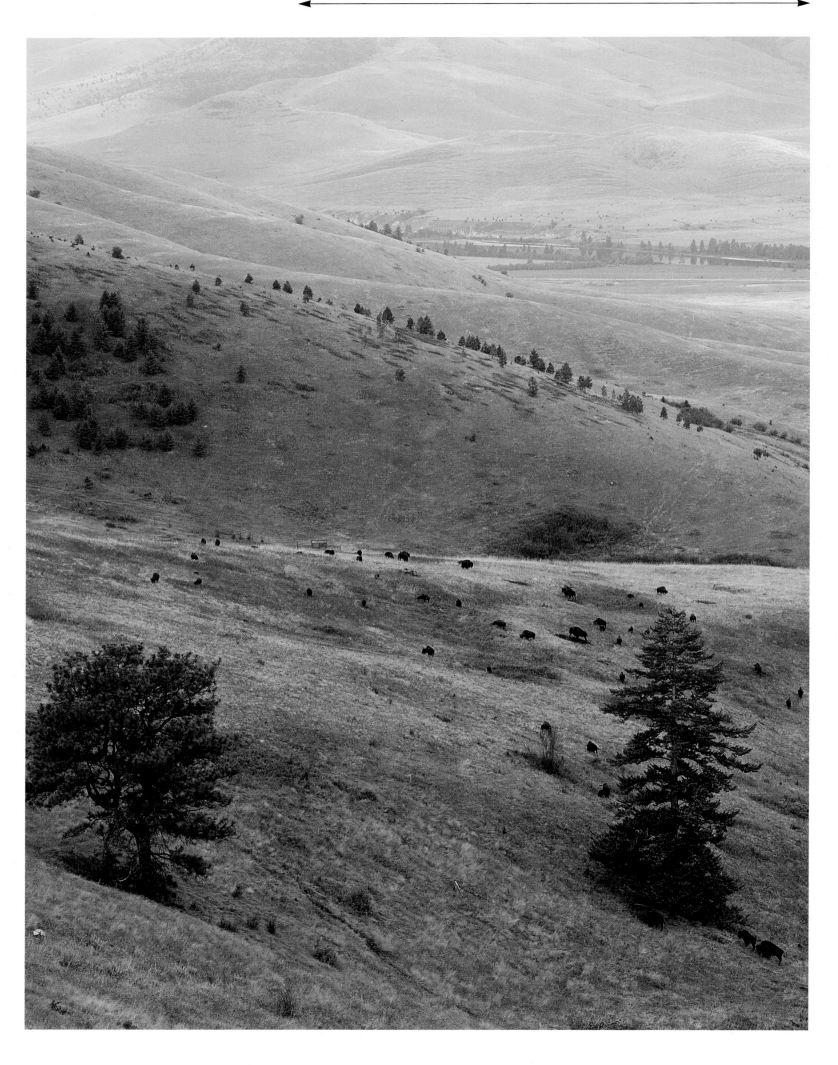

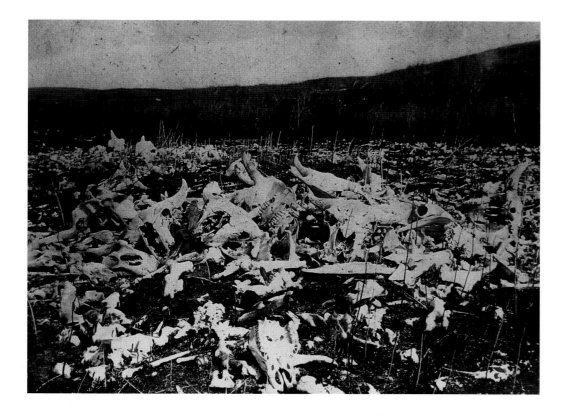

only bison bones, they killed and ate coyotes. Before the winter was over, they ate their dogs. When they considered eating the horses, the chiefs, hoping for permission to return to the prairie, said no.

> *Wherever the whites are established the buffalo is gone, the red hunters must die*
> *of hunger. Just a few years ago, the buffalo was grazing on both sides of the*
> *Missouri in countless herds; the prairie was often black with them, and living*
> *was easy for the Indian and his family, for they always had meat to eat and*
> *furs to trade.*
>
> —White Cloud, Lakota, to a mail carrier
> between Fort Berthoud and Fort Stevenson,
> Dakota Territory, December 1867

Desperate, Indian leaders who once owned enough to provide for the poor of their bands watched children and the old die of starvation. No wonder, then, that many were anxious to believe visionaries like Wovoka, who promised to bring the buffalo back. Despair fostered the Ghost Dance religion, leading to unrest among the Indians and scaring whites on the Plains. In response, the government ordered the arrest of Sitting Bull, the Hunkpapa warrior and a leader in the Ghost Dance on the Standing Rock Reservation. On December 15, 1890, he was killed when he resisted officers, including Indian police. Two weeks later, the army slaughtered the Lakota at Wounded Knee.

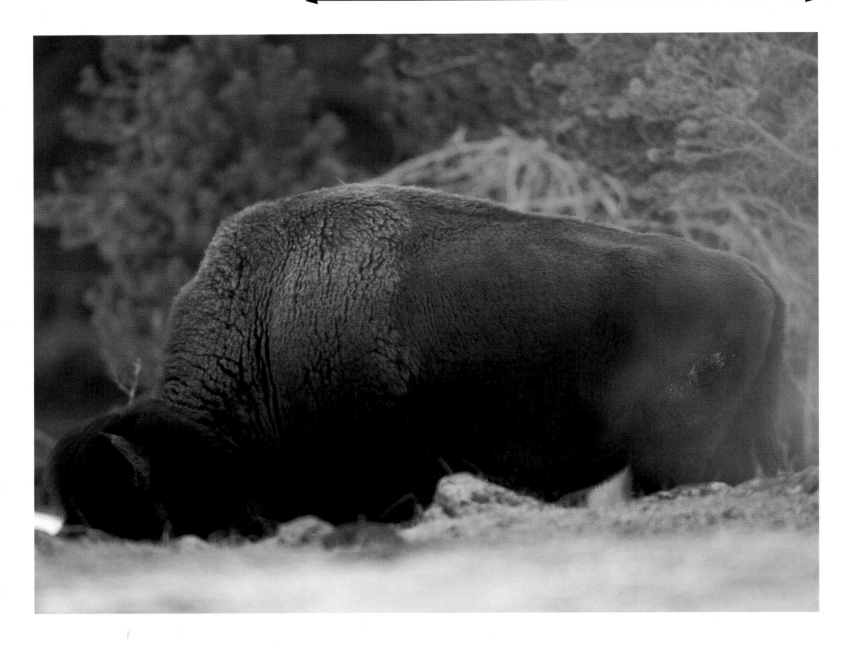

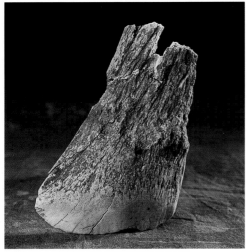

▲▲ GRAZING BISON BULL.

▲ ANCIENT CORE OF BISON HORN, WORN FROM USE AS DIGGING TOOL.

What is life? It is the flash of a firefly in the night. It is the breath of a buffalo in the winter time. It is the little shadow which runs across the grass and loses itself in the Sunset.

—Last words of Crowfoot,
Blackfoot orator, 1890-1821

The Great American Desert had become Boneland, scoured by bone hunters for the last profits from the bison herds. Prices paid for bison bones fluctuated between $2.50 and $22 a ton, averaging $8. One bone-buying firm out of the many in business estimated they bought the skeletons of 5,950,000 bison between 1884 and 1891. Old bones were ground for phosphorous fertilizer; fresher ones were carbonized into bone char, used by sugar refineries to whiten raw sugar. Horns and hoofs, sold for $6 to $30 a ton, made buttons, combs, knife handles, and glue.

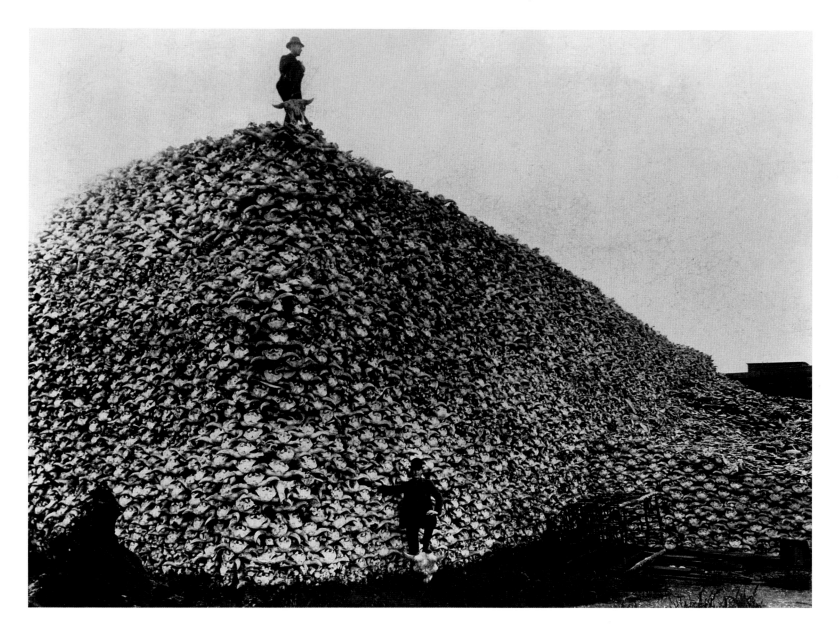

The average railroad boxcar held 29,400 pounds of bones, the remains of 500 bison. The Topeka *Mail and Breeze,* summarizing the bone industry, figured that if forty-foot railroad cars were filled with all the bison bones sold, the resulting train would have been 7,575 miles long—enough to more than fill two tracks from New York to San Francisco.

Meanwhile, a new kind of hunter, the wolfer, poisoned rotting bison carcasses, collecting wolf hides that sold for a dollar or two apiece, inadvertently killing everything else on the food chain as well—one more step in readying the Plains for settlement.

We are only little herds of buffalo left scattered;
the great herds that once covered the prairies
are no more.

 —Little Crow, Lakota, 1862

▲▲ BISON BONES, MICHIGAN CARBON WORKS, DETROIT, 1800S. CARBONIZED (BURNED) BONES WERE USED TO WHITEN SUGAR.

▲ BUFFALO BONE CORSET STAYS, 1800S.

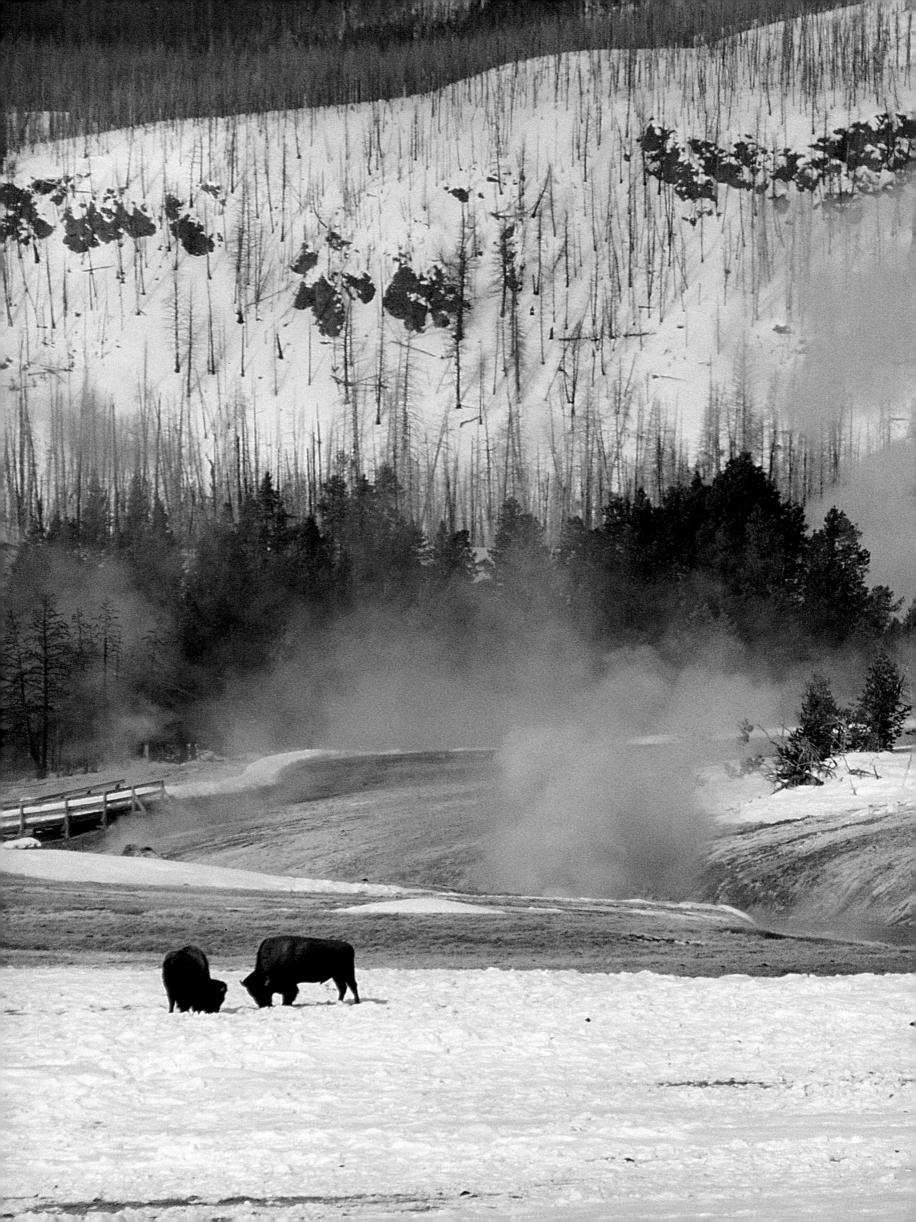

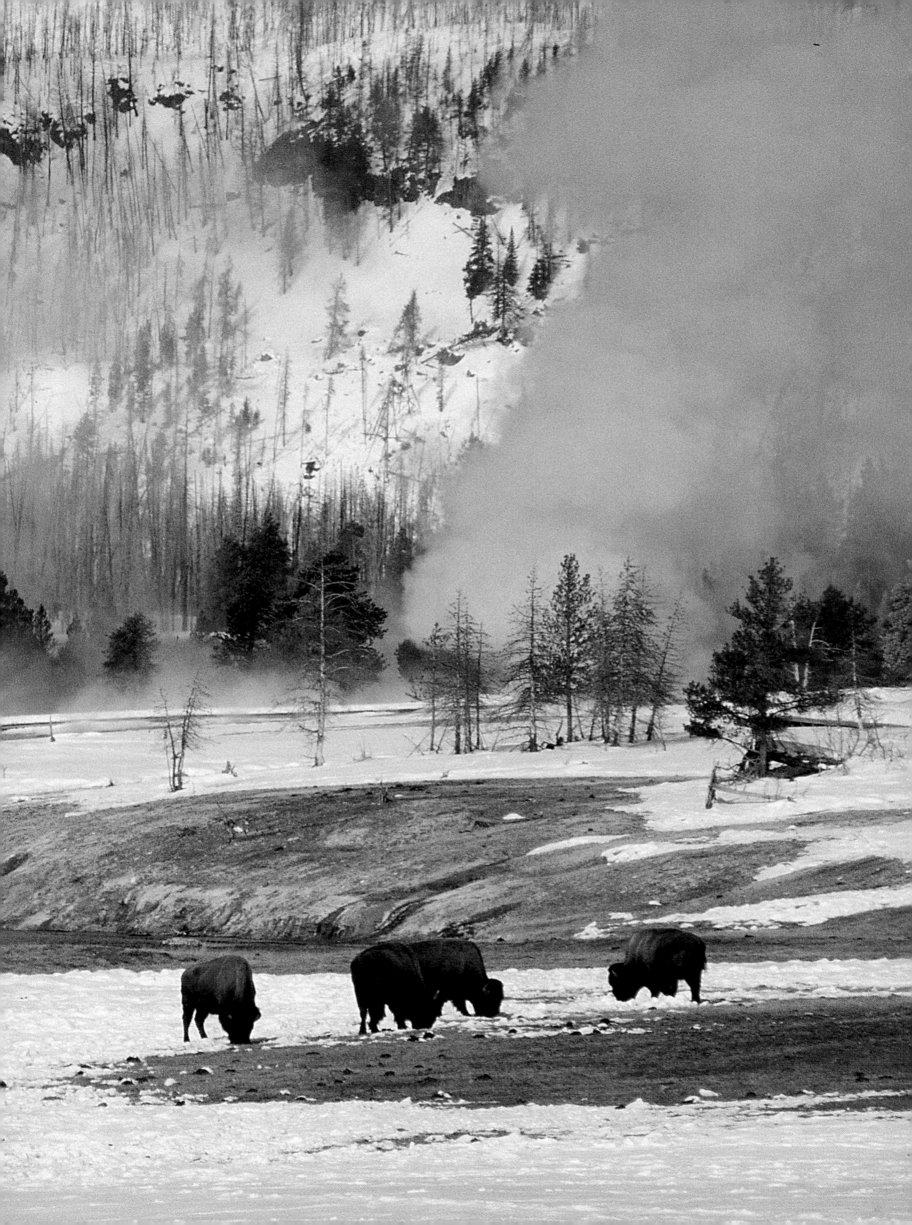

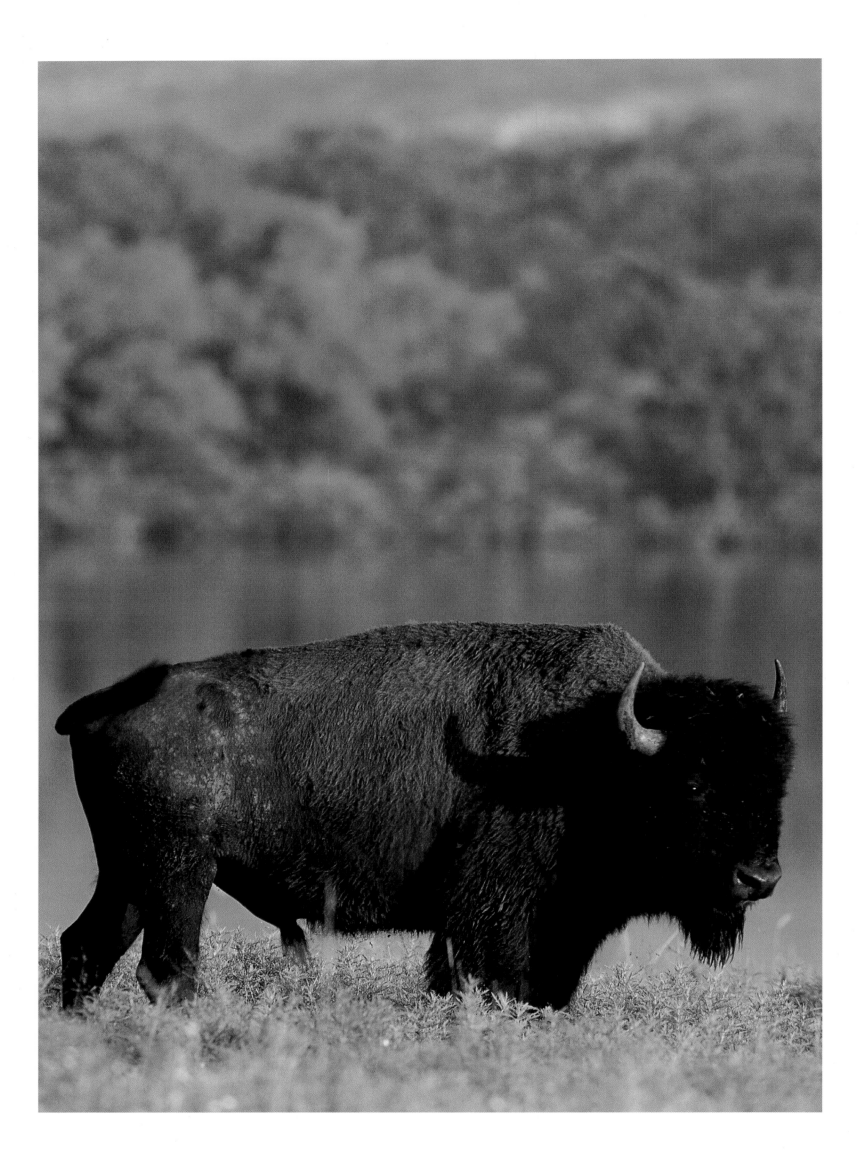

RETURN FROM THE BRINK OF EXTINCTION

*I was born upon the prairie, where the wind blew free,
and there was nothing to break the light of the sun. I
was born where there were no enclosures, and where
everything drew a free breath. I want to die there, and
not within walls. I know every stream and every
wood between the Rio Grande and the Arkansas. I
have hunted and lived over that country. I lived like
my fathers before me, and like them, I lived happily.*

—Ten Bears, Comanche

Historians disagree about when and where efforts began to salvage the bison species. Former hunters are credited by some with initiating restoration. Their primary objective was to kill the beasts. But hunting required them, like the Plains nomads, to spend more time among bison than most whites of the 1870s did. Few hunters emerged from the experience without increased respect for the animals.

Likewise, scholars work themselves into a numerical frenzy when they try to prove how few bison existed before efforts began to save the species from extinction. Whatever figure one accepts, the fact is that nearly all animals living today derived from a small genetic pool, many of them "tamed" by hunters who captured a calf after a hunt. So our bison may

◄◄ Bison forage near Yellowstone
Park's hot pools in winter.
◄ Standing broadside, bison bull
displays his massive shoulders
and head.
◄▲ Bison bull rolling in the dust.
▲ Charging buffalo decorates seed
bag label.

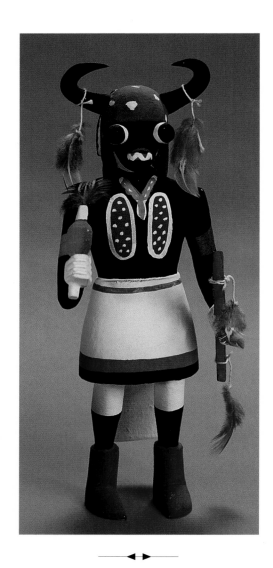

▲ THIS BUFFALO KACHINA WAS MADE
TWENTY OR THIRTY YEARS AGO,
PROBABLY AS A FACSIMILE OF ANCIENT
BUFFALO DREAMERS WHO WERE PART OF
HOPI CEREMONIALISM.

already be diverging from wild strains, becoming more domesticated.

Government concern about bison probably began in 1886, when William Hornaday, chief taxidermist at the U.S. National Museum, examined the bison hides on hand and found none good enough to exhibit. He got permission to form a hunting party to collect specimens. Hornaday, who referred to the Plains as "one vast charnel-house" during hide-hunting days, wrote to officials all over the West asking how many bison roamed nearby. Replies were so discouraging he decided to go immediately instead of waiting until autumn, when pelts would be prime. He arrived in Miles City, Montana, in May and spent four weeks of searching, collecting only three bison. Local cowboys spoke so persistently about a band of thirty-five animals farther north, however, that Hornaday decided to return.

In September 1886, he traveled into the rough country along the divide of the Missouri and Yellowstone Rivers and found the bison survivors living in badlands so broken they hadn't been pursued. His group killed several, including a huge bull that led the chase twelve miles before dropping over. Unable to finish skinning it before dark, the hunters returned to camp, leaving the carcass unguarded. In the morning, the hide and all the meat was gone, the leg bones broken and the marrow scraped out, the tongue removed.

Hornaday said the Indians were "skulking thieves" and concluded they'd left the head unskinned through laziness. One side of the bison's head was smeared with red paint, the other side was yellow. Around the base of one horn was tied a strip of red flannel Hornaday interpreted "as a signal of defiance," apparently unaware that red, the color favored by the Sun, was sacred. Red paint was mixed with marrow to paint the faces of young women for the Lakota buffalo ceremony, while yellow symbolized *Inyan,* the Rock, champion of violence, destruction, and revenge. Besides getting bison meat, which must have been rare in those times, the Indians were honoring the bull's spirit and perhaps wishing doom on the white killers.

Hornaday eventually killed twenty-five of the bison, nearly wiping out the remnant band. He found old bullets in the body of almost every adult bull. A year later, the American Museum of Natural History, realizing they had no bison suitable for display, sent hunters to the same spot. In three months of searching, they found none.

Meanwhile, a former bison hunter, Charles Jesse "Buffalo" Jones, was making money in Texas roping and training bison calves for

promotional stunts. In 1886, he invited reporters to watch him ride among wild herds to steal calves, which he fostered to dairy cows. He is pictured in drawings carrying two calves on his horse. Anyone who believes in such a feat is welcome to try it.

After poachers killed about one hundred bison that had wandered out of Yellowstone Park in the winter of 1893–94, officials found only about twenty animals left in the park. Since the herd wasn't increasing, park officials got $15,000 from Congress to buy twenty-one bison from private refuges in Montana and Texas. Buffalo Jones was hired as manager. He'd already sold ten of his adult bison for $1,000 each to Austin Corbin, a railroad magnate who added them to his private herd in New Hampshire.

A conservation-minded journalist, Ernest Harold Baynes, lived next to Corbin's preserve and realized that if the nation's only bison existed in private herds, their future was insecure. He began writing letters to prominent men, recommending that the government establish permanent herds. In May 1894, with perhaps fewer than three hundred animals left, President Grover Cleveland's signature made killing a bison punishable by a $1,000 fine or imprisonment. Baynes also organized the American Bison Society with a membership of fourteen conservationists, zoologists, and editors. William Hornaday was president, Theodore Roosevelt honorary president, and Baynes secretary.

Elsewhere, other individuals established private herds. Frederic Dupris, one of the first white settlers in the Cheyenne River region of Dakota Territory, developed the herd Scotty Philip often gets credit for saving. With his friend Basil Claymore, Dupris spent several months in the early 1880s capturing calves he raised at his ranch. In 1901, Philip bought nine of these animals and created a breeding group, increasing his herd to nine hundred head, the largest private herd of the time. Philip, known as "The Buffalo King," was a born promoter for the species and his native state.

One of his stunts was to arrange a battle between his bison bull, Pierre, and the meanest, fiercest, finest fighting bull in Mexico. Spectators looking for blood and gore were disappointed. When the fighting bull charged, Pierre simply lowered his head. The Mexican bull ran into it and dropped to his knees. Shaking his sore head, the smaller animal circled and tried to horn the bison's flank. Pierre whirled with incredible speed and lowered his head again, knocking the other bull flat. Amid boos from the Mexican crowd, a second bull was brought

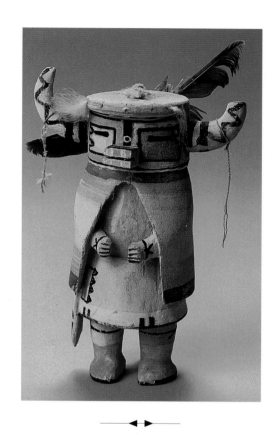

▲ A HOPI BUFFALO KACHINA, SAID TO BE A CENTURY OLD.

▼ PLAINS VILLAGE INDIANS USED BISON BONES TO FASHION DIGGING STICKS FOR HARVESTING ROOTS BETWEEN A.D. 1250 AND 1450.

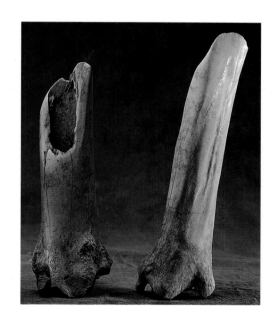

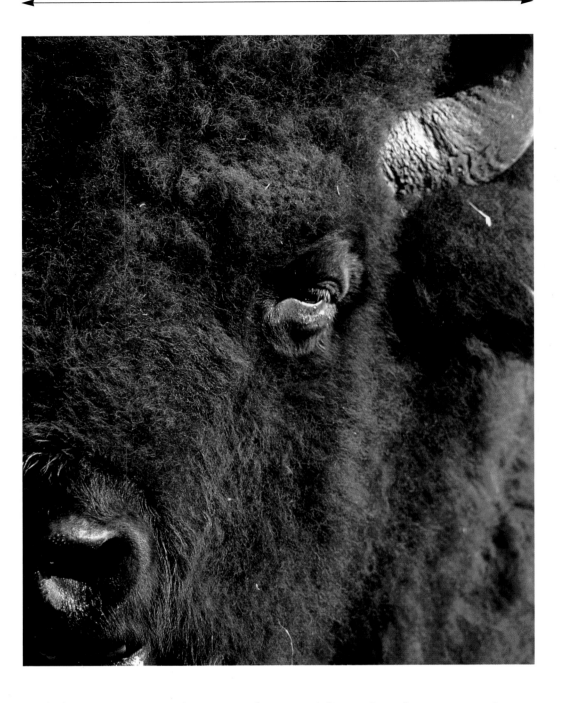

◄ THOUGH THIS BISON BULL APPEARS
CALM, HE WOULD GIVE LITTLE WARNING OF
A CHARGE. HE MIGHT UTTER A GROWLING
RUMBLE AND GRIND HIS TEETH IF THE
INTRUDER MOVES TOO CLOSE.

and the scene repeated again and again. After using the same tactics on
the third and fourth bulls, Pierre still stood calm and stolid. When offi-
cials let all four bulls into the arena, an annoyed Pierre finally charged.
All four bulls tried to climb the arena walls. Later, the Mexicans sched-
uled a contest between a young bison and a professional bullfighter. The
matador made a few passes with his cape, and the bison began to snort
and paw—but the fight was stopped.

Michel Pablo collected a private herd on Montana's Flathead Indian
Reservation until the land was opened to public settlement. He agreed
to sell his bison to Canada. Seventy-five cowboys worked for six years to
gather 672 bison, and Pablo eventually collected $177,000. By 1905,
about 800 bison survived in North America, 700 of them in private
herds. In 1907, Congress appropriated $15,000 to stock the first federal

BISON NUMBERS: FROM HIGHS, TO LOWS, TO RESTORATION

◄◄◄ ►►►

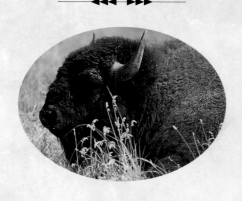

◄———►

▲ SOLITARY DOZING BISON BULL.

▲ ► BISON GRAZE NEAR WILDLIFE LOOP TRAIL, BLACK HILLS, SOUTH DAKOTA'S CUSTER STATE PARK.

250,000

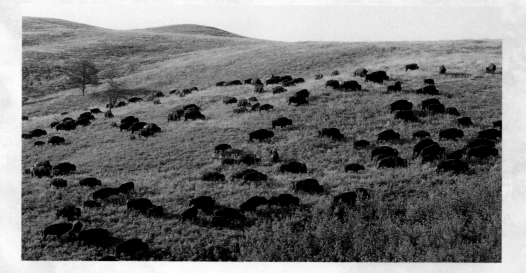

Estimates of how many bison once roamed the Plains vary wildly. Until about 1836, travelers crossing the Great Plains between the Rocky Mountains and the Missouri River were seldom out of sight of large herds.

Anecdotes gained strength with each retelling, becoming legends. One man who waited five days for a herd to pass calculated he'd seen four million head. Another, who waited three days for a herd to cross Montana's Milk River, found the herd's trail eighteen miles wide, pounded into dust six inches deep. During the summer of 1867, Captain Grant Marsh, piloting the steamer *Stockade* on the upper Missouri River, had to stop the engines for several hours when a swimming herd surrounded and stalled the craft.

In 1906, Canadian naturalist Ernest Thompson Seton finally tried to create a logical tally. He estimated that 24 million cattle and horses lived at that time on 750,000 square miles of fenced plains—about half the space available to the old bison herds. The same territory, he figured, might have supported 40 million bison and the remaining 500,000 square miles of prairie another 30 million. If another 5 million lived in the eastern forests, bison might once have numbered 75 million. Conservatively, he reduced this guess to 60 million. No one knows.

Official government sources reported bison to be near extinction in 1883. In January 1889, William Hornaday, chief taxidermist at the U.S. National Museum, started an official tally. He found just 85 wild bison and counted 200 more under federal protection, 550 near Great Slave Lake in Canada, and 256 in private herds.

Once Hornaday and others began to concentrate on saving the species, bison numbers rose slowly. A census in 1929 recorded 3,385 animals, while a 1950 survey reported 9,252. Responses to a questionnaire distributed in 1970 suggested that as many as 17,000 might be alive, and in 1972 historian and researcher David Dary estimated that the United States contained at least 15,000.

Today, the American Bison Foundation estimates that 250,000 head of bison live in the nation, along with more than 116 million cattle. Bison meat is becoming more widely available and growing more popular with American consumers, though more folks still eat beef. The annual bison slaughter is about 20,000 head, while 135,000 cattle are slaughtered every day.

▲ WESTLAND OIL COMPANY OF MINOT, NORTH DAKOTA, USED A CHARGING BUFFALO TO SYMBOLIZE ITS POWERFUL GASOLINE FROM 1920 TO 1960.

bison range, 8,000 acres of prairie in Oklahoma, formerly reservation lands for Apache, Comanche, and Kiowa people. Teddy Roosevelt signed a bill establishing a reserve in Montana, but with no federal money available, private donations had to be collected. Supporters noted that few donations came from the Great Plains, and none at all from Texas, Kansas, and the Dakotas—where the dead bison once lay so thick folks said they could walk the length of the Plains without stepping on the ground.

Ernest Baynes took his role as bison champion seriously. He lectured, exhibited bison robes and artifacts made from the animal, and worked to turn the "deposed monarch of the Plains" into a symbol of persecution, an apt hero for the American frontier. Understanding, perhaps, the nation's desire to profit from its investments of time and money, he also promoted bison as the work animals of the future. For a while, he drove as a team a pair of bison he'd broken, proudly exhibiting the black eyes and bruises they gave him. But when they became impossible to handle, he dropped the idea.

Several schemers considered making cloth from bison hair. Enterprising Canadians who had settled in the Red River region obtained lavish backing for a commercial operation to weave bison hair into cloth. Including high wages paid to workers, a yard of cloth cost $11.12 to make. Unfortunately, in the London markets, it sold for $1. Baynes collected tufts of bison hair, spun the fuzz into yarn, and knitted gloves; army officials liked the warmth of the blankets he made from bison wool, though the hair was too porous to offer adequate protection against rain. Still, Baynes never solved the primary problem: how to harvest the fleece from living bison.

The idea of crossing bison with domestic cattle to create an adaptable animal with good meat occurred to a Spaniard as early as 1598. By 1908, at least 345 hybrid mixtures of domestic cattle and bison existed. Buffalo Jones, always alert for profits, formed a company and sold stock before driving 120 bison into a valley near the north rim of the Grand Canyon. He imported Galloway cattle, but the operation faded into debt a few years later.

Theoretically, a bison bull should be able to mate successfully with a large-boned domestic cow, but early experiments resulted in cow and calf deaths. Reverse mating solved that problem, though some of the domestic bulls were unwilling to mate with bison cows. In Canadian experiments, only the female offspring were fertile. If backcrossed to

ENDANGERED BISON RELATIVES

◄◄◄ ►►►

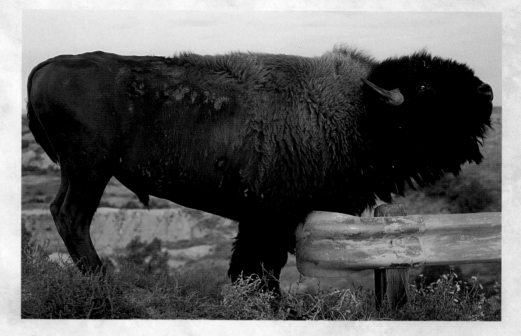

——◄►——

▲► OLD BISON BULL SCRATCHES HIMSELF ON GUARD RAIL, NORTH DAKOTA'S THEODORE ROOSEVELT NATIONAL PARK.

▲ SEVERAL MONTHS OLD, THIS BISON CALF HAS BEGUN TO SPROUT HORNS.

Several close relatives of the bison are endangered elsewhere in the world and now listed as rare by conservation agencies. Included are the wisent of Europe, an ancestor of our modern bison. Also near extinction are the dwarf water buffalo of Celebes and the wild Indian buffalo of Assam, Nepal, and India. Only two or three hundred of two other species, the seladang of Malaya and the kouprey of Cambodia, survive.

Conservationists say civilization is wiping out species at a rate of at least one a year. For mammals, the rate of extinction has increased 55 percent in the last century and a half. Two hundred of the remaining 4,062 species of mammals are listed as endangered. At this rate, all would disappear within thirty years.

What do we want with this vast worthless area,
this region of savages and wild beasts,
of deserts, of shifting sands, and whirlwinds of dust,
of cactus and prairie dogs?

—Daniel Webster

Endangered Species

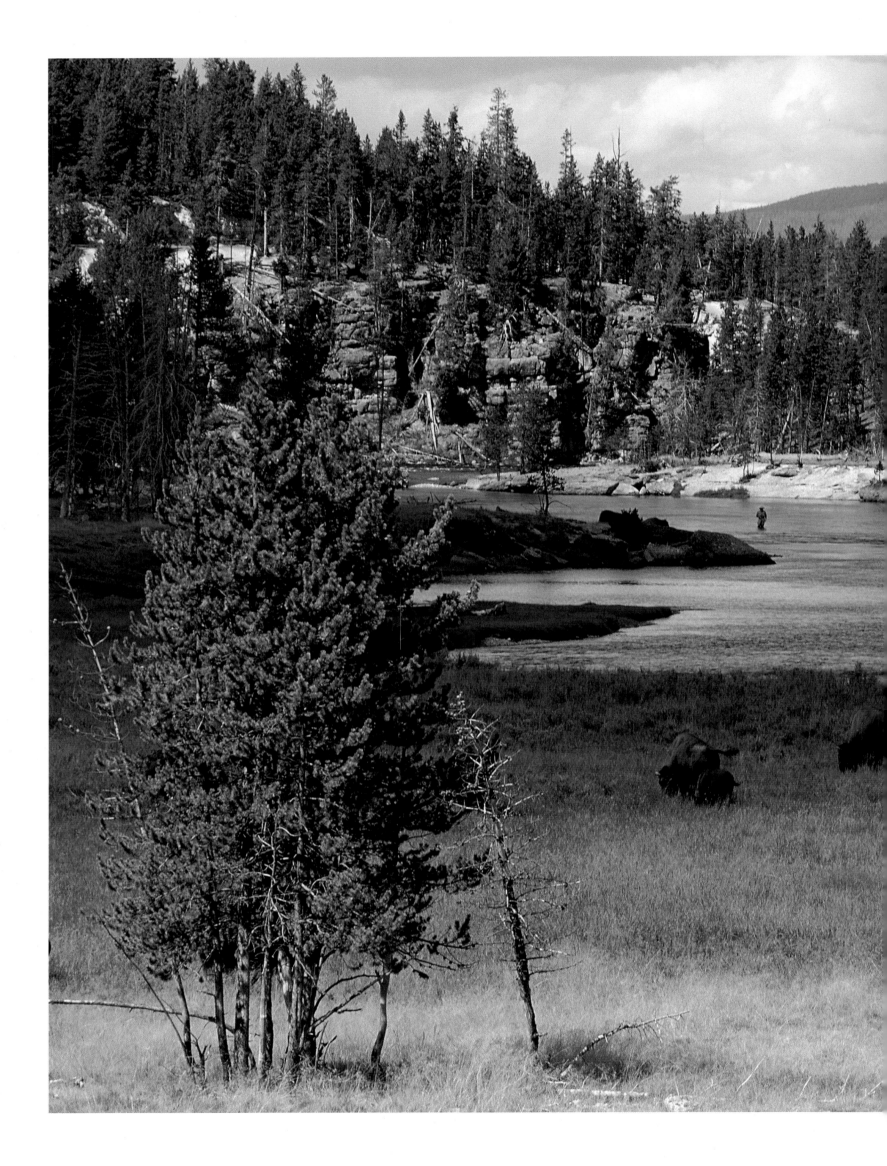

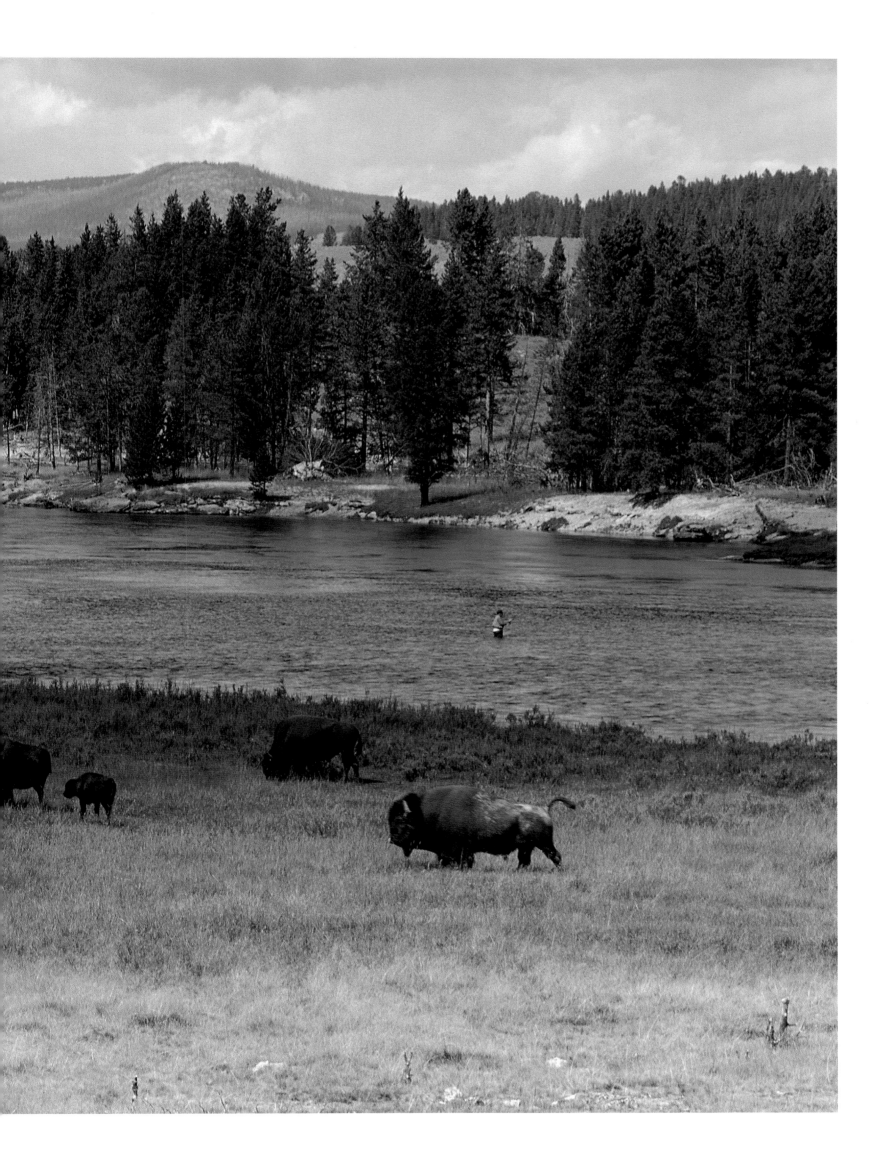

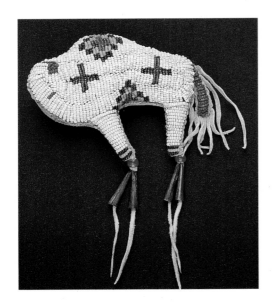

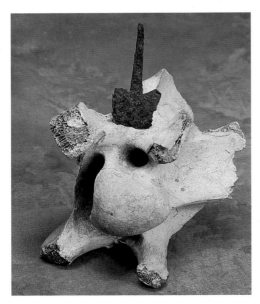

◄ Grazing bison herd, Hayden Valley, Yellowstone River.

▲▲ Beaded bison effigy, Rosebud Lakota, 1900s, contained a child's umbilical cord and hung from the cradle to keep the child safe.

▲ Buffalo vertebra with spear tip still embedded in it, probably from 1800s.

either parent species, however, their descendants were more able to reproduce, being about 16 percent bison. The animals (called "cattalo") retained some of the bison's characteristic winter hardiness. However, the cattalo were heavy in the shoulders and light in the hindquarters, precisely the reverse of the carcass standards for high-grade beef. By 1964, most Canadian ranchers had begun feeding herds in the winter, so researchers decided there was no need for an animal able to resist severe cold. The Canadian cattalo herd was slaughtered.

The white man does not understand the Indian for the reason that he does not understand America. He is too far removed from its formative processes. The roots of the tree of his life have not yet grasped the rock and soil. The white man is still troubled with primitive fears; he still has in his consciousness the perils of this frontier continent, some of its vastnesses not yet having yielded to his questing footsteps and inquiring eyes. He shudders still with the memory of the loss of his forefathers upon its scorching deserts and forbidding mountain-tops. The man from Europe is still a foreigner and an alien. And he still hates the man who questioned his path across the continent. But in the Indian the spirit of the land is still vested; it will be until other men are able to divine and meet its rhythm. Men must be born and reborn to belong. Their bodies must be formed of the dust of their forefathers' bones.

—Chief Luther Standing Bear, autobiography, 1933

Despite the failure of ideas that required altering the bison's nature to make the animal drudge more efficiently for civilization, the very fact that the species survived is cause for hope in many quarters. The settlers who followed the fur trappers and hide hunters to the Plains believed—because government officials told them so—that "rain follows the plow." By the 1930s the Plains, once blackened by bison herds, lay dry and lifeless, eroded to the bone. The rain did not follow cultivation, and the natural cycle of drought sent thousands of farmers elsewhere to seek their fortune. Yet in the 1940s, the same prairies produced so many millions of bushels of wheat that some spoiled on the ground because there wasn't enough storage or transportation. Clearly, the ground was fertile enough, but the climate was inhospitable to farming.

During recent decades, many Plains dwellers have learned more about the nature of grasslands. Like the Ghost Dance followers of the 1890s, we now believe that understanding the grasslands will provide insights leading to a future where bison roam again.

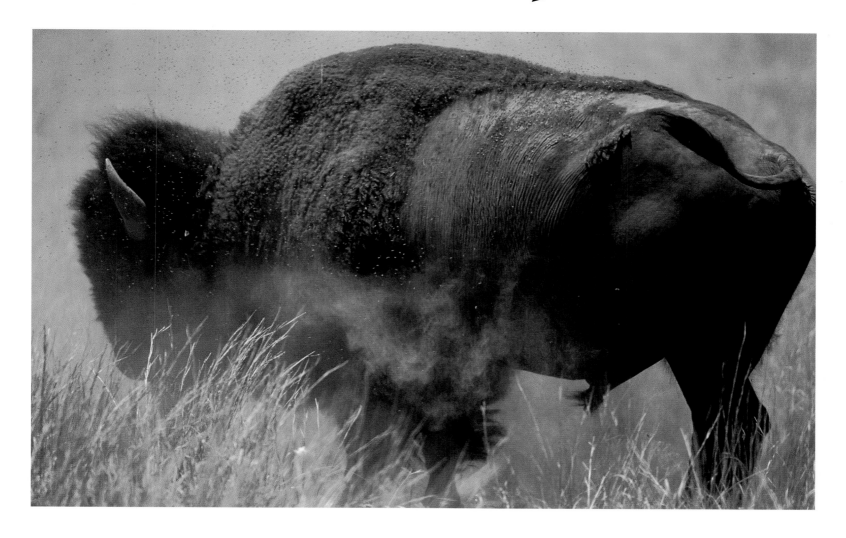

niya tanin yan mawani ye
oyate le imawani na
hotaninyan mawani ye
niya taninyan mawani ye
waluta le imawani ye

With white breath
I am walking
toward you, Buffalo Nation
I am walking
With a voice you can hear
I am walking
With a voice you can see
I am walking
For this scarlet pouch
I am walking
Behold it!

 —Song of the White Buffalo Maiden,
 Teton Sioux Music, Francis Densmore

▲ DUST RISES AROUND A BISON'S LEGS AS
HE PAWS THE GROUND IN AGITATION,
PERHAPS PREPARING FOR A BATTLE DURING
THE RUT. A BULL TRAPPED IN AN
ENCLOSURE WITH SEVERAL ELK KILLED A
DOZEN BEFORE HE COULD BE REMOVED.

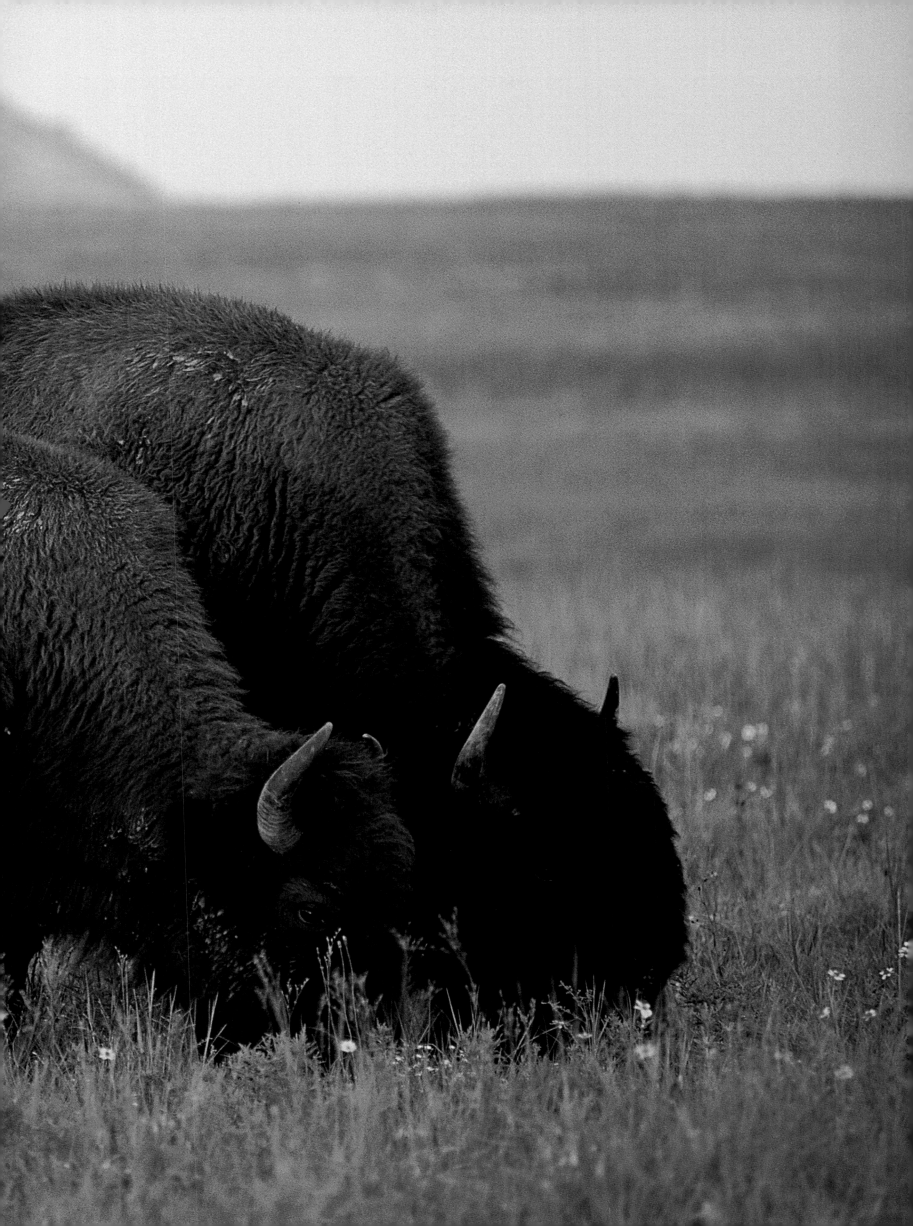

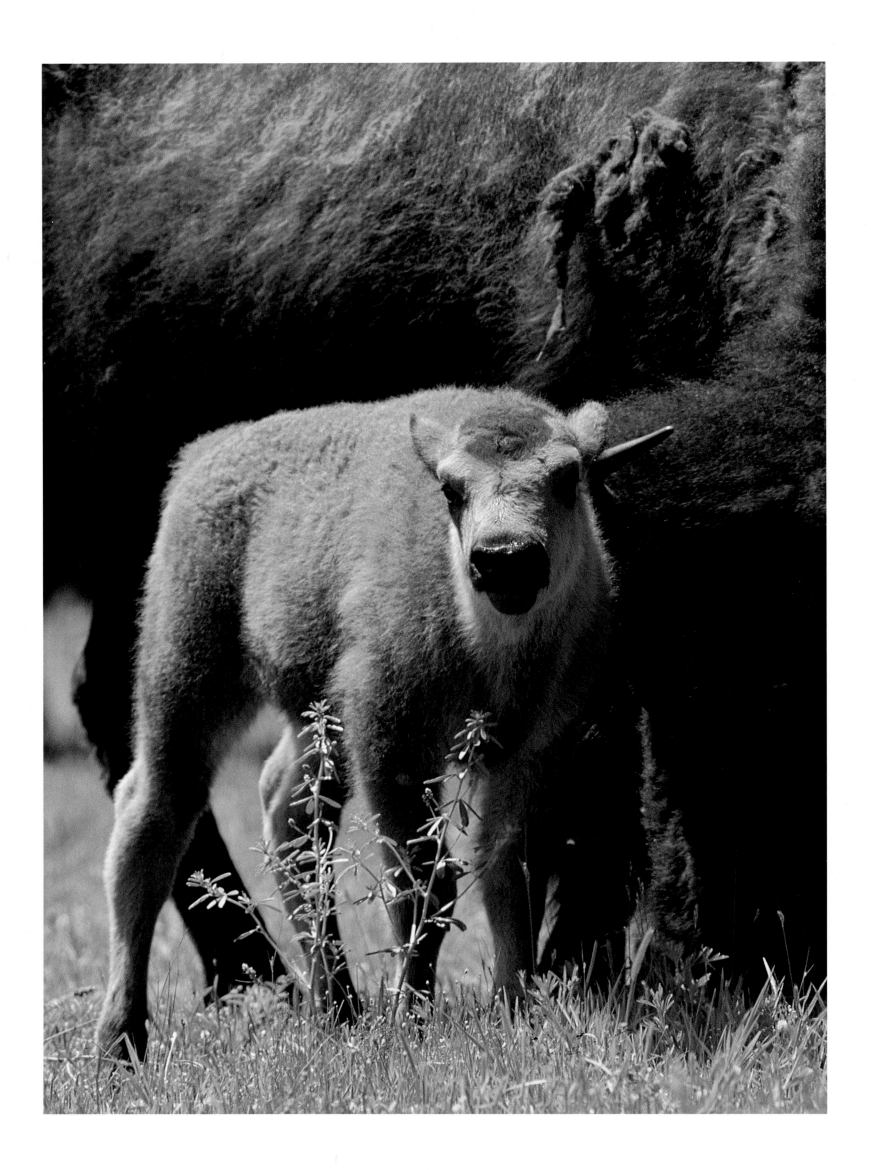

Today's Bison and the Cycle of Life

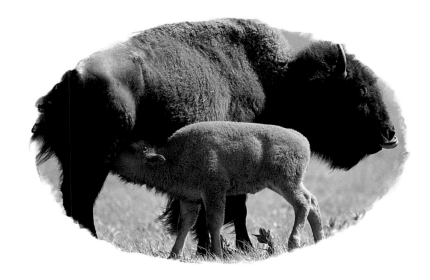

I love the land and the buffalo and will not part with it.

—Satanta, Kiowa

◄◄ Grazing bison bull and a young
cow in prime condition, Indiahoma,
Oklahoma.
◄ Bison calf a few days old stands
beside its young mother.
◄◄ A new bison calf nursing.
▲ Early spring, Wichita Mountain
National Wildlife Refuge, Oklahoma.

Every spring for eons, bison cows have wandered alone away from the herd, heeding the summons of birth after a gestation period of 275 days. In a hollow on a grassy knoll, the cow lies down, able to look alertly around her. She follows a habit centuries old, though few modern predators are capable of killing her. Her acute hearing and sense of smell will provide evidence of danger before she sees it. If she stares intently, her ears pointing toward some disturbance, the herd will heed the warning in her body language and flee.

Efficiently, the cow expels a smooth pink package weighing forty to sixty pounds. She stands at once to chew the membrane away from her baby. She licks the moist fur on his face first, then his entire body. Head wobbling, the calf soon begins to push against the earth with still-soft hind hooves, lifting its hindquarters. While the calf toils at the business of standing up for the first time, the cow licks him, rumbling encouragement from deep in her throat. Every few seconds she raises her head to scan her surroundings. During this brief period before her calf can escape a predator, her instinct to defend him is set hair-trigger fine—she will try to kill anyone or anything coming too close.

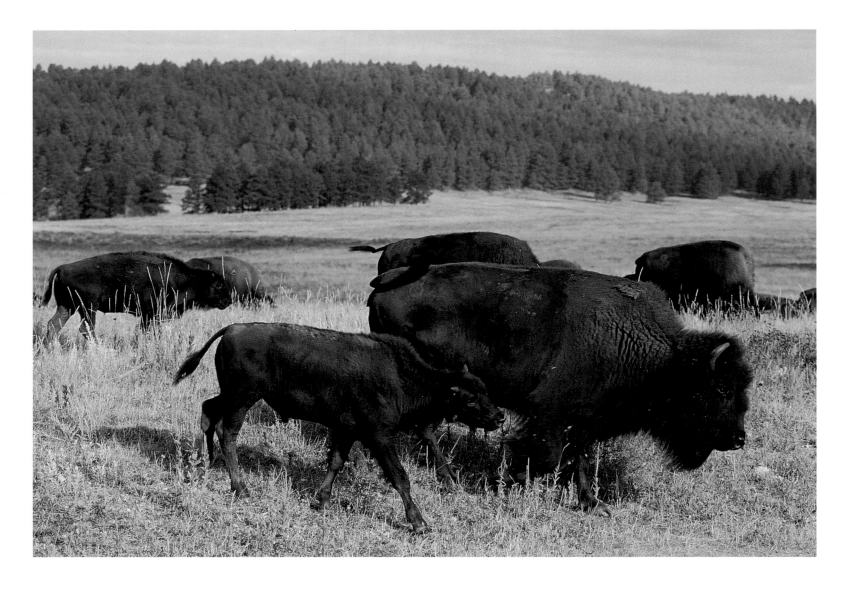

▲ DURING ITS FIRST SUMMER, A CALF'S
HAIR DARKENS AND ITS SHOULDER HUMP
GROWS MORE PRONOUNCED. COWS
WITH CALVES GENERALLY SEPARATE
FROM BISON BULLS DURING THE SUMMER,
LIKE THESE PAIRS.

Ten minutes later the calf takes his first steps, probing at once between his mother's hind legs for the smooth brown teats of her udder. In an hour, the calf can keep up with the cow, even if she runs. Once again the largest land mammal in North America survives to lope through the grasses. Reddish brown now, the calf will turn darker in three to four months and lacks the pronounced shoulder hump of his elders.

During this first day of life, the calf will nurse more often than a bovine baby and begin to eat grass, unlike a beef calf. Growing rapidly, the bison calf may weigh 400 pounds in a year. As he nurses or plays, he will utter contented chuckling grunts, his tail serving as a barometer of his excitement or pleasure. When he is cornered, angry, or confused, and thus dangerous, his tail stands straight up. He will notice the slightest change in his environment—a pickup left unattended, for example—and investigate it at once, often followed by the entire herd. Because bison are used to dominating their surroundings, they play rough.

Rangers in Custer State Park still recall the appearance of the first Volkswagen there. Its driver approached too close to a bull while

taking a picture, then hopped back into his car. The bull shoved the VW experimentally and discovered that it fell over and uttered interesting shrieks. Another bull, attracted by the commotion, pushed at it with his horns. When rangers arrived, several bulls were playing buffalo dodge ball with the vehicle, and the rangers had to control their laughter before figuring out how to rescue the tourist.

People with experience say bison are so unpredictable that it's never safe to trust one by turning your back, even to an animal reared by humans. Their wild instincts, developed among predators like the saber-toothed tiger, are still strong. Making a quick movement of any kind, or getting between a bison and its line of escape—the most open area in the vicinity—can trigger a charge. Since you can't outrun one, however, experts suggest standing your ground if a bison charges, making noise or hitting the animal close to an eye at the last possible second. A cow protecting her calf, however, is unlikely to stop. As is the case with most wild mothers, never get between a mother and its young.

"You can move a bison anywhere he wants to go," say experts, noting that vehicles driven often among bison usually display dents and holes poked by horns. Since bison prefer to move away from people, one of my neighbors who raises bison says that when he wants them in the corral, he gets on the opposite side of the herd and "tries to annoy them enough to move away but not enough to charge." Early in his bison-raising days, Roy Houck, on whose ranch most of the movie *Dances with Wolves* was filmed, once chased a young bison heifer all day, wearing out two horses as the bison got more cantankerous. After he mounted the third horse, the rogue bison spun around and chased him. So each time she slowed, he'd ride back, get her attention, and then "run like hell again" until he got her back to the ranch.

A bison cow usually produces her first calf at age three or four, remaining productive for at least twenty years—one cow gave birth at age forty-five. Standing five feet tall at the shoulder, a cow may be seven feet long from the tip of her nose to the root of her tail and weigh 700 to 1,200 pounds. Fully grown at six or seven years, a bull is often a foot taller and twelve feet from nose to tail. He may weigh a ton, though the average is 1,600 pounds.

In profile, bison look deceptively awkward, with great heads and shoulders seeming to overbalance the slender hindquarters. But they can outrun and easily outmaneuver most horses, pivoting on their front or hind feet to switch ends at a run that may reach speeds of thirty-five

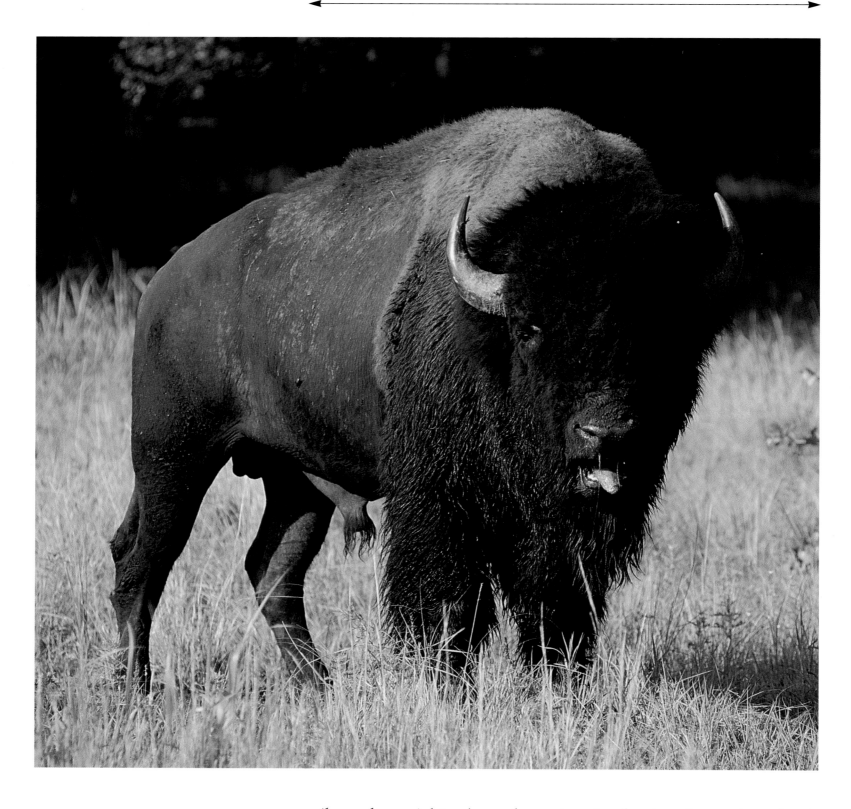

▲ A BISON BULL STANDS BROADSIDE TO SHOW HIS BULK TO AN INTRUDER, HEAD SLIGHTLY LOWERED AND HIS TAIL SWITCHING. HE MAY SWING HIS HEAD, BELLOW, SNORT, AND PAW BEFORE CHARGING — OR HE MAY NOT. BULLS ARE MORE AGGRESSIVE IN THE RUTTING SEASON.

miles an hour. A bison's esophagus is twice the size of a cow's, so its air intake and consequent endurance is astonishing. Because the windpipe is also closer to the surface than that of a beef animal, it is more easily damaged, so if cowboys must rope a bison, they aim for the feet.

Bison are the most social big game animals on the continent, preferring to stay together in a herd that moves ponderously, at the speed of the slowest animal. This tendency to move together means bison confined to a pasture create deeply eroded trails to their water. Still, a stampede will destroy most fences man has yet devised, and humans have

BISON
OR
BUFFALO?

◄◄◄ ►►►

◄—►

▲ BISON OFTEN WALLOW IN DUST TO GROOM THEMSELVES—TO GET RID OF WINTER HAIR, INSECTS, OR TO SCRATCH INSECT BITES.
▲ ► ANCIENT BISON WALLOWS USED BY MANY ANIMALS ARE STILL VISIBLE ON THE PRAIRIE.

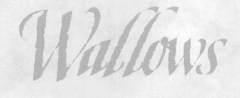

Wallows

Bison bison is the scientific name for bison (popularly called "buffalo"), a member of the *bos* family. The animal is genetically related to bovines such as domestic cattle, but distinct from the true buffalo of Asia and Africa. Early Spanish explorers spoke of bison either as *vacas de tierra*—"cattle of the country"—or as *bufalo*, their name for *Syncerus caffer*, the wild ox of Africa and India. English settlers recognized the animals as distinct from cattle, but referred to them with a French term for oxen, *les boeufs*. Some authorities say the word was slurred and shortened to "buffalo." Until about 1845 it was spelled in various ways: boffle, buffler, or buffilo.

Most Great Plains natives call the critters "buffalo," considering "bison" to be evidence the speaker is a pretentious and citified nonnative. "Buffalo" is also attractive for its onomatopoeic qualities, imitating the huffing sound the shaggy animals make and the low tone of their grunts.

As a verb, to buffalo someone in the 1870s meant to confuse, cheat, or intimidate. Fur trappers called a dense person buffalo-witted. On the frontier, Indians called Negro troops sent west in the post–Civil War era Buffalo Soldiers, probably referring to the texture of their hair. Buffalo wood was a sly description of chips—dried manure—while buffalo tea referred to the filthy water left in the circular depressions where the animals rolled and scratched themselves. All over the Plains, these buffalo wallows are still visible.

Several plants were named for buffalo, including *Solanum rostratum*, buffalo bur, a short dryland annual with sharp spines, and *Shepherdia canadensis*, the buffaloberry shrub, with fruit so tart it nearly puckers the mouth. Buffalo grass is a grama, *Buchoe dactyloides*, valued on the Great Plains for its ability to cure into a forage that remains nutritious all winter.

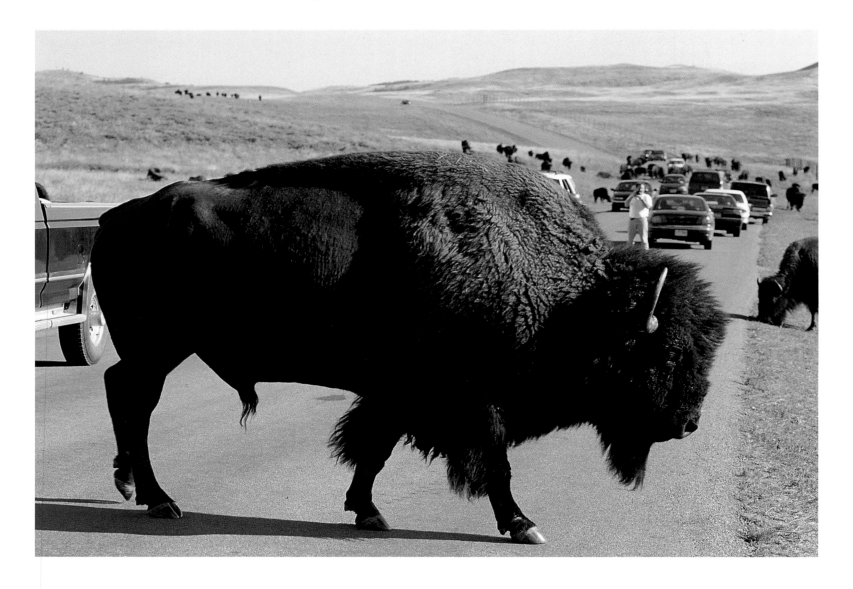

▲ MARCHING ALONG HIS CHOSEN ROUTE, THIS VENERABLE BISON BULL IGNORES LINES OF VEHICLES WAITING FOR HIS CROSSING. ONE MAN HAS UNWISELY LEFT HIS CAR TO TAKE PHOTOS.

found no sure way to stop them. From a standing position, a bison can jump with the agility of a deer over modern barricades ten feet high.

Cornered, bison use their heads and horns as weapons. In Yellowstone Park, rangers once found a female grizzly dead in the middle of mauled grass and patches of bison hair. Bruised and bloodied, all the ribs on one side broken, its belly punctured by two holes, the bear was killed, they concluded, after it attacked a young bison. When cattle-raisers on Alaska's Kodiak Island lost too many cows to bears, they started raising bison, which fight off the brown monsters.

Though a bison usually issues ample warning of an impending charge—raising its tail, pawing the ground and bellowing—the animals are so unpredictable they may charge without warning. During one roundup, I saw a bull casually sweep his horns along the belly of an animal crowding him. The second bull's intestines instantly burst forth. An African big game hunter visiting Yellowstone sneered at the ferocity of American game. Walking away after taking a picture, he was gored in the buttocks severely enough to require surgery.

Hide hunter Charles Reynolds testified to the bison's self-defense capabilities during the 1800s. He and a partner were walking up to skin a cow when she raised her head. Before they could react, she charged, horning the other man and opening him from belly to throat so cleanly that Reynolds could see his heart still beating—though it didn't beat long.

A bison's head is overlaid with skin more than two inches thick, besides its cushion of long hair. Experimenting, a nineteenth-century sportsman once shot a bison from fifteen yards with a Henry rifle and caused only "angry head-shaking." Then, from the same distance, he fired several times with a Spencer carbine, causing the bull to stagger but not fall. Examining the skull later, he found no fracture.

The bison day is devoted to grazing, rest, and finding water, which they can smell for miles. In a prairie drought, bison can live without water for several days, eating prickly pear cactus for moisture. Near dawn, small bands of three or four animals will rise and begin to graze, moving at a slow walk, ripping up mouthfuls of grass and swallowing it at once.

▲ WINTER IN YELLOWSTONE. BISON HAVE BEEN KNOWN TO DISMANTLE SNOWMOBILES, KILLING THE DRIVER.

▶ BISON BULL, CUSTER STATE PARK, SOUTH DAKOTA.

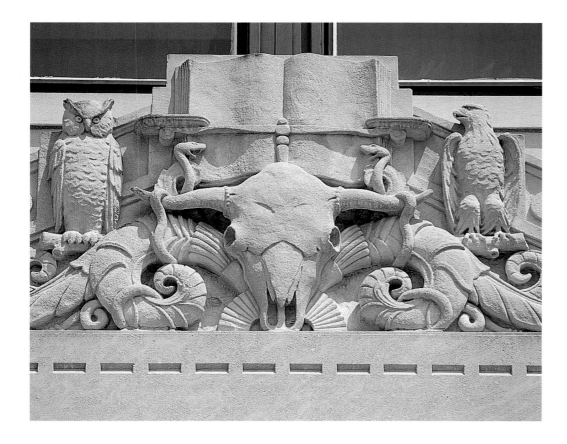

◄ ARCHITECTURAL DETAILS, PAWNEE
COUNTY COURTHOUSE, OKLAHOMA,
DEPICT SIGNIFICANT ANIMALS OF THE
REGION; THE CENTRAL ELEMENT IS A
BISON SKULL.

Full, they stand or lie down, chewing their cud—regurgitating small amounts of their meal to chew it more carefully and swallow it again.

But while cattle may starve to death if snow covers their forage, bison sweep their heads back and use their hooves to dig through as much as five feet of snow. In blizzards, a herd faces the snowy wind by forming a V-shape, big bulls in front of the group. When those in the rear begin to drift under, the whole herd moves ahead and takes a new stand.

These adaptable beasts have been moved from Dakota's zero temperatures to the subtropical climate of the Hawaiian island of Kauai with no ill effects. Bison are also raised in Florida, Texas, and other southern states. Dry temperate regions probably helped them develop great recuperative powers. Hunters have butchered animals with scars from bullet or arrow wounds, and found legs and ribs that had knitted after a break.

In the early centuries, bison probably encountered few diseases, though a plague apparently killed cloven-hoofed animals between Nebraska's Blue and Platte Rivers between 1820 and 1830. Other natural disasters thinned their numbers. Alexander Henry once wrote of seeing dead, dying, blind, and singed bison after a prairie fire in northern Dakota burned over a huge tract of country. Since bison habitually follow their leaders, they sometimes drowned after walking onto river

THIS BRONZE BISON SCULPTURE BY
EDGAR BRITTON WAS PRESENTED TO THE
UNIVERSITY OF COLORADO, BOULDER, BY
THE CLASS OF 1942.

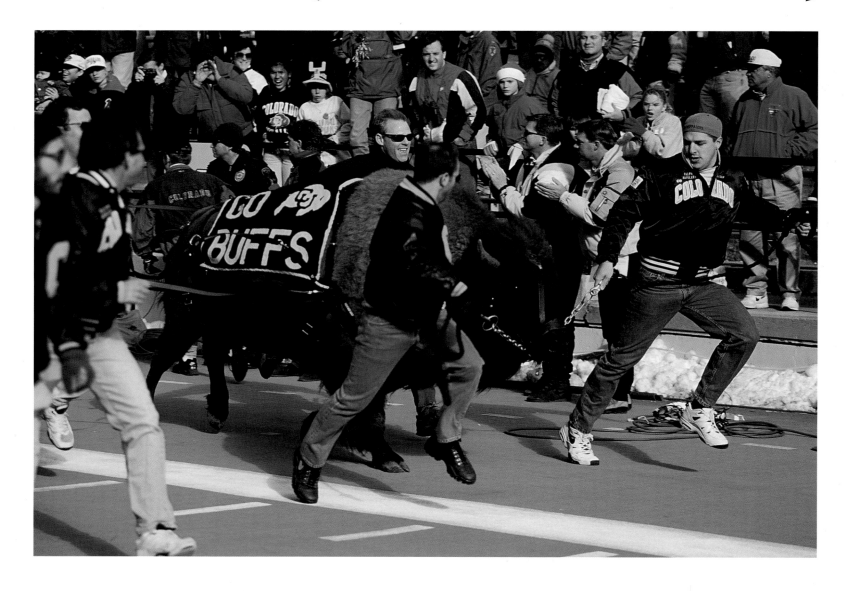

▲ "RALPHIE," THE MASCOT OF THE BOULDER BUFFALO FOOTBALL TEAM, LEADS THE TEAM'S CHARGE ONTO THE FIELD.

ice. Early accounts tell of brown floods in spring: thousands of carcasses floating down western rivers. Grizzly bears gathered at the Great Falls of the Missouri to feed on carcasses. Riverbank tribes often harvested such animals even after they began to rot. Maximilian of Wied, on his Missouri River trip of 1833, heard reports of rivers dammed by bison bodies.

Despite an environment full of challenges and accidents that can be fatal, bison have survived on the Plains for perhaps twenty-five million years, outliving every serious opponent but man. Having outlasted even the hide hunters, bison may now face the greatest challenge of all, the danger of being loved to death.

These days, a consumer can buy bison meat, usually at three times the price of beef, from New Mexico to Idaho, on both seacoasts, and in other countries. Many people who fantasize about "the good country life" picture themselves raising bison, and many are trying. A bison raised inside a fence, vaccinated for disease, and sometimes dehorned is in danger of becoming what one wildlife biologist (who keeps five

▲ RESTING COMFORTABLY WHERE HIS KIND USED TO ROAM, THIS BISON SCULPTURE, "MONARCH OF THE PLAINS," CREATED BY STEVEN C. LEBLANC, IS NEAR FOLSOM STADIUM, UNIVERSITY OF COLORADO, BOULDER.

bison on his ranchette and photographed one in his living room) calls "just another cow with a hump."

Herd of Buffalo Crossing the Missouri on Ice

*If dragonflies can mate atop the surface tension
of water, surely these tons of bison can mince
across the river, their fur peeling in strips like old*

*wallpaper, their huge eyes adjusting to how far
they can see when there's no big or little bluestem,
no Indian grass nor prairie cord grass to plod through.*

*Maybe because it's bright in the blown snow
and swirling grit, their fast heads are lowered
to the gray ice: nothing to eat, little to smell.*

*They have their own currents. You could watch a herd
of running pronghorn swerve like a river rounding
a meander and see better what I mean. But*

*bison are a deeper, deliberate water, and there will
never be enough water for any West but the one
into which we watch these bison carefully disappear.*

—William Matthews

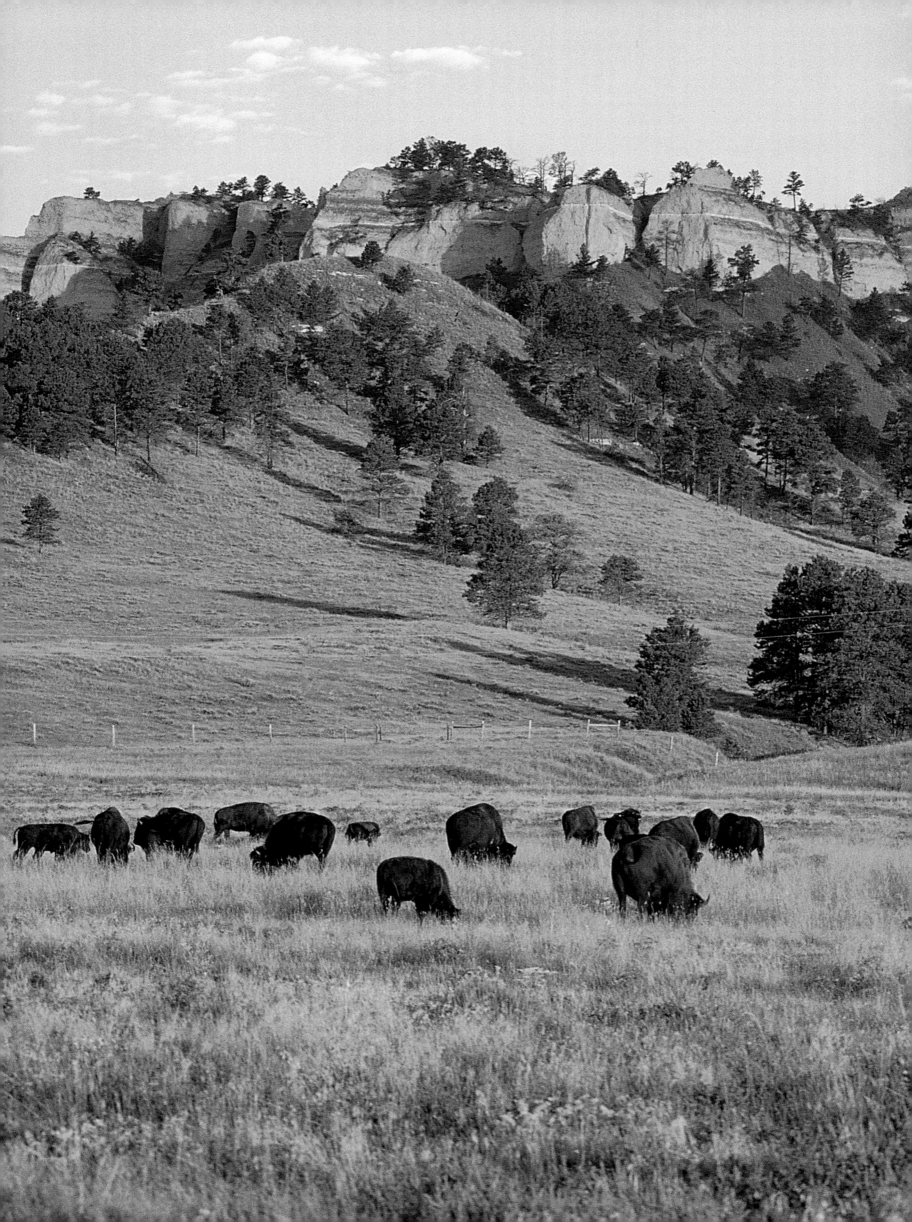

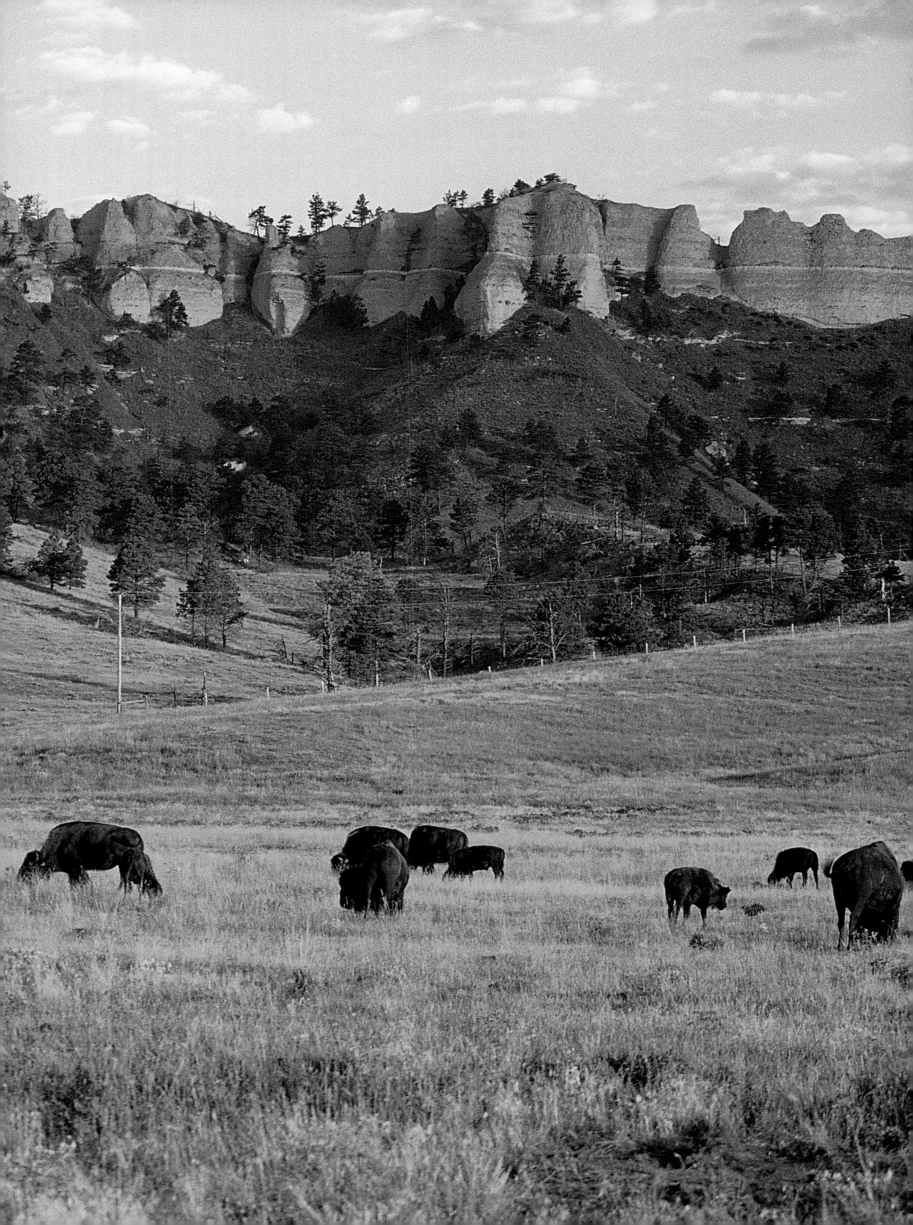

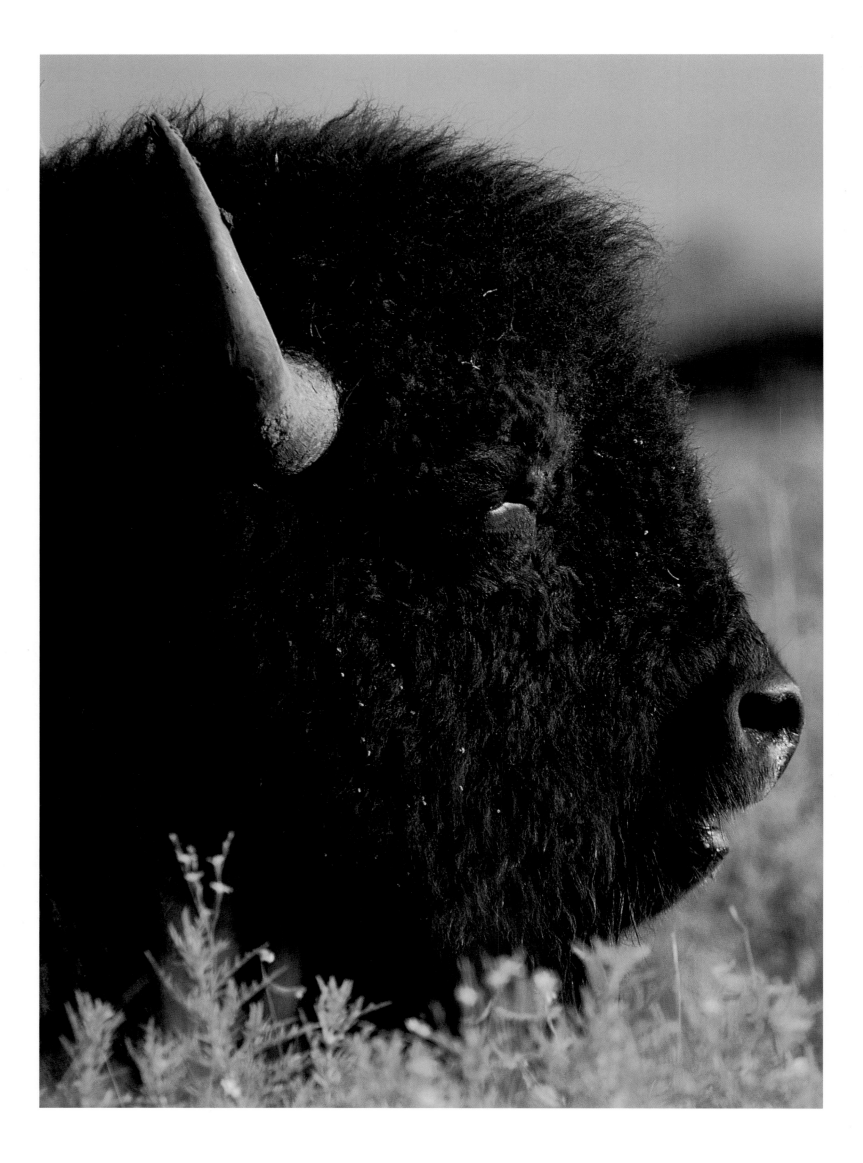

Ranching
with Bison

He! They have come back racing,
He! They have come back racing,
Why, they say there is to be a buffalo hunt over here,
Why, they say there is to be a buffalo hunt over here,
Make arrows! Make arrows!

Give me my knife,
Give me my knife,
I shall hang up the meat to dry—Ye' ye!
I shall hang up the meat to dry—Ye' ye!
Says grandmother—Yo' yo!
Says grandmother—Yo' yo!

—Song of the Buffalo Hunt, Lakota

R oy Houck, known as South Dakota's "Buffalo Man," is a descendant of pioneers. He operated the family's Triple U ranch along the Missouri River until 1959, when riverside residents were ousted by construction of the Oahe Dam. He moved his purebred cattle to the Plains northwest of Fort Pierre, South Dakota.

When a blizzard packing winds up to ninety miles an hour struck in 1966, Houck's herd suffered—but while he worked to haul dead cattle

◄◄ Bison graze below sandstone
bluffs in 22,000-acre Fort Robinson
State Park, Nebraska.
◄ Huge bison bull.
◄▲ Agitated bison.
▲ Buffalo jerky.

103

▶ STOUT WOODEN FENCES, INTENDED TO BE BISON-PROOF, AT A SOUTH DAKOTA PARK.

▶ ▶ SLEEPY BUT ALERT BUFFALO.

▶ ▶ ▶ 1,000-BISON HERD, BLACK HILLS, SOUTH DAKOTA.

away and feed the living, he noticed that bison on the neighboring Scotty Philip ranch were playing in the snow.

"Nature bred buffalo for this country," said Houck, "and I don't see how we can improve on that." Two weeks later, he began getting rid of his cattle and buying bison. In the thirty years since, the practicality of raising bison on Plains grassland while sustaining the environment has attracted more than two thousand producers located in all fifty states. Some say a bison costs half as much to raise but sells for twice as much as a cow. A 1997 Dakotas blizzard that killed 100,000 cattle while bison roamed over buried fences amplified the message.

Part of the attractiveness of bison to environmentalists who want to rid public range of cattle is their ancient habit of roaming, so that a wild bison in a big enough space does not return to a particular area until the grass has revived. But, like cattle, bison tend to move in a group and follow the same paths. Only massive ranges allowed bison the freedom to move without cutting deep trails—and in a territory as large, cattle might behave the same way.

Bison are territorial and domineering toward other livestock, but they ignore cattle, so it's safe to pasture the two species together. Moving a herd of bison is another matter. One rancher says nothing but a brick wall will stop a single running bison and wouldn't stop a herd. Crowded, bison get nervous. The smaller the enclosure, the more likely they are to charge a human or a vehicle, and they use their horns to hook horses. Modern ranchers like cattle guards because they don't have to open gates. The usual guard is a rectangular hole in the road

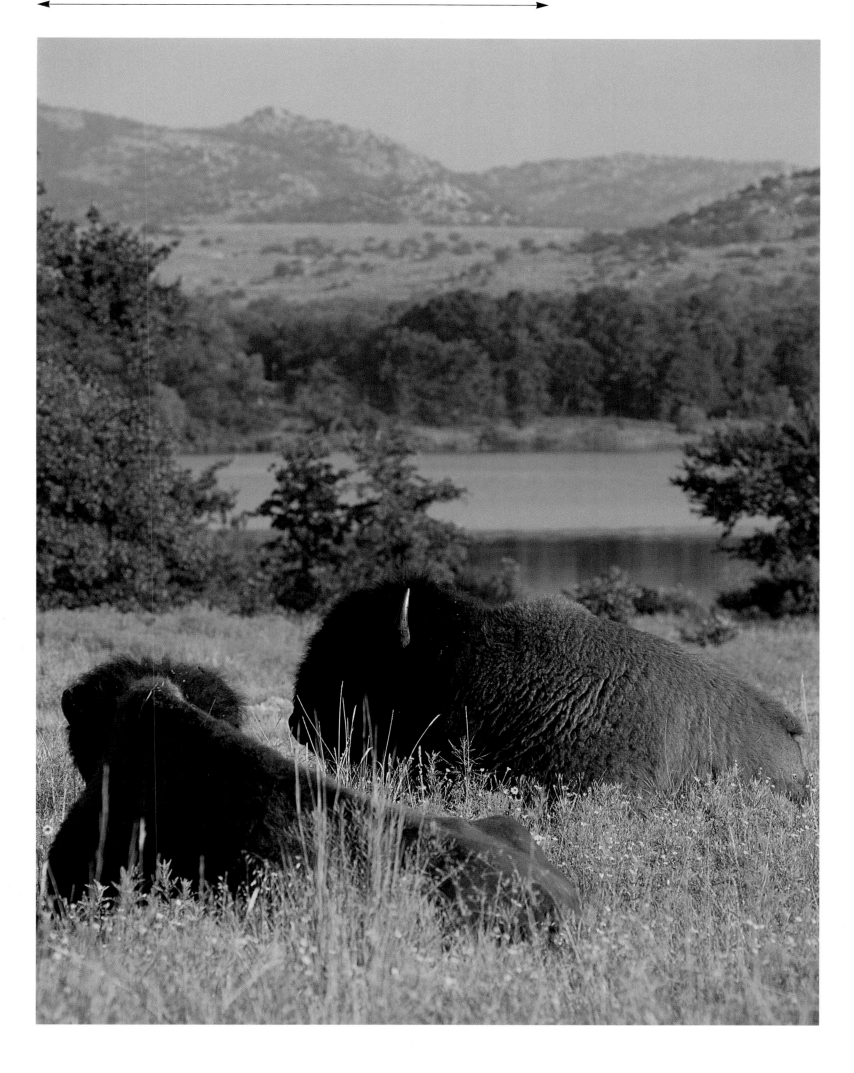

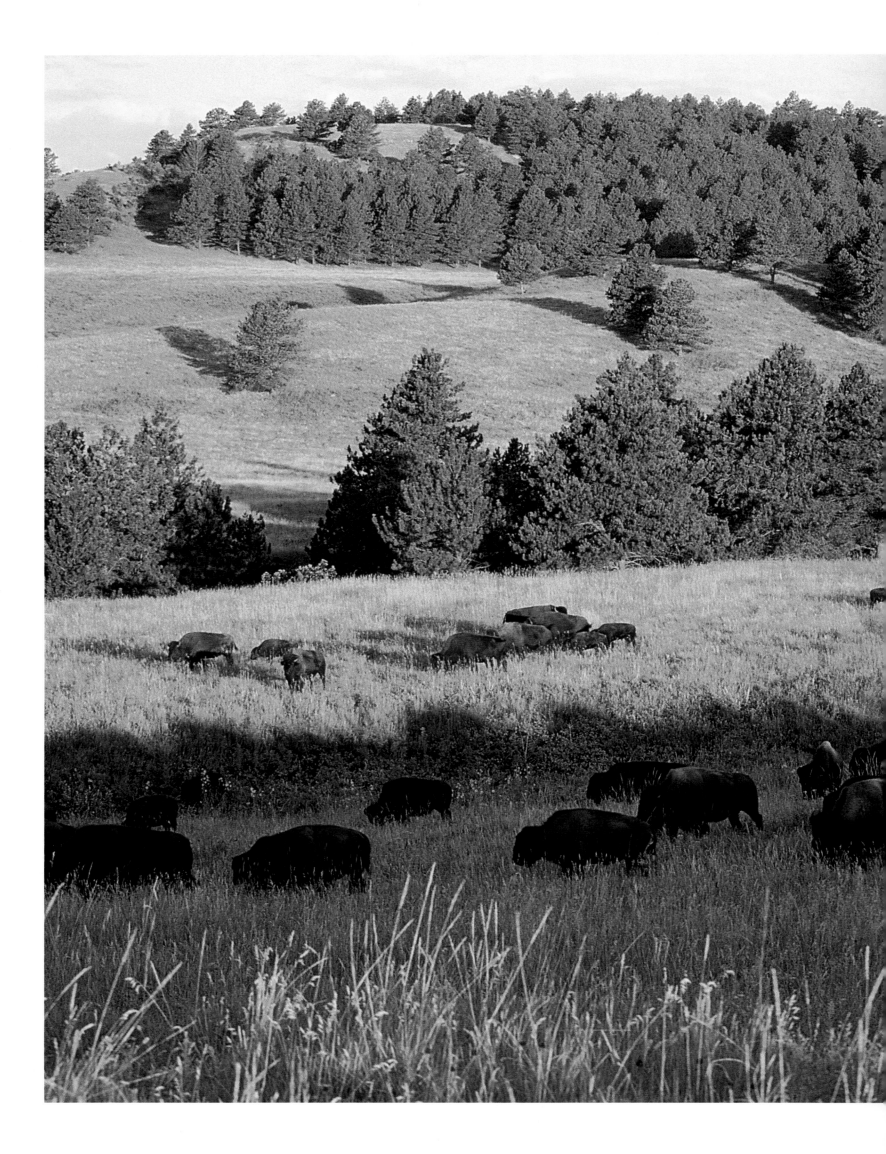

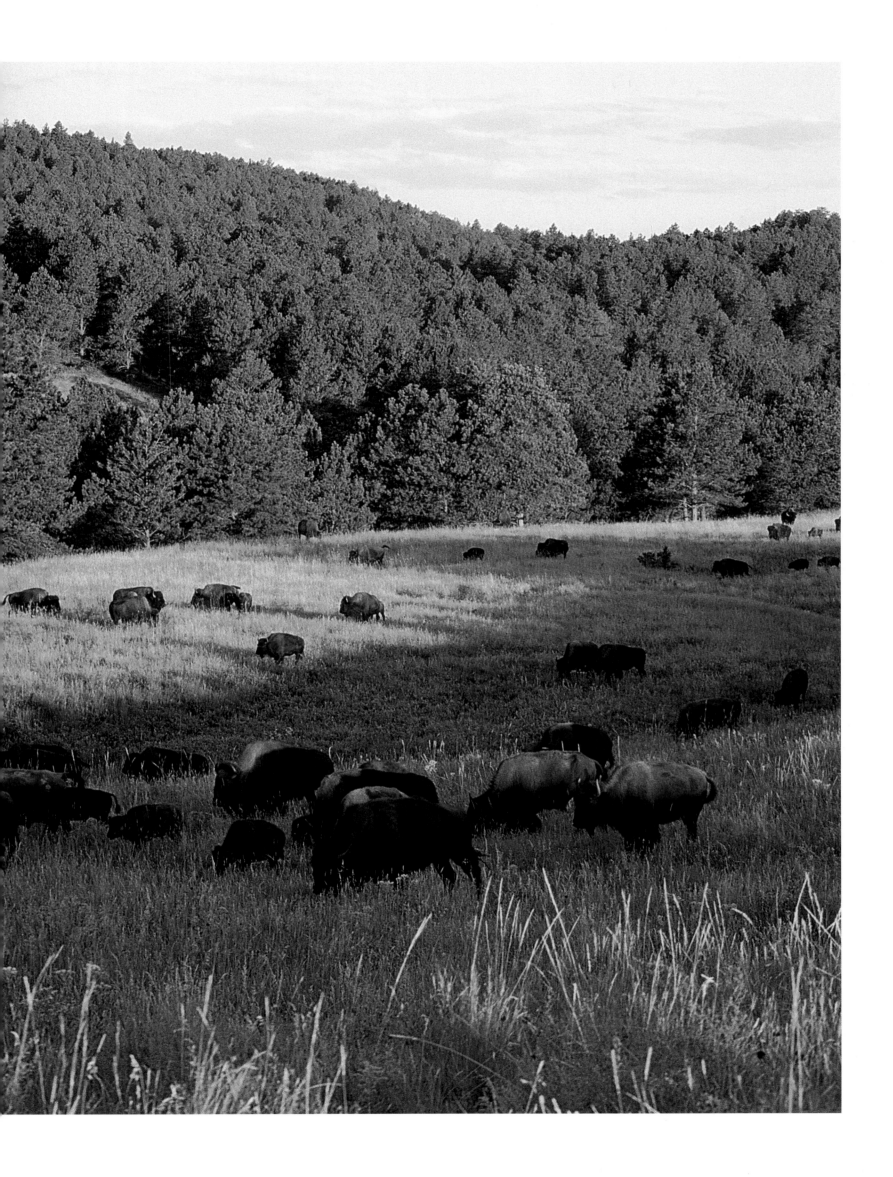

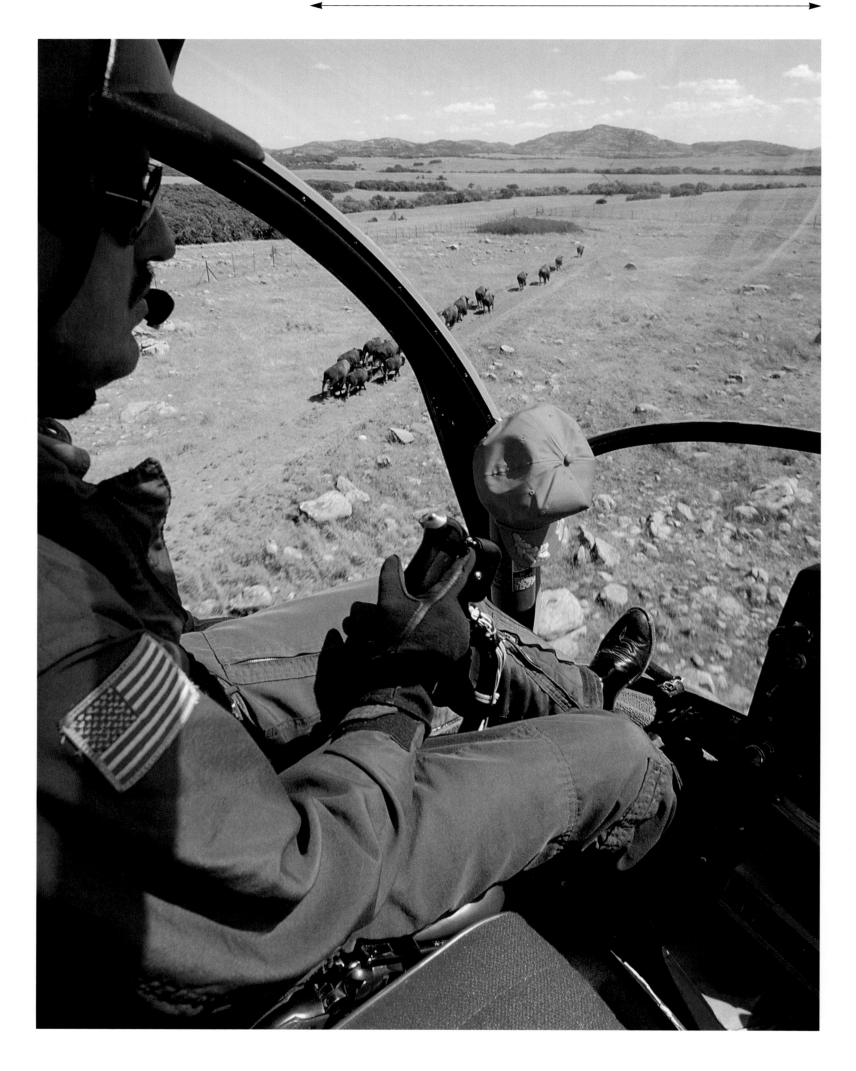

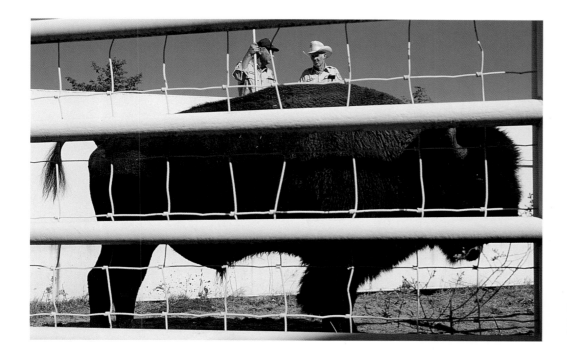

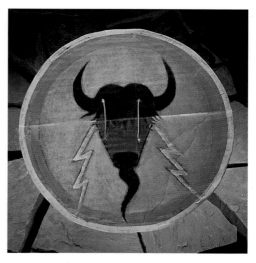

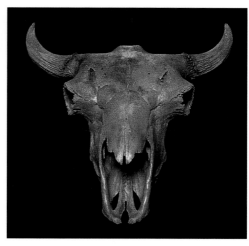

bridged by pipes laid across the hole so a pickup can cross, but a horse or a cow will refuse. Bison hop right over a normal guard, though one group was deterred when the rancher put a dead skunk in the hole.

Moving the animals outside the ranch is another problem. Unless the truck has a roof, the animals try to jump out, and if they settle down, they don't want to leave the security of the dark trailer. When his bison were ready for market, Houck first tried trucking them several hundred miles to the nearest packing plant. But the wild animals were dangerous to load and, once agitated, often injured themselves or died on the trip. Meat inspectors rejected so much bruised meat that Houck started his own slaughterhouse in 1974. The family trained neighbors to help until the operation could butcher thirty-five bison in an eight-hour day.

Today, as in the past, a typical bison operation can provide not only meat but a variety of by-products. As the public's interest in western themes has increased, creators of bison products have devised uses for various parts of the animal as well as imitating historical Native American uses. Hides can be sold green or salted for shipment and turned into wall hangings, rugs, or furniture throws. Small pieces can become pillow covers, seat cushions, and garments. Skinned heads are dried and aged for sale, and can be mounted. Shoulder mounts, including the bison's hump, are popular to hang in hunting and ski lodges. Skulls, with or without horns, may be bleached, or used as a canvas for painters, or hung. Horns are made into jewelry, gun and hat racks, furniture legs, and powder horns for black-powder weapons enthusiasts

◄◄ ARLYN E. MILLER ROUNDS UP BUFFALO BY HELICOPTER, A SAFER METHOD FOR MOVING THE CANTANKEROUS BEASTS THAN HORSES AND RIDERS, IN THE WICHITA MOUNTAINS NATIONAL WILDLIFE REFUGE AT LAWTON, OKLAHOMA.

◄▲ STOUT FENCING FOR BISON, ANNUAL AUCTION, LAWTON, OKLAHOMA.

▲ BUFFALO SHIELD, PAINTED BY STEPHEN MOPOPE, 1930S.

▲▲ BISON SKULL, 350 TO 500 YEARS OLD, FOUND IN MCINTOSH COUNTY, OKLAHOMA.

"MIRACLE," THE WHITE BUFFALO

◀◀◀ ▶▶▶

◀—▶

▶ A 1,100-POUND BUFFALO COW
STANDS PROTECTIVELY NEAR MIRACLE,
A ONE-IN-SIX-BILLION WHITE CALF BORN
IN A PRIVATE HERD OF FOURTEEN
ANIMALS NEAR JANESVILLE, WISCONSIN.

Miracle

When a white buffalo was born in a private herd in Wisconsin in 1994, representatives of many Great Plains Indian tribes visited with prayer and thanksgiving. The baby was named Miracle, since for various tribes with similar stories of its meaning, it is a symbol of hope, rebirth, and unity.

Susan Shown Harjo, president of Morning Star Institute, a group head-quartered in Washington, D.C., that works to preserve Native cultures, said she cried when she heard the news. Beatrice Looking Horse, a Lakota who drove eight hundred miles from her South Dakota reservation to see Miracle, says, "It is a sign of mending our sacred hoop. There will be unity among our people." Offerings and visible prayers in the form of sweet grass bundles tied with eagle feathers, alabaster carvings, and rings of sage have been left on the gate to the pasture.

The likelihood of a white buffalo being born is in the vicinity of one in six billion. Lakota people brought up as Christians compare the event to the second coming of Christ. The only other documented white buffalo, Big Medicine, lived thirty-six years and died in 1959.

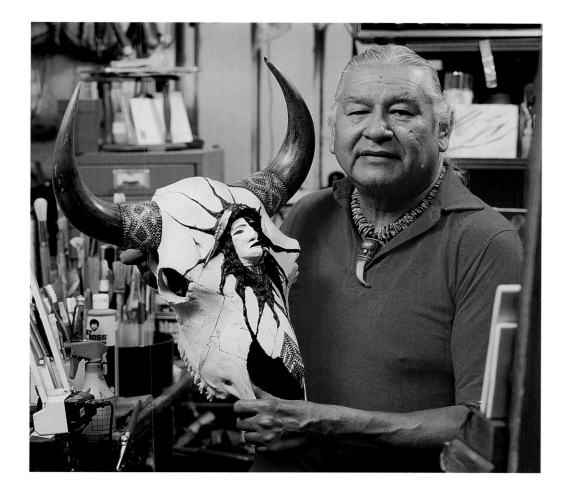

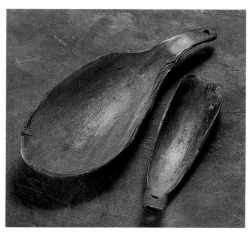

◄ JEROME BUSHYHEAD, SOUTHERN
CHEYENNE ARTIST, HOLDS A PAINTED AND
SCULPTED BUFFALO SKULL THAT SYMBOLIZES
THE TRIBE'S DEPENDENCE ON THE ANIMAL.
▲ KIOWA CARVED BUFFALO HORN LADLES.

who recreate life in the 1830s. Hooves and bones might be decorated with scrimshaw or made into jewelry, including bolo tie slides, hat pins, necklaces, pendants, earrings, belt buckles, and buttons. Hooves are made into ashtrays, and leather into boots and clothing. Some folks gather bison wool to clean, wash, and card into yarn for weaving.

Houck shakes his head in surprise as tourists gather bison chips and shellac them for desk decorations. Some search for the perfect disk and practice for the region's annual "buffalo chip flip." Even gall bladders are sold—to Koreans who believe them to be aphrodisiacs. Experienced bison ranchers say that a little effort paid to marketing by-products can be the "gravy" in a bison operation.

In 1975, Houck organized fourteen other producers into the National Buffalo Association so they could combine efforts to promote the production, marketing, and preservation of bison. In 1980, members established the North American Bison Registry (NABR) to regulate bison ranching by ensuring the purity of the breed, encouraging genetic propagation of exceptional stock for breeding programs, and verifying parentage of bison so that superior bloodlines can be identified and recognized, thus lending credibility to selective breeding programs. Approximately 260 bison from private herds and 2,450 from public

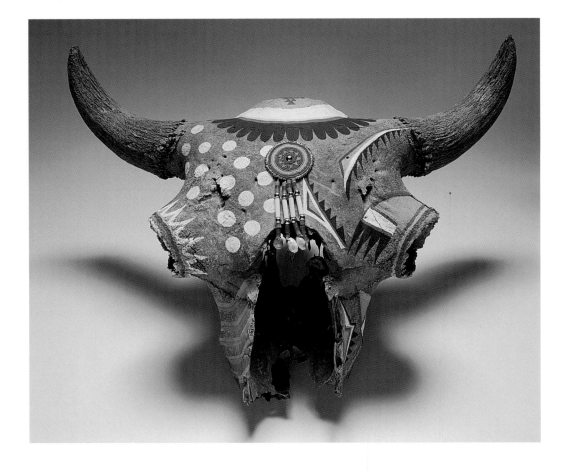

▶ THIS 500-YEAR-OLD BISON SKULL, ERODED BY GRAVEL IN THE CIMARRON RIVER WHERE IT WAS FOUND, HAS BEEN DECORATED BY CONTEMPORARY COMANCHE ARTIST DOC TATE NEVAQUAYA. THE ARTIST WAS RECENTLY HONORED AS AN OKLAHOMA STATE TREASURE.

herds have been certified or registered since 1981. In 1987 the group became the American Bison Association, and membership reached 1,250 members in the United States and other countries by the end of 1992.

Generally, bison are marketed by the producers without any middleman, so the rancher must also be a salesperson. Some bison producers sell meat directly to consumers at the ranch or via mail order, while others sell to feedlot operators, wholesale to meat markets and restaurants, or to meat distributors for resale. All are confident that sales opportunities can only grow.

Bison meat, they say, carries as much as 35 percent more protein per ounce than beef because it has less fat and is lower in cholesterol. Bison meat in a grocery store is usually 10 to 30 percent more expensive than comparable beef cuts. But, say proponents, bison is 97 percent fat-free, making a $4.50 pound of bison burger equal to a $2.25 pound of beef burger. It's important to note, however, that bison ranchers are comparing range-fed bison to beef sold after being fed corn in a feedlot. Just as the public has not learned to accept bison meat, most folks don't know that range-fed beef contains less fat and raising beef on grass could eliminate feedlot pollution. Bison meat is darker than beef, possibly because it contains more iron, but otherwise may be indistinguishable in flavor.

Breeders consider bison potentially more profitable than beef and believe that once the public understands the benefits of bison, the demand will become more stable. Unlike feedlot-raised cattle, bison are not normally injected with hormones, artificial growth stimulants, or subtherapeutic drugs. Further, the American Bison Association passed a resolution in January 1988 opposing the use of these chemicals in bison. No drugs have been licensed for use in bison intended for human food.

As bison-raising becomes popular, prices paid for breeding stock have shot up dramatically. These figures may reflect the current interest in "hobby ranching," as ranches are bought by people who do not have to make a living from them. The average price per head rose from $379 in 1983 to $851 in 1987 to more than $1,500 in 1993.

One rancher who raises both bison and cattle regularly gets $4,000 to $5,000 for a young pregnant bison compared to $850 for a young pregnant cow. At the 1998 Denver Stock Show, a two-year-old bison bull sold for $101,000. But such figures present a distorted view of the profits available to smaller operations with less available cash. The irregularity may lead the inexperienced into risky ranching schemes that pose additional dangers to grasslands. In a normal market, no one would "get his money's worth" for an animal so expensive.

Bison ranchers estimate that the total annual economic impact of their industry has reached $500 million. With bison ranchers broadcasting the benefits of their industry, new would-be Ted Turners are buying plots of land and keeping fifty to a hundred bison on an acreage that may prove to be too small. Some biologists say confinement will change the bison's habits. Others suggest that the habits of wild bison and wild cattle might once have resembled each other more than we know. If we domesticate bison, we may simply repeat the processes of training cattle in behavior that damages the ecosystem. In both cases, the important factor may be size of territory, but the trend in rural areas is toward smaller and smaller holdings as big ranchers are driven out.

Listen, he said, yonder the buffalo are coming.
These are his sayings, yonder the buffalo are coming,
They walk, they stand, they are coming,
Yonder the buffalo are coming.

— Bison song, Lakota

▲ ▲ Buffalo rib eye steak and ▲ buffalo stew are both served in an El Reno, Oklahoma, restaurant. The establishment's owner raises buffalo, an experience he describes as "hell."

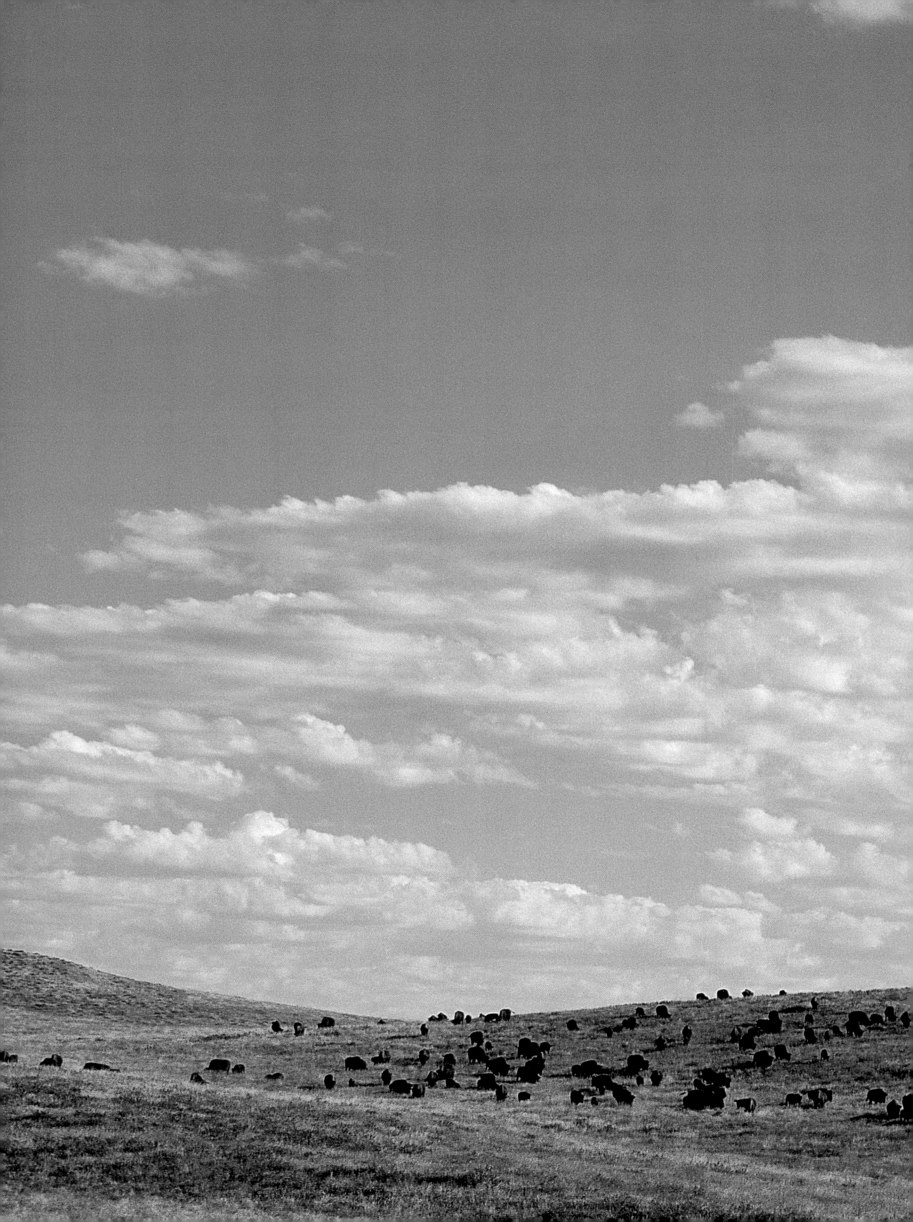

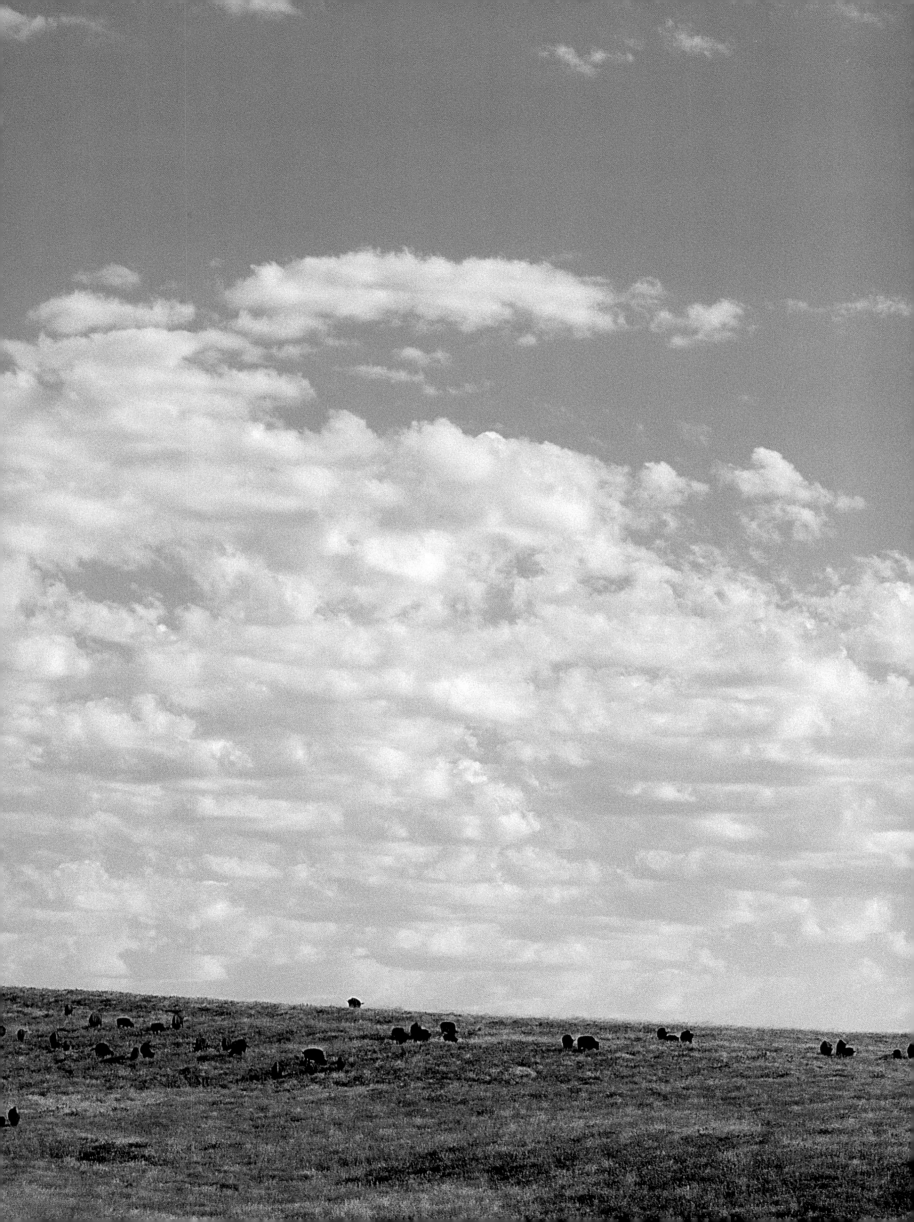

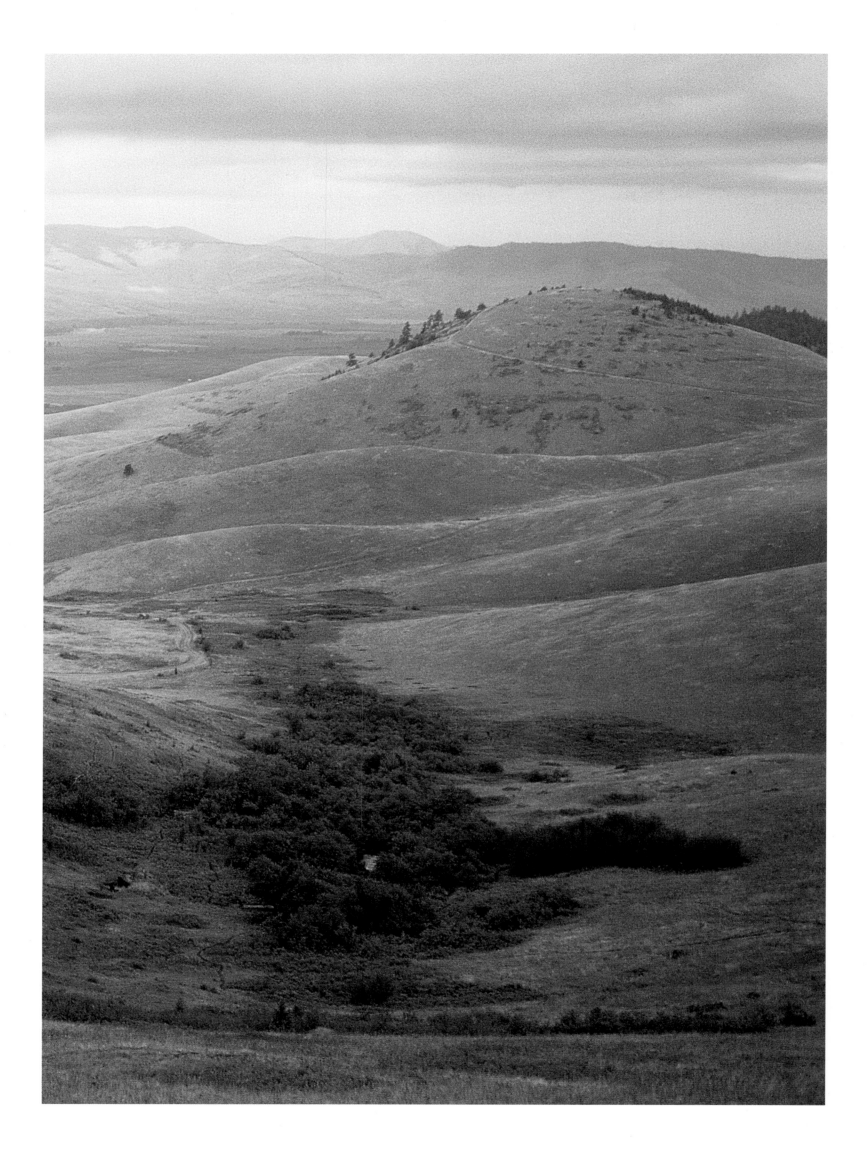

AS THE
GRASSLANDS REVIVE

*Saying the bison are back is only another way of
saying the prairie is back. Although not as intensely
photographed or advertised, the jointed goatgrass,
rattlesnake fern, spleenwort, and lady's tresses also
have returned. All of the grassland West is a candidate
for restoration ecology, a candidate for resurrection,
and that resurrection must include bison. The prairie
between the Rockies and the Mississippi River was held
by three pillars: bison, fire, and grass, and the place
cannot live again until all three return.*

—Richard Manning, *Grassland,* 1995

The earliest whites who saw the grasslands of North America
described a "sea of grass," surging in waves of green beyond the
horizon. The nomadic civilization already in place left little trace on
the land, no written record, only terse drawings on bison hide. So the
new culture has been slow to recognize the complexity of Indian life
and the interdependence of grass, bison, and humans on the Plains.
Without the bison, Plains Indian culture was diminished and the grass-
lands were ravaged.

◀◀ FEELING SAFE, BISON SCATTER AND
GRAZE OVER A WIDE AREA.

◀ NATIONAL BISON RANGE, OUTSIDE
MOIESE, MONTANA.

◀▲ A BULL BISON'S SKULL MAY BE
PROTECTED BY HIDE TWO INCHES THICK.

Homesteaders wanted land cut into uniformly square green fields like those of Europe and the eastern United States, rich with black earth. Disappointed by scarce moisture and low crop yields, whites called the place the Great American Desert. The plow proved them right in the 1930s when the Plains yielded mostly dust and debt.

We now know that plowing the Great Plains was a serious error. This arid landscape represents a complex evolutionary process and preserving it demands that we pay attention to its history rather than attempt to force it to be perfect farmland like its European model. An endangered species may not thrive if isolated from either its natural nourishment or its normal predators. Bison and grasslands developed in concert. Unless we are sure we can provide a better arrangement, we should stick with what nature has devised. In fact, if we allow cattle to exercise their wild instincts, they might evolve into more efficient users of grass while remaining easier to control than bison.

Writing about grasslands, Richard Manning has observed, "A century's worth of work, warfare and technology replaced 50 million bison with 45.5 million cattle. One wonders what progress is for."

Now that bison appear to be out of danger of extinction, debate about their future rages on the Plains. In 1989, Frank J. Popper and Deborah Epstein Popper, who teach, respectively, in the urban studies and geography departments at Rutgers University, landed in the middle of the controversy with their suggestion for a "Buffalo Commons."

After years of research, they noted that the semiarid short-grass prairie, windswept and nearly treeless, was "historically untenable" and "increasingly empty." They declared that ten central states, "America's steppes," now face ecological devastation "as a result of the largest, longest-running agricultural and environmental miscalculation in the nation's history," predicting that much of the area would soon be almost completely depopulated. After a brief and scathing history of ill-advised agricultural practices, they used maps covering nearly every county to document how Plains residents are moving to the metropolitan fringes of the region. Rather than allow the area to become a wasteland, the Poppers suggested that the federal government plan to convert large stretches of the region to native grass and native livestock: bison.

Government officials in the Plains states became hysterical with anger, trotting out old lines like "It's my land and I can do what I want with it." When the Poppers spoke in the region, several counties usually contributed law enforcement officials to ensure their safety.

A similar proposal, the "Big Open," was advanced for grasslands in eastern Montana. Though many residents scoffed at the idea, nearly 50 percent of the territory's ranchers are enrolled in the state's "Block Management Program," which has similar provisions. Canadians in Saskatchewan are examining like options. However, it is absurd to deny our culture's attempt to turn grasslands into farmland has failed. Moreover, while organizations and individuals battle over the reintroduction of predators in several western areas, it is also a fact that grizzlies, wolves, bison, and elk are all, as Manning says, "creatures of grass." A sound grasslands ecosystem demands them all. Restoring the grasslands, then, would require that humans learn to live within its boundaries.

The Inter-Tribal Basin Cooperative, founded in 1990 by a group of Indian leaders on the Plains, works to teach reservation residents how to manage bison herds. They are determined to bring the bison back to Indians all over the West, providing opportunities for the renewal of Native culture. Dozens of tribes around the country now raise a total of 10,000 bison. Some tribal leaders say white ranchers are only in bison-raising for the money, while the Indians want to preserve the animal's wild nature and the traditional tribal relationship with the herds. Others say today's animals are only distant cousins of their wild forebears anyway, so the profit motive doesn't matter.

No matter who raises bison, few owners can provide the large territory necessary to realize the full potential of the animals. Others may have to enter into cooperative plans if bison are to occupy again their rightful place in the Plains ecosystem.

Oh, yes, I went to the white man's schools. I learned to read from school books, newspapers, and the Bible. But in time I found that these were not enough. Civilized people depend too much on man-made printed pages. I turn to the Great Spirit's book which is the whole of his creation. You can read a big part of that book if you study nature. You know, if you take all your books, lay them out under the sun, and let the snow and rain and insects work on them for a while, there will be nothing left. But the Great Spirit has provided you and me with an opportunity for study in nature's university, the forests, the rivers, the mountains, and the animals which include us.

—Walking Buffalo,
Tatanga Mani, Stoney

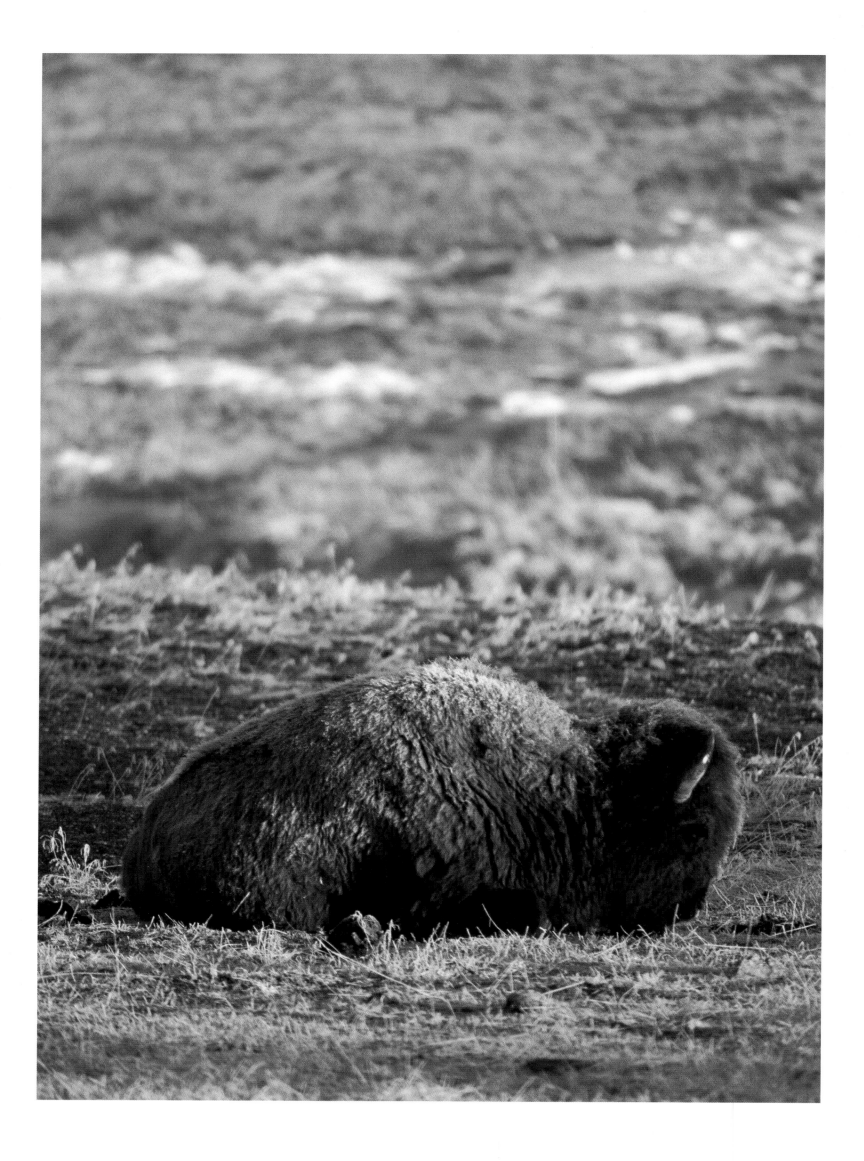

Facts and ideas from dozens of written and oral sources have insinuated themselves into these reflections on bison, as have personal experiences. Following are some essential citations, documentation, and places to look for additional information on the topics surveyed in each chapter.

PROLOGUE: THE GHOST DANCE (p. 17)

The Lakota Ghost Dance Song (p. 15) and the quotations from Ben Black Elk were reprinted in *I have spoken: American History through the Voices of the Indians*, compiled by Virginia Irving Armstrong, Swallow Books, Chicago, 1971, pp. 129 and 158-9, respectively. The Ghost Dance Song was recorded by James Mooney in "The Ghost Dance Religion and the Sioux Outbreak of 1890," U.S. Bureau of American Ethnology, *14th Annual Report*, 1892-93, pp. 2 and 178.

The quote from Eagle Voice (p. 17) is from *When the Tree Flowered: The Fictional Autobiography of Eagle Voice, A Sioux Indian*, by John G. Neihardt, University of Nebraska Press, Lincoln, 1951.

Ben Black Elk's comments (p. 20) originally appeared in "How It Feels to be an Indian in the White Man's World," *Red Cloud Quarterly*, vol. 5 no. 2, April-June 1968, pp. 1-3.

CHAPTER 1: MONARCH OF THE PLAINS (p. 25)

The quote from Okute (p. 25), Wabanakis Nation, which originally lived on the Kennebec River, is from pp. 18-19, *Touch the Earth: A Self-Portrait of Indian Existence*, compiled by T. C. McLuhan, Outerbridge & Lazard, New York, 1971; Pocket Books, 1972.

The bison song from a Sun Dance ritual (p. 36) is from *When the Tree Flowered*, p. 124.

CHAPTER 2: IN THE TIME OF THE BUFFALO NATION (p. 41)

The most comprehensive and poetic discussion I've found concerning how the bison became central to the rituals as well as to the culture of Plains tribes was written by Larry Barsness in *Heads, Hides & Horns: The Compleat Buffalo Book*, published by Texas Christian University Press, Fort Worth, 1985. As a bonus, the book is beautifully illustrated with photos and paintings. The author demonstrates that when Plains tribes lost the bison, much of their historical wisdom about survival on the prairies became meaningless. Furthermore, since their culture was created in fraternity with bison, the nomads lost the basis of their convictions. Not only was the slaughter of the buffalo an environmental tragedy, it resulted in the destruction of a complex and beautiful civilization before historians and scholars knew it

existed. While bison are returning to the Plains, it remains to be seen whether tribal leaders can recreate enough of the old kinship to construct a new society relevant to modern Indians.

The classic and well-documented guide to American Indian history during the 19th Century is still Dee Brown's *Bury My Heart at Wounded Knee: An Indian History of the American West*, published by Holt, Rinehart & Winston, New York, 1970. The text is supplemented by photographs, quotes, notes, and bibliographical material.

The quotation by Walking Buffalo (p. 41), is reprinted in *Touch the Earth*, p. 23. Many of the quotations in the following essays come from this source, which includes some moving photographs of Indian leaders and background on the occasion of the speeches.

Ouray, an Uncompahgre Ute chief in Colorado, made his comment about skinning a buffalo (p. 43) at a meeting with the McCook Commission in 1872 after a white commission member said the Utes were just lazy. The comment was originally taken from Marshall Sprague's *Massacre*, published by Little, Brown, Boston, 1957, pp. 96-97, and reprinted in *I have spoken: American History Through the Voices of the Indians*, p. 96.

The chant while setting up a buffalo altar (p. 49) is from *The Sun Dance People: The Plains Indians, Their Past and Present*, by Richard Erdoes, Random House/Vintage Sundial, New York, 1972, p. 1.

The quote from Mato-Kuwapi, Chased by Bears (p. 49), is from *Touch the Earth*, p.39.

One of the earliest efforts to document Lakota beliefs, Melvin R. Gilmore's *Prairie Smoke*, was first published by Columbia University Press in 1929, then reissued by Minnesota Historical Society Press in 1987. This scholarly study remains one of the best guides to what Gilmore calls "legends and myths"—actually oral history and moral tales, most gathered while he lived among Plains tribes. Topics of particular interest are stories showing beliefs about the earth as well as animals and plants, the tipi, trading between tribes, and ideas about property and agriculture. A bibliography of Gilmore's other works is appended.

While it remains useful, George E. Hyde's *Red Cloud's Folk: A History of the Oglala Sioux Indians*, published by University of Oklahoma Press, 1937, and reissued in 1975, is not entirely reliable. Hyde was typical of early scholars in refusing to consult tribal oral tradition. He failed to realize that Plains culture demanded truth above all in stories regarded as tribal history. Hyde also ignored the record provided by George Catlin, and dismissed his paintings as romantic. Still, he provides a readable history of the Oglala band, including a

valid description of the way the U.S. government treated the Lakota.

Another authority, Thomas E. Mails, examines some of the intricacies of Plains culture in *Dog Soldiers, Bear Men and Buffalo Women: A Study of the Societies and Cults of the Plains Indians*, published by Prentice Hall, New York, 1973. His detailed study is enhanced with photographs and superb drawings of the system of cults governing the actions of many Plains nomads.

Bruce Nelson's *Land of the Dacotahs*, University of Minnesota Press, 1947, remains one of my favorite sources, though its author says the book "does not purport to be a history" of the Lakota people. Nelson offers detailed insights into Lakota life along with his strong and vividly stated opinions—often based on personal observation. He tosses in a little clearly identified fiction and his annotations are fascinating.

Royal B. Hassrick's study, *The Sioux: Life and Customs of a Warrior Society*, published by University of Oklahoma Press, 1964, concentrates on the years between 1830 and 1870, the era when the Lakota bands were at a peak of pride and accomplishment. Hassrick drew on accounts by tribal elders and white travelers, along with historical documents, to form a comprehensive picture of the complex culture, adding astute analysis based on deep respect for the tribe.

Throughout my long study of Lakota culture and religious practices, which included invitations to participate in some rituals, I have been guided by three extraordinary writers who were apparently able to put aside their own cultural prejudices to immerse themselves in the Lakota belief system. In writing these works, they provide the deep background essential to understanding how Lakota religious philosophies are thoroughly intertwined with everyday life. They probably come as close to understanding as any wasicu (white) is likely to. Joseph Epes Brown spent considerable time with Black Elk, the celebrated Lakota leader, and Pendle Hill published his pamphlet *The Spiritual Legacy of the American Indian* in 1964. Later, Brown modestly listed himself as "recorder and editor" of *The Sacred Pipe: Black Elk's Account of the Seven Rites of the Oglala Sioux*, Penguin Books, 1971. William K. Powers has published two important documents: *Oglala Religion* and *Yuwipi: Vision and Experience in Oglala Ritual*, University of Nebraska Press, Lincoln, in 1975 and 1982, respectively. James R. Walker's *Lakota Belief and Ritual* was edited by Raymond J. DeMallie and Elaine A. Jahner, University of Nebraska Press, 1980, with a 1991 reprint.

The Lakota Sun Dance prayer (p. 53) is from *The Sacred Pipe*, 1971, p. 90.

CHAPTER 3: THE LAND OF BONES (p. 57)

The quotation from Luther Standing Bear (p. 57) is from *Touch the Earth*, p. 45. Born 1868, Standing Bear was enrolled in

Carlisle Indian School in Pennsylvania. He later taught on the Rosebud Reservation in South Dakota and joined Buffalo Bill's Wild West Show as an interpreter. He spent his later years lecturing and writing.

Many sources report General Philip Sheridan's words (p. 62) as quoted here—"Kill the buffalo, kill the Indians." But so often nifty slogans that pass into public idiom are not what the historical figure really said. Sheridan's speech has been trimmed by time and memory. The occasion was an effort by the Texas legislature to pass a bill protecting buffalo from continued slaughter. The minute he heard of the effort, Sheridan left his regional military headquarters at San Antonio and dashed over to address a joint session of the House and Senate at Austin, Texas. Praising the buffalo hunters, Sheridan said, "These men have done in the last two years, and will do in the next year, more to settle the vexed Indian question than the entire regular army has done in the past thirty years. They are destroying the Indians' commissary; and it is a well-known fact that an army losing its base of supplies is placed at a great disadvantage. Send them powder and lead, if you will; but for the sake of a lasting peace, let them kill, skin, and sell until the buffaloes are exterminated. Then your prairies can be covered with speckled cattle and the festive cowboy, who follows the hunter as a second forerunner of an advanced civilization." Allegedly, he added that, "Instead of stopping the hunters, they ought to give them a hearty, unanimous vote of thanks, and appropriate a sufficient sum of money to strike and present to each one a medal of bronze, with a dead buffalo on one side and a discouraged Indian on the other."

A similar problem, the human tendency to aid memory by taking shortcuts, can be observed in the fact that the real name of the man whites know as "Chief Joseph"— Hinmahtooyahlatkekht, Thunder Traveling to Loftier Mountain Heights—is much longer and more descriptive, even in translation, than the nickname by which we have called him throughout our history. The quotation from Chief Joseph (p. 65) also appears in *Touch the Earth*, p. 54.

White Cloud, a Lakota who had followed Sitting Bull north, made his statement (p. 69) during a friendly chat. The comment was reported by Philippe Regis de Trobriand on pp. 187-88 of *Army Life in Dakota*, published by R. R. Donnelley & Sons, Chicago, 1941, and reprinted in *I have spoken*, p. 87.

Crowfoot's last words (p. 70) are from *Touch the Earth*, p. 12.

Little Crow's words (p. 71) appeared originally in "Taoyateduta is not a Coward," *Minnesota History*, Vol. XXXVIII, 1962, p. 115, and are reprinted in *I have spoken*, p. 80.

CHAPTER 4: RETURN FROM THE BRINK OF EXTINCTION (p. 75)

Ten Bears (p. 75) is quoted on p. 132 of *Indian Oratory: Famous Speeches by Noted Indian Chieftains*, compiled by W. C.

Vanderwerth and published by Ballantine, 1971.

Daniel Webster's quote (p. 81) is from *The Sun Dance People*, p. 1.

Chief Luther Standing Bear's words (p. 84) come from his autobiography, originally published in 1933, and are reprinted on page 107 of *Touch the Earth*.

The Song of the White Buffalo Maiden (p. 85) was sung by Charging Thunder and is taken from Francis Densmore's *Teton Sioux Music*, University of Nebraska Press, 1918, p. 68.

It is entertaining, if confusing, to compare comments from Western historians who attempted to determine how many bison may once have roamed the Plains and how few were left when salvage efforts began. The great unknown is just how small was the genetic pool of bison from which modern herds derive.

In researching my own *Roadside History of South Dakota*, I was struck, again, by the inconsistencies of white history. Though the town of Dupree was unquestionably named for Frederick Dupris or his ancestors, both spellings persist. And we still pronounce the state's capital city, named after Pierre Choteau, as "Peer," to the amusement of speakers of French.

Chapter 5: Today's Bison and the Cycle of Life (p. 89)

Satanta's comment (p. 89) appears in *Indian Oratory*, p. 147.

Tom McHugh's book, *The Time of the Buffalo*, published by University of Nebraska, 1972, is particularly interesting because the author supplemented his research with first-hand study, hiking and camping close to bison herds for weeks. Concentrating on the natural history of bison, he discusses the buffalo's behavior and the social life of the grasslands community. He tested historical conclusions with his own experiments, donning a buffalo hide as the Indians did to sneak up on the herd. He reports that while bison will more readily accept a man under a robe than one garbed normally, the decoy also provokes "bold" inspection, including the threat of being hooked or charged.

William Matthews' poem (p. 99), "Herd of Buffalo Crossing the Missouri on Ice," appears in his book *Forseeable Futures*, Houghton Mifflin, 1987.

Chapter 6: Ranching with Bison (p. 103)

The Lakota Song of the Buffalo Hunt (p. 103) is from James Mooney, reprinted in *Myths and Legends of the Great Plains*, edited by Katharine Berry Judson, A. C. McClurg, Chicago, 1913, p. 51.

The song on p. 113 is from *Bury My Heart at Wounded Knee*, p. 387, and is cited as from the Bureau of American Ethnology Collection.

Epilogue: As the Grasslands Revive (p. 117)

The quote from Richard Manning (p. 117) is taken from *Grassland: The History, Biology, Politics, and Promise of the American Prairie*, Penguin Books, 1995, the best overview of grasslands I have seen. He explains technical botanical and biological matters clearly, in simple language. He visited and quotes people of widely diverging opinions about the use of grassland. He resists adopting the shrill tones most advocates use out of sheer frustration with human ignorance. This statement, a clear summary of the grassland facts that those who live there must consider for our present and future actions, appears on p. 237. Manning comments that we must recreate a society that is part of the grasslands rather than trying to "obliterate it in favor of asphalt and corn."

Some useful information about modern bison ranching is found in the *Bison Breeder's Handbook*, published by the American Bison Association (P.O. Box 16660, Denver, CO 80216; (303) 292-BUFF (2833); fax (303) 292-2564). The book offers specific and detailed advice—spiced with promotional lingo—about bison ranching oriented toward beginning operators. Its pages are filled with ads about bison producers, equipment, and bison-related products.

The association's 1,300 members host an annual bison show and sale in Denver and publish *Bison World*. In addition, the group has produced a 19-minute color video, "The Return of the American Bison," and a bison meat chart with color photos showing popular cuts of meat and where they originate on the carcass along with hints on cooking.

The comment by Walking Buffalo, Tatanga Mani, appears on p. 106 of *Touch the Earth*.

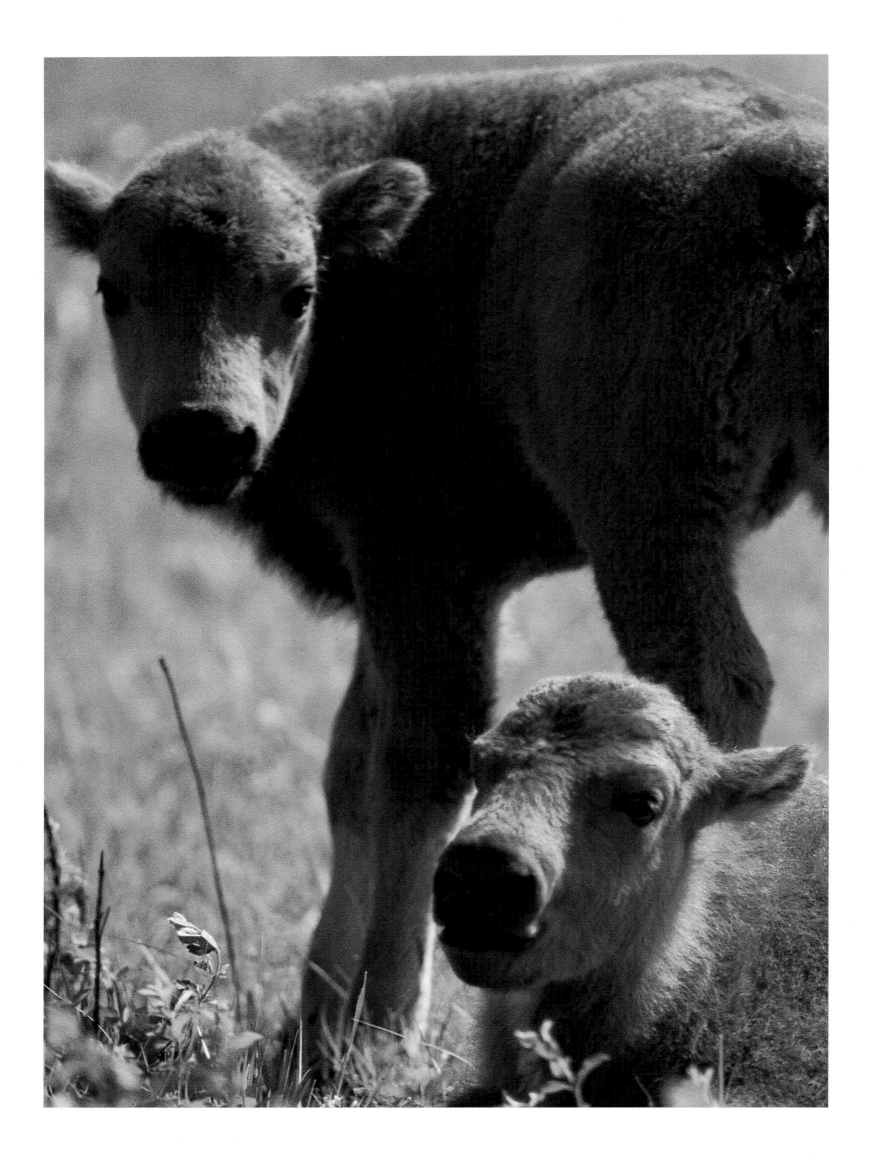

Atlas of the New West: Portrait of a Changing Region. William E. Reibsame, general editor. Boulder, University of Colorado: Center of the American West, 1997. This account is a succinct and pointed summary of bison recovery.

Gard, Wayne. *The Great Buffalo Hunt.* Lincoln: University of Nebraska Press, 1959. This narrative is one of the most authentic of the lives of the buffalo hunters, though its references to the joys of slaughter may jar modern readers: the buffalo hunters are "mighty men," all "heroic figures" and "rugged pioneers who tamed the west," clearing the plains of the pesky bison to deprive the "hostiles" of their resources, clearing the way for civilizing influences from ranchers and settlers. Intriguing collection of songs and legends.

Haines, Francis. *The Buffalo: The Story of the American Bison and Their Hunters from Prehistoric Times to the Present.* Norman: University of Oklahoma Press, ca. 1955. Good information; more balanced and broader than Gard's.

Laubin, Reginald, and Gladys Laubin. *The Indian Tipi: Its History, Construction, and Use.* New York: Ballantine, 1975. First printed by the University of Oklahoma Press in 1957, this book is referred to as "The Bible" by modern folk who want to make and/or live in an authentic Plains-style tipi. The Laubins traveled with and lived in a tipi long before most other non-Indians considered the idea. They give detailed information for making three-pole and four-pole lodges, discussing every aspect of tipi life including furnishings, decoration, and transportation of the long framework poles, making clear they learned from experts—the Indians themselves.

Legends of the Mighty Sioux. Compiled by workers of the South Dakota Writers' Project, Works Progress Administration (WPA), 1941; reprint Interior, South Dakota: Badlands Natural History Association, 1987. Compiled for children from the stories of living Lakota, with lively illustrations.

Marriott, Alice, and Carol K. Rachlin. *American Epic: The Story of the American Indian.* New York: New American Library, 1969. Respectful history, great bibliography.

The Oxford History of the American West. Edited by Clyde A. Milner II, Carol A. O'Connor, and Martha A. Sandweiss. Oxford University Press, Oxford, 1994. A fat and well-documented overview.

Sandoz, Mari. *The Buffalo Hunters.* New York: Hastings House, 1954. This great hunting narrative offers more knowledge and respect for the Plains tribes than does Gard's.

Trails West. Special Publications Division. Washington, D.C.: National Geographic Society, 1979. An illustrated overview prepared by scholars; a bit dated but with good photos and intriguing snippets of information.

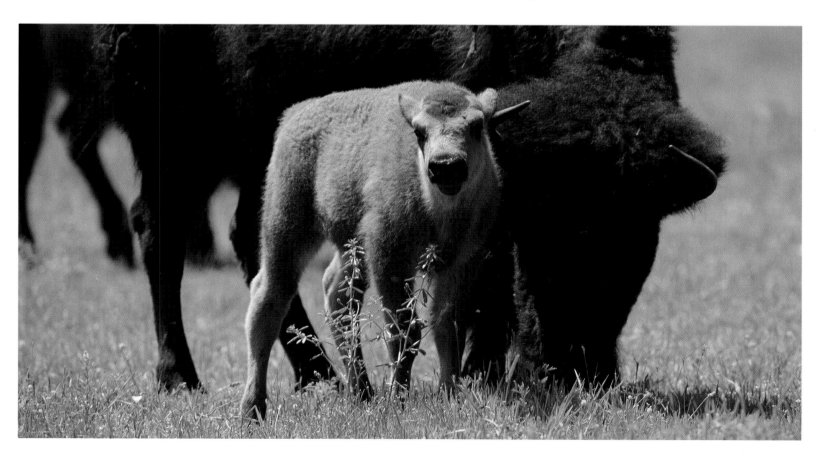

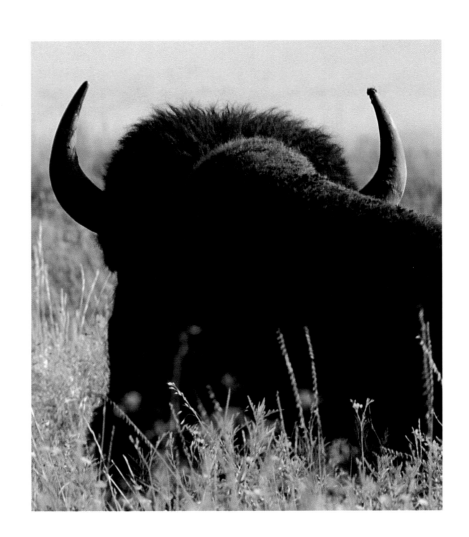